Environmental Management

The key to the survival of museum collections is a stable indoor environment and vital to this is a well-maintained building with effective environmental services. *Environmental Management* sets out clearly the theory and practice of achieving an appropriate museum environment for both collections and people.

The book emphasises the need for planning and places the environmental needs of museum collections at the forefront of the responsibilities of museum managers. May Cassar stresses the role of the building as the first line of defence against environmental instability, recognising the importance of regular environmental monitoring and control, and the division of museum spaces into critical areas housing collections and non-critical areas accommodating offices, cafes and communal spaces.

Environmental Management presents a strategic approach to environmental management, in contrast to the piecemeal approach to environmental monitoring and control still practised by many museums. However, rather than providing ready solutions and rigid rules, the book introduces principles and ideas on which to base decisions about creating the right environment.

May Cassar trained as a conservator and in recent years has had further training and considerable experience in the application of environmental design and engineering principles in museum buildings. She is a fellow of the International Institute of Conservation.

The Heritage: Care–Preservation–Management programme has been designed to serve the needs of the museum and heritage community worldwide. It publishes books and information services for professional museum and heritage workers, and for all the organisations that service the museum community.

Editor-in-chief Andrew Wheatcroft

Architecture in Conservation:
Managing developments at historic sites
James Strike

The Development of Costume
Naomi Tarrant

Forward Planning: *A handbook of business, corporate and development planning for museums and galleries*
Edited by Timothy Ambrose and Sue Runyard

The Handbook for Museums
Gary Edson and David Dean

Heritage Gardens: *Care, conservation and management*
Sheena Mackellar Goulty

Heritage and Tourism: *In the global village*
Priscilla Boniface and Peter J. Fowler

The Industrial Heritage: *Managing resources and uses*
Judith Alfrey and Tim Putnam

Museum Basics
Timothy Ambrose and Crispin Paine

Museum Exhibition: *Theory and practice*
David Dean

Museum Security and Protection: *A handbook for cultural heritage institutions*
ICOM and ICMS

Museums 2000: *Politics, people, professionals and profit*
Edited by Patrick J. Boylan

Museums and the Shaping of Knowledge
Eilean Hooper-Greenhill

Museums and their Visitors
Eilean Hooper-Greenhill

Museums without Barriers: *A new deal for disabled people*
Fondation de France and ICOM

The Past in Contemporary Society: *Then/Now*
Peter J. Fowler

The Representation of the Past: *Museums and heritage in the post-modern world*
Kevin Walsh

Towards the Museum of the Future: *New European perspectives*
Edited by Roger Miles and Lauro Zavala

MUSEUMS & GALLERIES
COMMISSION

Environmental Management

Guidelines for museums
and galleries

May Cassar

and Routledge
London and New York

First published 1995
by Routledge
11 New Fetter Lane, London EC4P 4EE

Simultaneously published in the USA and Canada
by Routledge
29 West 35th Street, New York, NY 10001

Typeset in Sabon by Florencetype Ltd, Stoodleigh, Devon

Printed and bound in Great Britain by T J Press Ltd, Padstow, Cornwall

British Library Cataloguing in Publication Data
A catalogue record for this book is available from the British Library

Library of Congress Cataloging in Publication Data
A catalogue record for this book has been requested

ISBN 0–415–10559–5

Contents

Contents

Plates

Figures

Boxes

Foreword by Garry Thomson

After the Second World War there was much to be done in museum buildings in Europe. Unfortunately, for many years little consideration was given to improving the conservation of their contents. Restoration? Yes! Conservation? Oh yes, that was the same as restoration, was it not? Things got worse. With the widespread use of fluorescent lamps it became possible to raise the intensity of artificial lighting to much higher levels. And, as ever, direct sunlight was allowed to fall on precious paintings. Furthermore, Europe's increased affluence meant that homes and offices, and museums too, could be made much warmer in winter with consequent dangerous dryness.

Curators of that day seemingly knew less about conservation than the ordinary Victorian householder!

In recent years, great strides have been made towards better conservation. But a gap still remains between recent technical advances in environmental monitoring and control and their application by museums trying to cope with the varied demands on their time and limited resources.

This book is successfully aimed at these problems, and contains much valuable advice.

Preface

The key to providing a stable collection is a stable environment; the key to a stable environment is a well-maintained building with effective environmental services.

Environmental Management emphasises the need for forward planning. It places the environmental needs of museum collections at the forefront of the responsibilities of museum managers, setting these professional responsibilities against the legal obligation to provide healthy and comfortable conditions for people who visit or work in museums. The book stresses the role of the building as the first line of defence against environmental instability, recognising the importance of regular environmental monitoring and control, and the division of museum spaces into critical and uncritical areas.

These guidelines present a strategic approach to environmental management – a vastly superior alternative to the piecemeal approach to environmental monitoring and control still practised by far too many museums. The book highlights the complex interdependence of influences that make up the museum environment, demonstrating the interdisciplinary nature of environmental management.

But this is not a recipe book; it provides no ready solutions, and avoids rigid rules about ideal environments. Instead, it introduces principles and ideas to think about, digest and act upon as appropriate – recognising the possibility that objects can be stable when they have reached equilibrium with conditions that are not necessarily ideal. Specific levels and bands of environmental control are only recommended in the context of these principles.

A great deal of research still has to be done and there are no definite answers to many problems that exist. However, the current uncertain state of knowledge in limited areas of the museum environment must not prevent museums from planning and undertaking environmental improvements that will benefit the collection.

The text of this book is organised into four Parts. The first, incorporating chapters 1 to 3, introduces the subject of resource management in the museum context (chapter 1), then examines the complex and often contradictory demands made

by objects and people on the museum space (chapter 2). The important subject of the preventive conservation strategy has a chapter to itself – creating a good indoor environment is not simply a matter of installing a complete air-conditioning system in the hope that it will cure all problems.

Part 2 starts by taking the widest possible view, in chapter 4 setting the museum in the context of its local climate, and working inwards to the implications for the environmental design of the building itself. Chapter 5 builds on this foundation, and describes the framework of the all-important monitoring programme, which systematically assesses building, collection, and internal environment; without an effective monitoring programme, a preventive conservation strategy will be based on guesswork, and may prove expensive, ineffective, or even harmful to the collection.

The three chapters of Part 3 examine the control options available for the display environment, from the most centralised (chapter 6), through more localised or portable solutions (chapter 7), to the truly local 'on-the-spot' control afforded by display cases and other environmentally controlled enclosures (chapter 8).

Part 4 covers two easily overlooked aspects of the environment of the museum object: storage and transportation. The storage environment (chapter 9) is an environment like any other, and its effects on the condition of objects is just as profound as that of the display space. Transportation, whether an object is being moved to the next room or to another continent, creates a mobile environment that presents a large potential threat to environmental continuity.

Throughout the text are boxes providing supplementary technical information to support the general principles discussed in the book; many of them also serve as self-contained information sheets on various practical aspects related to the museum environment. At the back of the book are a bibliography, a list of testing laboratories, professional institutions and other sources of information, a glossary of terms, and four valuable datasheets.

Throughout, the term 'museum' should be assumed to include art galleries; 'object' should be taken to mean both 'artefact' and 'specimen'.

Acknowledgements

This book draws upon over two years of research into the application of environmental monitoring and control in museums and galleries in the United Kingdom. I owe a debt of gratitude to all the museums that directly and indirectly provided me with information and inspiration which contributed to the writing of these *Guidelines*.

I should like to acknowledge the invaluable comments of the conservators, conservation scientists, museum curators, collection managers, architects and building services engineers who formed the original expert group which reviewed the guidelines: Jane Arthur, West Midlands Area Museum Service; Susan Bradley, The British Museum; Dr Richard Clarke, Birmingham Museums & Art Gallery; Rosemary Ewles, formerly at the Museums & Galleries Commission; Johan Hermans, Museum of London; Michael Houlihan, The Horniman Museum & Gardens; Suzanne Keene, Science Museum; Dr David Leigh, formerly Head of The Conservation Unit; Crispin Paine, Committee of Area Museum Councils; Sarah Staniforth, The National Trust; David Watkins, Brock Carmichael Associates; Peter Winsor, The Conservation Unit.

The seven English area museum councils, the museum councils of Scotland and Wales and Northern Ireland also provided useful comments on a later draft. Individual extracts were also reviewed by JoAnn Cassar, University of Malta; Stephen King, Graham Martin, Ian Pennistone and Amanda Ward, Victoria and Albert Museum; Kevin Mansfield and Dr Tadj Oreszczyn, The Bartlett Graduate School, University College London; Tim Whitehouse, formerly at the Museum of Photography, Film & Television; Martin Wright, Philips Lighting. A special word of thanks goes to Casimir Iwaszkiewicz for valuable professional comment and personal support during the preparation of this work. I am grateful to Stephen Ball for editing the final version of this work.

While acknowledging the assistance of these experts, the opinions and facts I have expressed, including any errors, are mine alone.

Lastly, I should like to acknowledge the initiative of the Museums & Galleries Commission in setting up the post of Environmental Adviser with the aim of writing these guidelines and the support of my colleagues at the Commission while these guidelines were being written.

May Cassar
London, May 1994

Part 1

The principles of museum environmental management

1

Managing resources

Management, then, is the job of organising resources to achieve satisfactory performance; to produce an enterprise from material and human resources.

<div align="right">Peter F. Drucker, in Pugh, Hickson and Hinings,

Writers on Organisations in Society, Penguin, 1983</div>

There is now a great public awareness of the essential fragility of even the most robust-seeming archaeological and historic objects. Disappearing Italian frescos and crumbling Egyptian antiquities will be familiar themes for most of the museum-going public, though these are only the most dramatic examples of a problem that can exist on a smaller scale in every museum in the world.

Coupled with this new awareness are two other realisations: that there is something called 'conservation', which can minimise the damage caused to cultural objects; and that the public funding of museums and galleries is declining, to be replaced by hard-to-find commercial and private finance. In short, the museum-going public is becoming aware that museums have a serious long-term problem on their hands.

The public view of conservation is probably still overwhelmingly that of restoration, in particular the painstaking reassembly of artefacts from fragments. The less obvious face of conservation, at least from the public's point of view, is preventive conservation management – the creation and maintenance of an environment that limits the decay of museum objects to the absolute minimum consistent with public access.

This public view is important, and not just because museums need to maintain a healthy influx of visitors. It is this 'lay' opinion of a museum's work that is now vital for some aspects of financing. Commercial sponsorship and private donations are likely to be founded on the donor's belief that the museum still has an informative and custodial role in contemporary society – and the associated belief that museum managements 'know what they are doing' when it comes to protecting the objects in their care.

Managing preventive conservation

Preventive conservation management within museums has two distinct yet complementary aspects: the technical and the organisational. Technical information enables those who monitor and control the museum environment to work effectively, to create the physical environment that is of such fundamental importance to the survival of the collection. In many museums, conservators are the staff responsible for the physical environment of objects, and the relationship here is usually simple and direct – the aim is to preserve the collection by controlling the environment.

The institutional context

But collections also exist within an institutional context. Problems with the physical environment of collections are better understood – and are certainly more likely to be resolved – if they are debated and discussed in the context of the institution's operational framework. This wider setting brings in different people with different ideas for collection use, and introduces broader and more complex issues. The collection can no longer exist in the separate, central position it normally occupies in the minds of conservators and curators. The questions of what to do, and how to do it, cease to be simply reducible to technical problems of the discovery of environmental defects and the search for appropriate remedies.

Getting involved

Preventive conservation staff – who will often be experienced conservators – cannot remain aloof either from wider management issues or indeed from the public world beyond the museum doors. And the relationship must be more than a one-sided series of demands from the conservation department to the museum management: preventive conservation staff should strive to participate in the development of museum policies, to be part of the decisions that contribute to a well-run museum and not just those that affect the collection. It is as important to know the size of the museum and who the decision-makers are as it is to know the size and location of a collection.

Change: threat or opportunity?

Change is sometimes difficult to accept, and to those responsible for the care of the collection change can often appear as a threat to its security. Loans, special exhibitions, increased visitor access, may expose objects to new hazards. There is an ever-present temptation to intervene, to say 'no' on behalf of one's collection.

Exhibitions and increased access

But without the public, a museum dies. At best, it becomes a hidden repository, a vault of treasures locked against the world; at worst, in these days of rising costs and falling subsidies, the museum dies literally and closes. There can be no greater threat to a collection than its dispersal following the closure of a museum.

Greater access to the collection improves public goodwill, raises a museum's profile, and increases the sales from its shop – all of which contribute to the survival of the collection. Conservation staff who oppose such a move without good reason may win the day, but will lose goodwill in the long term; they will be increasingly isolated from the decision-making process, and will be seen by their colleagues as a kind of unhelpful, obstructive internal police force.

Instead, access to collections should be carefully managed so that a balance is found between greater accessibility and the minimum risk of damage. Far from being isolated, conservation staff must be key participants in the attainment of this delicate balance. Change should be seen as a glorious opportunity to instil preventive conservation procedures within a museum; everybody, throughout the museum, is forced to think in terms of conservation whenever there is a major change – whether temporary or permanent – in the use of museum space.

Large exhibitions present the same opportunities – and the same kind of conservation challenge. Conservation staff will need to liaise with marketing and publicity staff to identify the spaces that can be used for events and to advise on safe types of activities. Compromises can often be found: for example, the public can be allowed access to stores housing less environmentally sensitive collections, or objects duplicated elsewhere.

Events which are organised around an exhibition should be managed to minimise the impact on objects on display. This will mean wide discussions resulting in guidelines for the maximum number of persons that can be accommodated, and numbers and controls on outside agencies like caterers, florists, photographers, and film units. Greater access does not mean that 'anything goes', or that well-established environmental principles can simply be abandoned; but it does mean that preventive conservation staff have to strike a sensitive balance between sticking to principles and knowing when to compromise.

Acquisitions

The development of a museum's acquisitions policy is another sensitive area for conservation staff. At first sight, the rate of growth of a museum collection seems to have little to do with preventive conservation. However, new acquisitions demand space and staff time, and may require special protection; unless there are unlimited resources to satisfy these demands – which is highly unlikely – the new objects will increase the pressure on the care of the existing collection. The implications for conservation staff are clear: they will have to be involved at an early stage in any discussions – should the museum be collecting what it cannot adequately care for; and if an acquisition is deemed vital to the collection, where can additional resources be obtained for its care?

Here again there is a conservation balancing act: new acquisitions may attract visitors, and can improve the quality of a museum's collection; against this stands the grim reality of limited resources, which severely constrain the level of care that can be given to a collection.

5

Preventive conservation: everybody's responsibility

The necessarily pragmatic approach to preventive conservation involves the management of human resources as well as the physical environment. Training in preventive conservation across the museum staff structure is vital, fostering an awareness of collection needs, and involving and empowering other museum staff. Preventive conservation becomes everybody's responsibility, and is no longer the exclusive preserve of the one person or department representing the 'conservation police'.

Collections are assets with many potential uses: study, loans, display, storage. Once collection care is accepted as a collective responsibility, any conflicts that may arise between preservation and use can be reconciled. This may mean that conservators will have to reappraise their role within the museum; they need to recognise and create opportunities for preventive conservation. By accepting a changed role, preventive conservation staff become problem-solvers, gaining eyes and ears throughout the museum – not the people who say 'no', but those who help find solutions.

See the section on training at the end of this chapter (p. 10).

Principles, priorities, and purchasing power

Making the case for conservation

Museums in the United Kingdom depend heavily on grants to fund environmental improvements, using them to cover the purchase of monitoring and control equipment or to support capital improvements to museum buildings. However, grants often have to be supplemented by financial contributions from local sources and/or sponsorship – an often difficult process because environmental measures, though essential to the preservation of a museum collection, are intrinsically unglamorous and their results hard to demonstrate in the short term. Tighter financial resources demand more convincing arguments – not to satisfy those working in museums of the need for environmental monitoring and control, but to reassure administrators and sponsors that money spent in this field is wisely spent.

There are several ways of demonstrating a museum's commitment to environmental care, its wise use of resources in this direction, and the benefits of a sound environmental policy. These include:

- Evidence of a sound environmental policy. A museum should be able to demonstrate that it already has a comprehensive environmental strategy, and that it has the right procedures in place to achieve as much environmental control as possible given its present resources.
- A list of quantifiable benefits. Environmental management brings many unquantifiable benefits to the collection, but it does no harm to emphasise measurable benefits such as savings in the cost of conservation treatments.

It is financial good sense to invest money in curing the causes rather than the effects of environmental problems.

- Intelligent financial management. For example, it may be possible to draw on the staff training budget to commit funds regularly to raise environmental awareness and knowledge among staff. Certain costs may need to be charged to budgets which may not be directly conservation-related.
- Evidence that the museum is not underselling itself. For example, a charge could be made to outside hirers for their use of staff time to inspect objects after an event.

Planning expenditure

There is no guarantee that large sums of money spent on environmental monitoring and control systems will produce an efficient and effective museum environment; but it is equally true that panic buying of equipment, or a 'patch-and-make-do' attitude, must be avoided at all costs. There must be a strategy for the purchase of equipment or services to control the environment if the available money is to be spent in the most effective way. Environmental measures must be costed and undertaken in a sequence that reflects the museum's plan for environmental improvements. A written museum-wide strategic plan will co-ordinate expenditure on conservation of the collection, building inspection and maintenance, and staff training, which are usually the responsibility of different staff members and set against separate budgets.

Monitoring gear before control gear

It makes financial sense for a museum operating an environmental strategy to buy monitoring equipment first. Control equipment costs more to buy, operate, and maintain, and its purchase should be based on selection and information from the monitoring programme in order to target precise requirements.

How much will it all cost?

Any guide to costs will date rapidly, particularly where fast-changing technologies lead to volatile prices. However, a comparative guide using dated prices is a useful first step in developing an environmental policy, assessing its costs, and prioritising measures.

Figure 1 illustrates the cost of a range of typical materials and equipment used to monitor and control the museum environment. The items range from basic monitoring equipment and good housekeeping materials to computerised control equipment. The costs, which range from £1 to over £10,000, have been divided into eight bands.

An upper limit of 'over £10,000' has been set because computerised control equipment often requires associated building work that will depend on the

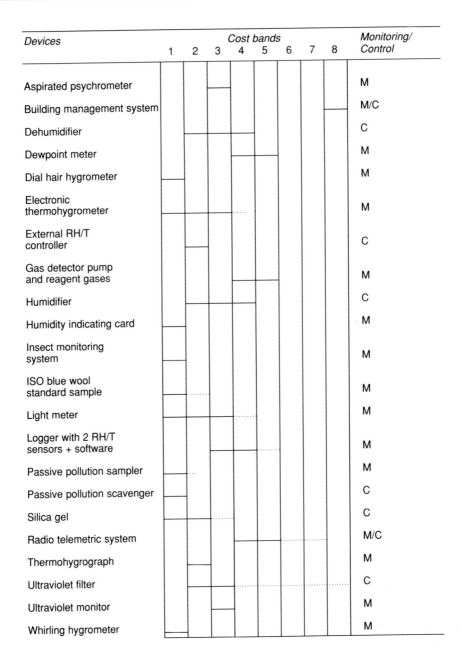

Figure 1 Comparative costs of environmental monitoring and control devices

Cost bands are based approximately on 1994 prices

1 = £1 – £100
2 = £100 – £500
3 = £500 – £700
4 = £750 – £1000

5 = £1000 – £2500
6 = £2500 – £5000
7 = £5000 – £10,000
8 = £10,000+

nature of the site. For example, in 1991, it cost the Courtauld Institute Galleries at Somerset House in London £110,000 to install a Building Management System with one external outstation, ten internal outstations, eleven carbon dioxide sensors, twelve combined relative humidity and temperature sensors, computer terminal with printer, software, programming, and commissioning. But this did not include associated building work, electrical wiring or fees.

The equipment and materials in figure 1 are examples of items that can be purchased within a certain cost range. How many items of each kind a museum buys will depend on the testimony of its monitoring programme. In general, a museum should:

- think ahead about its future equipment needs before selecting a particular type or model of equipment;
- try to obtain the best equipment its resources will allow;
- strive to upgrade the accuracy and ease of use of the environmental equipment it uses; and
- develop the range of parameters that it monitors and controls.

Running costs

It is difficult to estimate running costs of typical environmental control systems because of the numerous variables involved, such as organisational and personal requirements for heat and light, the type of building, and prevailing weather conditions. Systems maintenance can be divided between planned or 'preventive' maintenance – such as routine servicing – and unplanned or 'corrective' maintenance – such as breakdown repairs. Anecdotal evidence suggests that the total cost of maintaining a system is comparable to the cost of energy to run it. However, while the energy costs are usually known, most users will not know whether systems maintenance charges are reasonable.

Consultants and surveys: getting value for money

Products and materials are only one source of costs. Museums also purchase specialist services from consultants who undertake feasibility studies or condition surveys. A 1990 study of environmental surveys in museums and galleries concluded that museums should establish a survey's aims very clearly before commissioning consultants – is it to identify the causes of problems or to propose solutions to problems, for example? They should also shop around because costs vary widely.

The study, which covered over sixty museums and galleries in the UK, revealed that over 50 per cent of surveys carried out only to identify the cause of problems were not charged for, or were heavily subsidised by museum councils. By contrast, over 50 per cent of surveys carried out to propose solutions to problems cost over £2500 (figure 2). Overall, value for money appears to vary widely, in terms of both the quantity and quality of data recorded, and the length of time spent on analysis and rectifying problems. The message is clear: always brief consultants tendering for a survey well, and provide as much

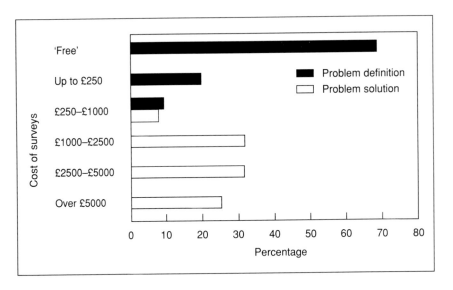

Figure 2 The cost of surveys

background information as possible. This is the only way to ensure that the museum gets what it wants, and what it pays for.

Using the resources

No matter how expensive, or sophisticated, or even accurate a piece of equipment is, it will be worthless if it is not properly used. Correct use extends into many areas – the choice of location, and the interpretation and analysis of data, for example. Human resources too are an integral component of the preventive conservation and environmental management; this means continuous professional development of staff through the appropriate level of training in the museum environment. Unless museum managements recognise the importance of training, and the crucial role of staff responsible for the museum environment, the future of the collections they administer looks bleak indeed.

Training

Training in preventive conservation should be available to everyone in the museum. Since conservators often take the lead in preventive conservation matters in museums, it is crucial that training should equip them at every level with appropriate technical and managerial skills.

Most primary training courses cover the principles of preventive conservation, and impart basic information on the use of environmental monitoring and control equipment. However, at every opportunity the thread of preventive conservation must be woven through theoretical and practical conservation

Plate 1 Training in preventive conservation should be provided for all grades of staff within a museum.

Acknowledgement: The Scottish Museums Council, recipient of the 1993 National Training Award – Scotland

training; otherwise, preventive conservation could be perceived as at best a sideline, and at worst a distraction from the main business of interventive conservation.

Short, intensive training courses have been effective in advancing the skills of conservators in mid-career by building on their experience in the workplace. The course developed by the Getty Conservation Institute in Los Angeles, and furthered in Europe by the Conservation Unit in collaboration with the Getty Conservation Institute, has for the first time addressed the organisational framework of preventive conservation in museums.

But the question remains whether conservators between primary and mid-career training are equipped to manage preventive conservation in all its aspects. There is a need for the specialised training of conservators in collection management and in conservation and environmental planning. All the signs are that preventive conservation has become a specialism in its own right. The preventive conservator with responsibility for the care of collections in its broadest sense is already with us, in fact if not in name.

Reaching the public

There is another – perhaps less obvious – target for a training policy: the public. Museum visitors are increasingly aware of the vulnerable nature of many objects in museums and galleries, and many will know of the damage and deterioration suffered by famous exhibits on display around the world. Much of this information is disseminated – sometimes sensationally – by modern media, and particularly by television. But there is much that even the smallest museum can do to inform its visitors about the vital role of preventive conservation through good environmental management.

Preventive conservation can easily be added to the museum's existing information output – for example, through exhibitions; university, college, and school teaching; local media and events; and special loans. Information about preventive conservation can reach people by exactly the same routes as information about the objects themselves.

And information is the key. There is no reason to hide preventive conservation from visitors, as though it were a secret matter only to be revealed to initiates. If an object demands special preventive conservation care, tell the public; if an exhibition space operates under tightly controlled environmental conditions, put up a notice that says so – and why. Inform and explain. Better still, mount an environmental exhibit – ideally, one that includes objects that have been damaged beyond repair by the wrong temperature, humidity or light conditions.

This information policy must reach beyond the exhibition spaces themselves. For example, where a museum decides to introduce a strict cloakroom policy to keep outdoor clothing away from the display spaces, the explanation for the policy should be displayed as prominently as the policy itself. Without this explanation, a strict cloakroom policy could look like petty officialdom, or an

attempt to take money from visitors in the form of cloakroom receipts. The result would be resentment, not enlightenment.

Environmental management is itself an interesting theme for the museum visitor. There can be no surer way to bring preventive conservation into the public eye – thereby making it a more attractive subject for grants and other financial aid – than to satisfy this interest.

2

Objects, people, and space

Get your room full of good air, then shut up the windows and keep it. It will keep for years. Anyway, don't keep using your lungs all the time. Let them rest.

Stephen Leacock, *Literary Lapses*, 1910

Museum objects and the internal environment

The object

Museums house an enormous variety of objects. One exhibit may be a fragile archaeological object, unearthed after centuries in a stable, almost natural environment. Another could be an electronic computer, still capable of performing its intended function and only barely obsolete. Each object commands its place in the museum through its history or associations, or because of its scientific or social interest.

Once an object enters a museum, the nature of its existence changes. There is a new and possibly hostile physical environment, and the object's original functions are modified or may be lost in the new context. But there is one overriding imperative for objects of every age, composition and condition: preservation. The museum assumes the responsibility for maintaining the object's physical stability, to slow down the processes that cause decay.

The central problem of care and conservation is that nothing lasts for ever – every object has a limited life. The aim of museum staff is therefore to slow, not stop, the rate of decay. An object's survival is affected by:

- the materials from which it is made;
- the environmental conditions in which it was kept before being added to the collection;
- its use before being added to the collection;
- the environmental conditions in which it has been kept since becoming part of the collection;
- its use as part of the museum collection in exhibitions, for research, as an educational aid, or as a working object;
- any previous conservation treatments or repairs.

The effects of storage and display

Objects in museums are affected by display and storage conditions. Unsuitable environmental conditions are a serious cause of decay, frequently made worse because the effects may remain invisible for a long period. By the time the damage is noticed the whole fabric and structure of an item may already be weakened.

Museum objects can be divided into two main types: organic materials, such as leather, textile and wood, which have an animal or vegetable origin; and inorganic materials, such as ceramics, glass, stone and metals, which have a mineral origin.

Unless they are contaminated by mineral salts, the rate of decay of materials like ceramics, glass and stone is very slow, so these materials are often considered to be chemically stable. By contrast, an unstable object will require more care – and even then its life may be extended only by a few years. Paper, paintings, archaeological iron and other similar materials will respond more quickly to changing conditions, and can deteriorate rapidly unless their environment is controlled.

How ideal are 'ideal' conditions?

It has become widely accepted that 'ideal' conditions for the display and storage of a mixed collection of stable objects are produced by a relative humidity of 50 per cent and a temperature of 19°C. But this is an oversimplification. Even if these conditions could be sustained, they would not always be desirable.

Theoretically ideal values of temperature and relative humidity are only the starting point from which to create a suitable environment for a collection. Indeed, in some circumstances these conditions could be harmful: if the existing environment is not causing the collection to deteriorate, it should be left alone (though this needs careful evaluation – remember that environmentally induced damage is not always obvious until it is too late). For example, the relative humidity in stately homes is likely to be well above 55 per cent for much of the time; the objects in the house may have acclimatised to these conditions and could deteriorate if conditions are 'improved'.

Planning genuine improvements to suit the collection

Very few museums have the resources to establish and maintain ideal environmental conditions. But all museums – if necessary, with expert guidance – can assess the needs of the objects in their collections, to develop a strategy that will show both the best way to meet these needs and the inevitable compromises that will have to be made along the way.

The most important factor is what could be called environmental continuity. For most materials, consistency is more important than the actual value of physical parameters. When planning changes to the collection's environment, a workable compromise must be reached between published standards – the

'ideal' conditions dictated by theory – and the existing environment, with which the collection may be in equilibrium. There must be no rapid changes in relative humidity or temperature, and the plan should include steps to control light, and to reduce gaseous and particulate pollution.

There is considerable empirical evidence on the environmental causes of deterioration, but measuring the rate of decay of materials is fraught with difficulties. It is hard to link the rate of deterioration with the speed of changes in indoor environmental conditions, since the composition and condition of the object will also affect its rate of decay.

From an object's point of view, the fundamental principles of genuine environmental improvement can be summarised as follows:

- The slower the speed of environmental change, the less damage is likely to occur to objects. Fluctuations in relative humidity and/or temperature are serious causes of environmental damage to organic objects, and to porous inorganic objects contaminated with mineral salts.
- Objects made of organic materials should be kept in conditions of temperature and relative humidity that match the moisture content of the object.
- Objects should be moved only gradually from one set of conditions to another, to give them time to acclimatise. The faster the speed of environmental change, and the wider the band within which it fluctuates, the faster the rate of decay of objects made of animal or vegetable materials.
- Different sides of objects made of organic materials should not be exposed to different environmental conditions. For example, a painting hanging on an external wall may be warmer and drier at its front than at its back.
- Metallic objects liable to active corrosion at high humidities should be kept at a controlled temperature and low relative humidity.
- Damage caused by light is cumulative: it varies with both the intensity of light and the duration of exposure. Control of light exposure may therefore be achieved by lowering light levels and by shortening the time during which objects are exposed to light.
- Ultraviolet (UV) radiation is extremely damaging to coloured surfaces and to the structure of many organic materials, so it must be filtered out. Although UV radiation is emitted to varying degrees by all light sources, it is not needed for viewing objects.
- Filtering UV radiation alone, without controlling light intensity, does not provide adequate protection for light-sensitive objects. UV radiation becomes less of a problem as light intensity is reduced to an acceptable level.
- Display, storage or packing materials intended for use with objects must be tested for stability. Gaseous pollutants from these materials and in the air can cause metals to corrode, and may weaken some organic materials.
- Every effort must be made to exclude particulate pollutants. Dust and grit are abrasive to many types of museum objects.

- Routine cleaning of the museum building, regular inspection of the collection on display and in storage, and a pest management programme should prevent pest infestation.

All of these points are dealt with in more detail in the chapters that follow.

Conflict in common spaces

Environmental control and people

If the ambient environment in the museum is geared to the needs of the collection, the rate of decay of objects will be slow. As far as the museum's collection is concerned, environmental control sets out to achieve and maintain appropriate conditions for the preservation of a wide range of natural and synthetic materials.

But museum spaces are not solely occupied by objects; there are also human beings to be housed – staff and, in significantly larger numbers, visitors. Environmental control must therefore also provide healthy and comfortable conditions in buildings where people work and visit.

The relationship between the needs of people and the museum's collection is complex – sometimes complementary, sometimes antagonistic. For example, since the 1980s, the maximum thermostat setting for public buildings in the UK has been fixed at 19°C. If this legislation had been strictly applied, museums would now come closer to bridging the gap between the thermal comfort needs of people and the preservation needs of objects, and at the same time would use less energy to sustain controlled conditions. Unfortunately, the environmental conditions required by objects often differ from those required by people.

The different sensitivities of people and objects

People and objects are affected by the same physical variables of humidity and temperature; and just as the human body responds to its surroundings, museum objects will respond to ambient environmental changes. But there is a crucial difference: people are primarily temperature sensitive, whereas most museum objects are primarily humidity sensitive. Thomson has said that a 4 per cent relative humidity (RH) change has the same effect on objects as a 10° change in temperature. It has been calculated that the same change in RH has the same effect on people as a 0.1° change in temperature. It is safe therefore to conclude that objects are about a hundred times more sensitive to RH than people.

Another contrast is that people can take action to influence their environment; they can adapt to, and recover from, a thermally hostile environment by changing their pattern of activities or the amount of clothing they wear, or by moving from a place where they feel uncomfortable.

Objects, of course, have no such control over their environment. They are passive recipients of the ambient environmental conditions that people help to create, and are unlikely to recover completely after being subjected to a hostile

environment. If the new environmental conditions cause changes in an object's moisture content, for example, it may suffer physical damage.

The 'tolerance' of objects in the human environment

Objects are generally less tolerant of environmental change than humans. There is no reliable relationship between human comfort and the suitability of the environment for the collection.

The human body is affected by irritation of the nasal passages, the throat, and the eyes if ambient relative humidity drops below 30 per cent. Above this lower threshold, people are tolerant of considerable variations in humidity until relative humidity rises above 70 per cent, when we begin to feel some discomfort. In other words, human beings are least sensitive within the band 30 per cent to 70 per cent RH – a range that is unfortunately most critical for a large number of museum objects.

Stable materials are more tolerant of conditions primarily designed for human comfort: stone, highly-fired ceramics, and historic glass and metalwork are good examples. The environmental needs of objects become more demanding – and less in tune with human comfort – if they are in an unstable physical condition. A conservator's assessment of the condition of the objects is therefore an essential precursor to any decisions on environmental needs.

The similarities and differences between human needs and object needs are well illustrated in figure 3, which compares their separate environmental requirements. The figure plots temperature against relative humidities, and shows the tolerance bands for human thermal comfort and different groups of objects. The large block depicting the human range indicates wide margins of tolerance to both temperature and relative humidity. By contrast, mixed collections and hygroscopic (moisture-absorbing) objects require a stable relative humidity, and metals need a constant low relative humidity.

Most museum materials therefore need stable humidity control within a narrow band, which is sometimes difficult – and often expensive – to achieve and maintain. If both objects and people are to share the same space within museums, satisfactory environmental conditions will require carefully considered compromises.

People as an environmental problem

There is yet another dimension to the interplay of people and objects in museum spaces. By their very presence, human beings produce changes in their immediate environment. Human metabolic functions such as breathing, physical activity such as walking, even the amount and condition of clothing, can all alter the conditions of temperature and humidity in the air. In the enclosed spaces of a museum building, and particularly if there are large numbers of visitors, these effects can be highly significant: the resultant changes in relative humidity and temperature as the presence of people varies over a twenty-four-hour period will cause the environment around museum objects to fluctuate.

Plate 2 Crowds of visitors have always been the hallmarks of a successful exhibition but today it is unacceptable to ignore the environmental implications for objects and the building.

Acknowledgement: Museum of London

19

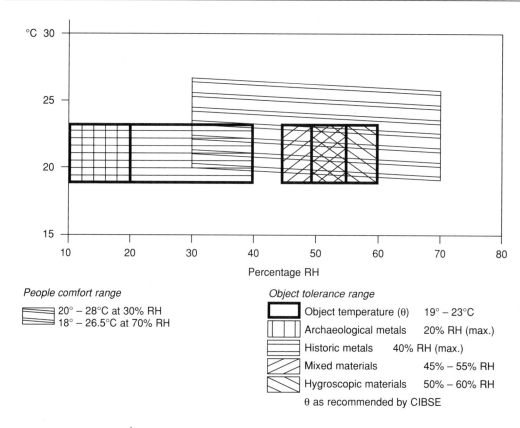

Figure 3 The 'ideal' environmental requirements of objects and people (adapted from J.R. Briggs, *Museums and Galleries*, 1984, pp. 767–8)

An adult releases approximately 60 grams of water vapour per hour, and at least 60 watts per square metre of body surface as heat – both of which affect ambient relative humidity. People also produce other gases such as carbon dioxide, which may be an indicator of poor ventilation and hence the presence of other pollutants: large numbers of people in a sealed building can cause a significant rise in carbon dioxide levels.

See chapter 7, p. 108, for the statutory obligation to control carbon dioxide levels in buildings.

Clothing may not be an obvious cause of environmental change in a building, but it can produce harmful effects. Visitors to museums often wear or carry heavy items of outdoor clothing, which may cause them to overheat and perspire as they walk through a space that is kept warm enough to provide thermal comfort for lightly clothed staff. On rainy days, people wearing wet raincoats cause additional moisture gains.

There are several approaches – all discussed in detail in later chapters – that will help to reduce 'people effects':

- The shared use of spaces by people and objects should be carefully planned, in order to achieve and maintain as stable a climate as possible.

- Museums have to provide fresh air for staff and visitors to breathe and adequate ventilation to dispose of pollutants and excess moisture, often under the regulation of legislation. But uncontrolled natural ventilation – for example, through open windows, or gaps and openings in a poorly maintained building – creates unstable ambient relative humidity, and should therefore be avoided by museums.
- Where there are large numbers of visitors, conditions around objects must be monitored and controlled. The simplest way to do this is to place objects inside cases to separate them from people.
- In extreme cases, where visitors are clearly creating conditions that will damage the collection, the only options may be to restrict visitor numbers or to use mechanically assisted ventilation and humidity control.
- 'Clothing effects' – often apparent as steep rises in humidity and temperature – can be substantially reduced by providing good cloakroom facilities and encouraging visitors to use them. Not enough museums have cloakroom facilities, and hardly any request visitors to use them, but cloakrooms can help to maintain a stable internal environment and reduce associated running costs.

3

Developing an environmental strategy

> It is surprising how often the reinforcement of one particular selected area
> can suddenly make the achievement of the strategic objective possible.
> John Harvey Jones, *Making it Happen*, Fontana, 1989

The four main influences affecting the indoor environment are weather, the
building, environmental services (such as heating, lighting and air-conditioning),
and human beings. More specifically, a museum collection is at risk from:

- inappropriate or fluctuating humidity, temperature and light;
- the presence of pollutants and pests;
- the way objects are handled and used; and
- activities within the museum.

These risks can only be overcome if there is an overall plan or strategy to deal with
them. This environmental strategy – the museum's blueprint for the preservation
of the collection – should therefore aim to achieve and maintain environmental
continuity and stability.

Assessing existing conditions

An effective strategy must be founded on accurate information about the
collection and its surroundings. What is the general condition of the collection,
the building, the internal environment? How are the objects used, displayed,
stored, and moved? Gathering information of this kind is fundamental to the
care of collections in museums and galleries, but the process is not merely one
of surveys and data collection. Too often, measuring and monitoring activities
do not take place within a framework for improvements to the museum envir-
onment. Connections remain unseen, influences remain unrecognised, the
causes of problems remain undiscovered, and the opportunity to develop a plan
for environmental management is lost.

The conservation audit

A conservation audit is an essential prelude to the development and implemen-
tation of an environmental strategy. An audit makes possible the systematic

compilation of factual information on the collection and its context: by constructing a profile of the existing environment, the state of the building, and the assets relating to the provision of environmental protection, a museum can establish the extent of any necessary improvements. Depending on the size and complexity of the museum and its collection, the full audit may take up to three years to complete.

A conservation audit should assemble factual information in four main areas: the collection, environmental monitoring, the building and the environmental systems. The collection survey and environmental monitoring can be undertaken by a conservator, while the audit of the building and services may require the involvement of an architect, building surveyor and building services engineers at different stages.

Once the conservation audit is under way there should be regular discussions between the survey team and the museum in order to give the programme of work that results from the audit an order of priority that reflects:

• the urgency of the work in terms of the environmental needs and security of the collection, and the safety of the staff and visitors; and

• the resources of the museum to implement the measures that are recommended.

All professionals involved in the survey will need to confer when drawing up the final report. The format of an audit report will depend on whether it is the first survey of the museum. If it is, a full report, illustrated with plans, drawings, photographs, environmental data and information on the condition of the collection should be included. Subsequent surveys, such as annual inspections, may only require forms to be filled on different aspects of the survey such as the building and the services. Five-yearly surveys of buildings and services should be comprehensive in the detail covered.

Box 1 Conservation audit

The condition of the collection

The collection survey, an essential component of the strategy, is designed to determine the physical state and future needs of the objects in the museum's care. Survey techniques vary, but can be roughly categorised by the scale of the task:

• A *small or medium-sized museum* may combine a collection survey with a check of environmental conditions and a general commentary on the state of the museum building. These general surveys can be carried out by an experienced conservator to discover both the condition of the collection and the likely causes of environmental damage. If the general survey shows that more detailed assessments are needed in some areas, specialist help can be sought.

• In a *large museum*, a detailed collection survey will be a major and complex undertaking, in terms of staff commitment, time, and financial resources: the survey of a national collection will involve both curatorial

23

and conservation staff. To reduce the commitment of time and money, therefore, a museum with a large collection may choose to use statistical methods on a representative sample of objects, rather than a full object-by-object survey.

How the collection is used

The people associated with a museum – staff and visitors alike – can produce a range of effects on the collection and its environment. The condition survey should be supplemented by an assessment of how the collection is used by staff, researchers, and, in a broader sense, by visitors. Parts of the collection spend most of the time on display or in storage; other objects are used almost exclusively for research purposes, or are regularly lent to exhibitions, so the use survey must include the environmental implications of handling and moving objects.

See chapters 9 and 10, pp. 121 and 129, for a discussion of storage and movement.

Environmental monitoring

Environmental monitoring is so important that the whole of a later chapter is devoted to the subject. From the strategic point of view, the monitoring programme should be set against its wider purpose of providing the baseline information against which any control or improvement policy must be set.

See chapter 5, p. 53, for more on the monitoring programme and techniques.

If a museum is already monitoring the environment, it must first assess how the monitoring is organised, what equipment is used and the range of environmental variables being measured. If regular monitoring has never taken place, intensive monitoring of relative humidity, temperature and light should be carried out first in the vicinity of vulnerable objects to produce a quick snapshot of conditions; or, if only spot-checks are possible, a written record of readings must be kept. These preliminary data will be used to define the aims and objectives of the long-term monitoring programme. Monitored data for at least one continuous year should be collected as part of the audit.

The building

The start of the collection and environmental surveys should be followed by internal and external inspections of the museum building. Initially, a building appraisal may be undertaken by a conservator, who will walk through and around the premises using sight, sound and smell and noting obvious defects; the detailed audit comes later, and will probably draw on the services of an architect or building surveyor. The final report, augmented by scale drawings, will incorporate a description of the building, its construction and condition, and a series of recommendations (short, medium and long term) for its maintenance.

An assessment of the building's services – especially environmental control systems such as central heating or air-conditioning – should come next. The

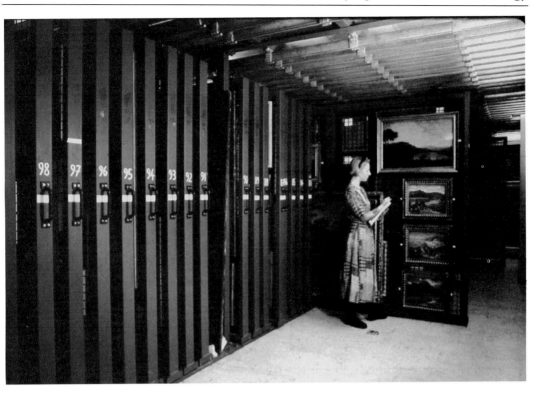

Plate 3 Condition survey of paintings collection being carried out in the store.
Acknowledgement: Jenny Williamson, Glynn Vivian Art Gallery, Swansea Museums Service,
Leisure Services Department, Swansea City Council

scale of the work will depend on the size and complexity of the installed systems, and where the work is extensive a building services engineer may have to be called in. The services report should include an appraisal of the essential hardware – boilers, pipework, radiators, ducting, pumps and so on – and advice on replacements, upgrades and repairs.

A museum will want to correct any defects shown up by the building and services survey as soon as possible. An energy audit is another – and recommended – option, its cost identified as a separate fee. If the building is sound but leaky to air or constructed of poorly insulating materials, say, or if a heating boiler is in good condition but inefficient, their upgrading or replacement by energy-efficient alternatives could offer long-term savings.

The final – dated – building and services report will contain factual information on the museum's environmental assets and it should identify and prioritise areas needing improvement. The date is important: the details of any physical alterations to the building and environmental systems should be attached to the original audit report as dated addenda.

Using the audit to assess the collection's needs

Armed with the conservation audit, museum staff can identify and prioritise the environmental demands of vulnerable objects in the collection, and in turn create the conditions that will maintain their equilibrium with the environment.

Environmental tagging

A tagging system categorises individual items or groups of similar objects according to their environmental needs. The conservator or other staff member uses the audit data to identify the object's needs, then physically labels it with the information. Suitable labels can take several forms, for example:

- a simple tag stating the conditions required by the object, and kept with it at all times;
- labels on boxes for groups of objects requiring the same environmental conditions;
- conservation-safe polyester tags carrying environmental information in barcode form, permitting electronic data retrieval and subsequent processing.

If the tag carries both identification and environmental information, it can serve as a physical reminder to conservators and curators alike of the conditions in which objects should be kept for environmental continuity. The need for continuity is thereby continuously promoted, with the result that conservation awareness is increased throughout the museum.

Building the strategy

The complete environmental strategy can now be built upon the findings of the conservation audit. Early in the survey process, initial sampling of the

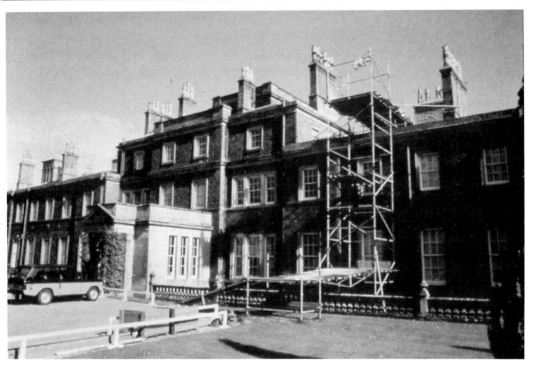

Plate 4 Roof inspection for repair requires appropriate measures to ensure a thorough job is carried out.

Acknowledgement: The Duke of Buccleuch, KT

collection, the snapshot of environmental conditions, and the first inspection of the building and services will already have revealed the areas in which work and resources are urgently required, and the strategy's likely emphasis. Planning for an environmental strategy can therefore start before the audit is completed.

Later, the full audit can be used to set a timetable and decide the priorities for the most cost-effective and appropriate improvements. The audit does not mark the end of the monitoring process, which should continue indefinitely to inform on decisions for long-term monitoring and control, including:

- capital expenditure for the purchase and installation of equipment;
- training of museum staff in the use and calibration of monitoring equipment, the recording and interpretation of data, and the operation and evaluation of control equipment;
- an annual programme of inspection and preventive maintenance to cover the building and environmental systems; and
- five-yearly surveys of the collection, the building and environmental systems.

Management and use

An environmental strategy is not limited to equipment and objects, but must also address the management of the museum and its indoor environment. Evaluating the effect of management practices on the collection will involve everyone in the museum who comes into contact with objects.

Staff training must seek to raise awareness of how routine use of the collection can cause changes in its environment, and how these changes will affect the stability of different materials; and work practices within the museum must also come under scrutiny. What are the different objects in the collection used for, and how frequently are they used? Is all relocation associated with their use really necessary, and can moves of objects be co-ordinated? Above all, is environmental continuity maintained through an object's cycle of use?

As an example of environmental pressures created by use, consider an object that is removed from storage for study purposes, photographed, examined, conserved and finally put on display. During this quite ordinary series of uses, the object has passed through no fewer than four different environments between leaving the store and going on display – a potentially damaging transition.

Is the strategy working?

Concern for the environment of the collection is the first step towards its improvement. Evidence of care being given to environmental continuity, of changes planned in advance, of the avoidance of disruption, are sure signs that the strategy is working. Environmental concern eliminates crisis management of the collection, and fosters an atmosphere of long-term collection care within the museum. It provides a powerful argument for integrating the environmental strategy into the museum's broader development plan.

Finalising the strategy

Measurable targets and a timetable for change are essential for both the conservation audit and the strategy – a museum's timetable for improvements depending on its resources of time, staff and available money. Three years is a good target period for completion of a conservation audit, to include at least one continuous year's targeted monitoring of relative humidity, temperature and light in designated areas. The choice of areas will depend on local circumstances: for example, a section of the collection that is thought to be vulnerable, or an inadequate store, or hitherto unmonitored parts of the building where conditions are suspect.

The creation of a strategy could proceed as follows: within one year of the conservation audit's completion, the museum's governing body produces a draft document discussing the strategy in detail; the document will include the seven elements described in the last block of figure 4. By the end of another year, the strategy as defined in the document, with any agreed changes, is incorporated into the museum's corporate plan. Thus within five years of the museum committing itself to environmental planning, a strategy will be in place.

To recognise the need for an environmental strategy is to accept implicitly the need to redress the balance between preventive and interventive conservation – though the collection will probably suffer if the additional resources needed for environmental management are simply appropriated from funds committed to interventive conservation. Inevitably, preventive conservation will create a demand for more resources to be committed to collection care. This demand can be justified only if – in the context of an environmental management strategy – trained staff can direct the additional resources to those areas revealed by the audit to be most in need.

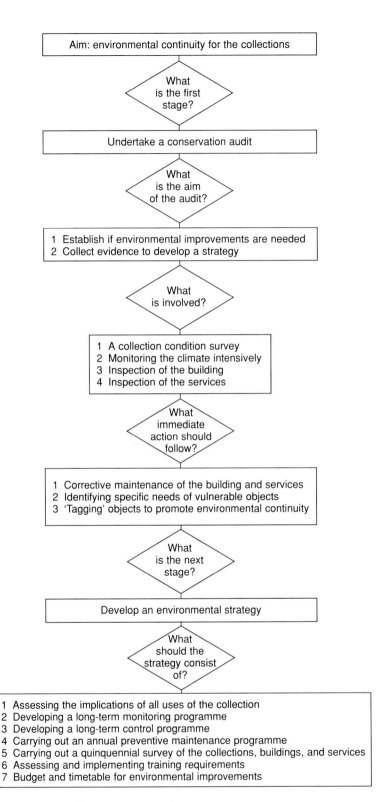

Aim: environmental continuity for the collections

What is the first stage?

Undertake a conservation audit

What is the aim of the audit?

1 Establish if environmental improvements are needed
2 Collect evidence to develop a strategy

What is involved?

1 A collection condition survey
2 Monitoring the climate intensively
3 Inspection of the building
4 Inspection of the services

What immediate action should follow?

1 Corrective maintenance of the building and services
2 Identifying specific needs of vulnerable objects
3 'Tagging' objects to promote environmental continuity

What is the next stage?

Develop an environmental strategy

What should the strategy consist of?

1 Assessing the implications of all uses of the collection
2 Developing a long-term monitoring programme
3 Developing a long-term control programme
4 Carrying out an annual preventive maintenance programme
5 Carrying out a quinquennial survey of the collections, buildings, and services
6 Assessing and implementing training requirements
7 Budget and timetable for environmental improvements

Figure 4 A strategic approach to environmental management

Part 2

Managing and monitoring the built environment

4

Weather, buildings, and environmental design

The bower we shrined to Tennyson,
Gentlemen,
Is roof-wrecked; damps there drip upon,
Sagged seats, the creeper-nails are rust,
The spider is sole denizen.

Thomas Hardy, *An Ancient to Ancients*

Weather

The performance of buildings is affected by weather conditions. A better understanding of the mechanisms that drive weather changes can help in the planning of a new museum in a number of ways, including the selection of the site, the orientation of the building and the internal layout of the rooms.

For an existing building, knowledge of prevailing weather conditions and their effects on the building allows environmental measures to be applied in more subtle ways – for example, when deciding the use of different rooms.

Meteorologists examine the world's weather at three different scales: macro, meso and micro. In their systematic use by meteorologists, terms like 'mesoclimate' and 'microclimate' have specialised meanings that go beyond the scope of these guidelines. But museum staff should be aware of the effects of scale on weather conditions.

The first and largest level looks at longer-term weather systems from a few hundreds or thousands of kilometres across up to the world scale. Mesometeorology deals with weather systems at scales of between 20 and 250 kilometres, which tend to be of a shorter duration – typically from a few hours to two or three days.

The smallest scale deals with events close to the surface of the ground. Here, the scale may be anything from a few tens of metres down to the very local. Buildings and ground cover have a significant effect, creating very local temperature changes and air movements, often in the form of eddies and turbulence.

The message for museum staff is simple: always monitor external relative humidity and temperature as part of the overall monitoring programme.

For the monitoring programme, see chapter 5, p. 53.

Large-scale weather patterns

Large events, such as atmospheric and sea movements on a continental scale, may seem remote from the immediate concerns of museum staff. But national weather patterns provide the ever-present background to local conditions. In the British Isles for example, the prevailing weather tends to come from the south-west. Average temperatures and rainfall, and strength and direction of prevailing winds, all follow trends determined by the country's position in global air and sea movements.

Large-scale weather patterns are not fixed for all time. There is now a great deal of evidence to show that climate systems change over time, and are significantly affected by human activity. The 'greenhouse effect' on average global temperatures is one well-known factor.

In 1991, a British study concluded that 'even if stringent measures were taken to reduce greenhouse gas emissions, some changes in the climate and sea level will occur anyway ... due to time-lags in the climate system response to changes in greenhouse gas concentrations that have already occurred'.

Any general view of national weather conditions must therefore be tempered by predictions of global and national weather change, where these are available. Climatic change will increasingly have a significant effect on environmental control measures in buildings.

Medium-scale weather patterns

On a smaller, regional scale, weather is affected by latitude, larger topographical features like mountain ranges and maritime influences. These factors can produce regional weather variations, even between centres only a few hundred kilometres apart.

The British Isles again provide a good example. The country is physically small, but there are marked regional variations in weather. For example, latitude differences mean that the south is generally warmer than the north; and the hilly western landscape obstructs the prevailing airstream with the result that the east is largely drier than the west.

In coastal areas, temperature differences between land and sea create cycles of air mass movement. By day, the direction of air flow is towards the land; by night, the direction of air flow is towards the sea. Humidity – the amount of water vapour in the atmosphere – is therefore higher in coastal districts than it is inland, though differences are smaller in winter.

Local weather and the 'microclimate'

Local weather is influenced by altitude and exposure, and by the presence of localised topographical features like small hills and valleys. There can be subtle differences between the climates of two towns only 15 kilometres apart.

On a still smaller scale, the microclimate comes into play. Here, buildings and vegetation cover have a significant effect. Different structures, and animals and plants, all vary in their absorption and reflection of solar energy. Winds are slowed by friction with the ground, and broken up or redirected by obstacles like trees and buildings.

Although the scale is small, the effects can be large. Temperature variations in the built environment can vary between extremes that are not found in exposed or more uniform sites.

Controlling and modifying the effects of the weather

Vegetation cover

Weather conditions in the vicinity of buildings may be modified by the control of vegetation cover. Trees and shrubs can be planted to guide, filter, obstruct or deflect the pattern of air movement.

Shelter belts of trees are of proven benefit in modifying the effect of wind on exposed sites. In the British Isles, where the prevailing winds are usually from the west, south-west-facing façades are best protected by shelter belts of trees. A penetrable bank on the leeward (sheltered) side of the trees will further help to reduce air turbulence.

A mixed stand of trees is more effective at reducing air flow velocity than a uniform one. The width of the protected area depends on the width of the stand of trees, whereas the depth of the area is largely governed by the height of the stand. Trees give a greater area of protection than solid barriers and this protection may extend as far as twenty times the height of the trees.

Vegetation can be used in other ways. Air stillness at the face of a north-facing wall will be improved if evergreens are planted next to the wall. Trees, shrubs, grass and expanses of water near buildings will damp down air fluctuations. Walks and pavements, on the other hand, will make them worse – as will fallen snow and other temporary features.

Modifying the built environment

The design and positioning of buildings influences the air movement around them. Control of these features will usually be left to architects, engineers and planners, but museum staff should be aware of the results. For example, demolition or redevelopment on an adjacent site could expose a previously sheltered part of the museum to the full force of the prevailing weather.

Air movement and pressure distribution outside the building will affect the pattern of air movement within it. In general, tall buildings create larger areas of calm on the leeward side; the shorter the building, the smaller is the size of the area of calm. These calmer areas will contain eddies of more turbulent air, depending on the shape and size of the building, and its position in relation to other buildings in the vicinity.

A row of detached buildings creates areas of calm downstream, with the areas between the buildings in the row affected by strong winds. Buildings arranged in a straight line aligned with the prevailing wind direction are partially protected by the building at the front of the line. By contrast, an alternating row of buildings aligned in the same direction will suffer from enhanced air flow effects such as turbulence (see figure 5).

Interaction between the external and internal environments

Air and ventilation

The weather affects ventilation and, consequently, the air quality, environmental stability and energy consumption within buildings. The driving mechanisms are wind speed, wind direction and temperature. Air enters buildings through windows, doors, ventilation grilles and other openings.

Most museum buildings are naturally ventilated. Uncontrolled inward and outward flows of air pass through open doors and windows, that is, natural ventilation, and the many cracks and gaps in the building's outer structure, that is, air infiltration. The air flows in and out because of pressure differences generated across gaps by the action of wind and temperature.

The position of doors and windows affects internal air flow, so a knowledge of a building's orientation will make it easier to decide where to locate them in both new and modified buildings. Older or poorly maintained buildings will probably have a high air infiltration rate. The consequences of this may be an unacceptable level of fluctuations in indoor relative humidity (RH) and temperature, and significant energy losses.

Improvements in thermal insulation can increase the proportional significance of loss through air infiltration, as conductive heat losses through the fabric are diminished. Buildings constructed wholly or partly underground have enhanced thermal stability: this is mainly due to the thermal mass of the surrounding soil and partly due to a significant reduction in air infiltration, which is the cause of most heat loss in conventional buildings.

The building as a buffer

The outer shell of the building is the main line of defence against external weather conditions. It protects the environment for both people and objects by separating the variable external climate from the more stable internal conditions. Various measures can be taken to reduce air infiltration and enhance thermal stability, both of which are required to achieve humidity stability.

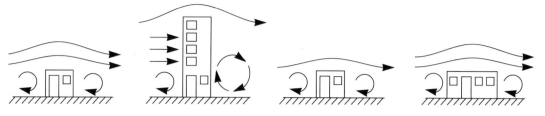

There is a larger area of calm in the lee of a tall building than in the lee of a comparatively smaller building

The protected area becomes smaller in *proportion to the building* as the building gets larger

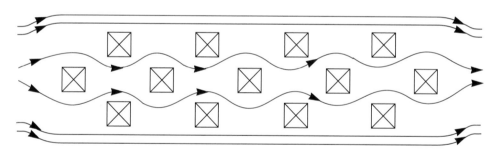

Buildings at the windward end of a linear arrangement protect subsequent buildings from the potential airflow

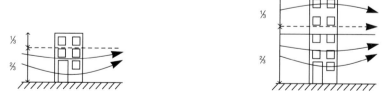

Alternating arrangements actually increase airflow effects between the buildings

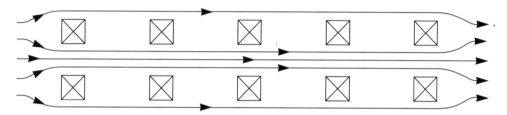

Pressure differentials on the windward side of a building are altered as the height of the structure increases; consequently, the pattern of air movement *within* the building is modified.

Figure 5 The effects of building size and arrangement on airflow (after T. S. Bontet, *Controlling Air Movement*, McGraw-Hill, 1987)

Glazing

Glass in external windows, doors and roof lights is a primary source of both solar gain and heat loss. Inside a room with external glazed surfaces, the heating effect of solar energy is increased by the greenhouse effect: the short-wavelength solar radiation passes through the glass and is absorbed by internal surfaces and contents; these then re-radiate part of the energy at longer wavelengths that cannot pass back through the glass. The result is a net heat gain.

Single thicknesses of glass will also allow the rapid escape of energy to the exterior. Large glazed areas can therefore cause room temperatures to vary between extremes of heat and cold. In other words, external glass can contribute to severe thermal instability.

The temperature instabilities created by glass can be decreased in two ways: (1) by reducing the area of external glass, for example with fewer and smaller windows; and (2) by multiple glazing techniques. Multiple glazing involves the use of two or more parallel layers of glass, usually separated by a precise thickness of air and enclosed in a sealed unit. There is little to be gained if the gap is greater than 20 millimetres; however, if high levels of sound insulation are required, improvements can be obtained with gaps up to 200 millimetres. Domestic double glazing, which normally has 6 millimetre or 12 millimetre gap, is a familiar example.

The thermal insulation performance of materials may be compared using U-values. The U-value of a material is the rate of heat transfer in watts through one square metre when the sides differ in temperature by 1°C: the lower a material's U-value, the better its thermal insulating properties. The U-value of an external wall can range from 2 to 0.2 with historic buildings typically having a U-value between 2 and 1. A typical modern external wall has a U-value of 0.45, whereas single glazing has a value about twelve times higher. In other words, heat is lost through a single glazed window at twelve times the rate of loss through the same area of the adjacent wall.

Double glazing almost halves the loss through single glazing. A useful rule of thumb is that 1 square metre of single glazing allows about seven times more heat loss than 1 square metre of wall with a U-value of 0.45. Performance can be improved still further using argon-filled double glazing or low emissivity coated double glazing units; these may reduce the heat transfer to only four times that of the wall.

See the subsections 'Excessive light and heat' (p. 45) and 'Sunlight in older buildings' (p. 48) later in this chapter.

Shutters

Shutters provide a simple, traditional way of modifying a range of environmental variables, but their effectiveness depends on climatic factors, and whether they are fitted inside or outside the window.

Shutters are generally more effective on the outside (see figure 6); heat loss and gain can be better controlled, because closed shutters shield the glass from the

Shutters	Heat loss/gain	Light	Dust	Air movement	Noise
Inside	✓ (UK)	✓			✓
Outside	✓ (Continent)	✓	✓	✓	✓

Figure 6 The effects of shutters in reducing environmental impact

sun and the wind. Where shutters are fitted on the inside, the glass is still exposed to the weather. The space between the glass and the shutter may also act as a miniature greenhouse, creating heat that may eventually produce a temperature rise in the room space.

Other shading devices

Blinds and other devices have been developed for use on windows, their precise application depending on the orientation of the opening.

On north-facing windows, vertical blinds or fins, in conjunction with double or triple glazing, have been successfully used for protection against solar effects. For south-facing glass, proven techniques to prevent heat gain include heat-reflecting glass, horizontal slats and external canopies. The more traditional use of Holland blinds can reduce daylight levels to about 500 lux, with the blinds still providing a secondary source of illuminance. Windows with an east–west orientation can be protected from heat gain by external frames that have the effect of setting the glass further back from the wall's surface, or by honeycomb screens, reflective blinds and heat-rejecting glass.

Drawn curtains and partitions

Curtains and partitions can be used as short-term measures to combat air infil-tration within buildings, though effective draught-proofing measures may even-tually have to be taken to cure the problem at its source. Curtains can significantly reduce the effect of leaky openings by obstructing draughts, and partitions can be positioned to alter the pattern of air currents.

It is often worth experimenting with short-term measures like curtains and screens; they can provide a low-cost, semi-permanent improvement in the stab-ility of temperature and relative humidity. However, internal shading will not effectively control solar heat gains. Nevertheless curtains or screens are better with an aluminium reflective surface on the outside rather than black.

Environmental zoning

Separate zones may be created within a building by comparing and matching their environmental characteristics. The most environmentally stable areas can then be allocated to the most sensitive parts of the collection.

At its simplest, environmental zoning can be established by keeping doors and windows closed to isolate different rooms. More sophisticated zoning will depend on monitoring to discover which areas of the building have the most stable climatic conditions. It may be possible to extend the results from monitored areas to other areas with similar physical characteristics.

Already stable areas will require less effort, energy and money to control than rooms subject to significant external and internal heat gains and losses.

Critical and non-critical areas

The concept of critical and non-critical areas is valuable for the assessment of plans for zoning and active environmental control. Not all areas in the museum need to be controlled to the level required by the most sensitive object (see figure 7).

Critical areas are the galleries, storage areas and conservation laboratories. These spaces are designated primarily for objects, so the environmental conditions in them can be geared to the needs of the collection.

Non-critical areas include offices, corridors and shops. These spaces are mainly used by people, and therefore need to be controlled only to maintain the comfort of office staff and visitors. Museums should not exhibit environmentally sensitive objects in non-critical areas.

Critical zoning in the design or renovation of a museum space can be achieved through a two-stage process:

* All museum staff draw up 'room profiles' listing the facilities, services and activities that will be provided in each room.
* Use the room profiles to create functional groupings: which spaces have to be near to each other to function effectively?

This exercise will distinguish the people-priority and object-priority areas, permitting a rationalisation of environmental controls.

The environmental design of museum buildings

It is often difficult to upgrade the fabric of an existing building to improve its environmental performance: some buildings are simply not appropriate for housing museum collections. Conditions in unsuitable buildings can often be controlled by mechanical systems, but when all else fails the only solution may be a move to another site.

Stay or move?

A museum's management may have to face important decisions concerning the suitability of a building. A vacant building has been offered: should it be accepted? Should the whole collection be moved to another existing building? Is

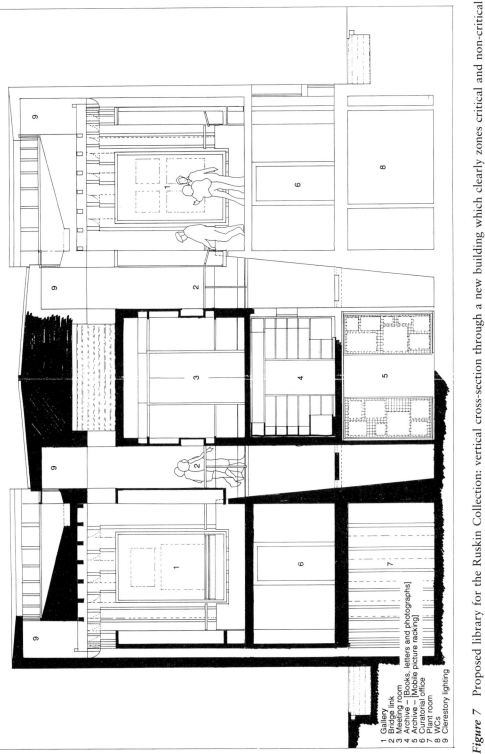

1 Gallery
2 Bridge link
3 Meeting room
4 Archive – [Books, letters and photographs]
5 Archive – [Mobile picture racking]
6 Curatorial office
7 Plant room
8 WCs
9 Clerestory lighting

Figure 7 Proposed library for the Ruskin Collection: vertical cross-section through a new building which clearly zones critical and non-critical areas at the design stage. The Ruskin Library project is a project of the University of Lancaster, UK, and is intended to house the archive, reading room and display area for the collection of papers, books, paintings and watercolours associated with John Ruskin.

Acknowledgement: McCormac, Jamieson, Pritchard

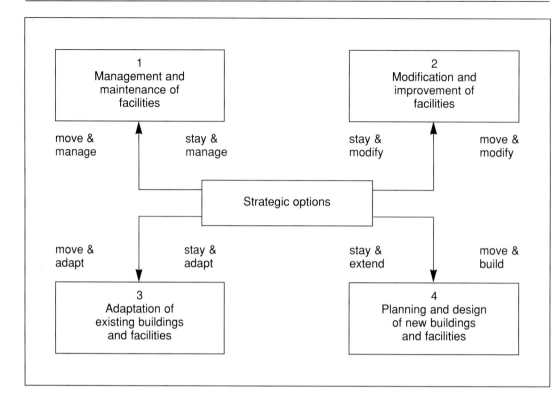

Figure 8 Strategic options available to museum managers (from B. B. Nutt, 'Agenda for education', *Facilities*, 9 (5), 1991)

there scope for a completely new building? Figure 8 outlines the options relating to the management, modification, adaptation or extension of the building.

Whichever environmental control strategy is adopted, the first layer of environmental protection should be provided by the building. The indoor environment can then be further refined by centralised, decentralised or localised methods of control. A conservator or curator on the museum staff should know how to read and interpret plans, sections and details of architectural and engineering drawings to help maintain the smooth running of any major project. Preventive conservation measures have most impact at the planning stage of a building project. As the architectural process develops, a conservator or curator can, at best, react with suggestions which fine-tune the design but they should not expect radical changes once this phase has started.

Strategy was discussed in chapter 3, p. 22.

The influence of the building on the internal environment

Thermal lag and insulation

The thermal lag of a building is the ability of the structure to delay the combined thermal effects of (1) changes in the external climate; (2) solar gains,

Building a museum is a specialist interdisciplinary activity in which the architect and client are on a continuous learning curve. Often the architect has not designed a museum before, and the client may never have commissioned a new museum building. Communication is an essential skill if full advantage is to be taken of the opportunity offered to both sides.

The life cycle of a new building starts with the brief. This is followed by design, construction, commissioning and performance testing until finally the building is brought into operation.

The museum client appoints the architect to lead the design team. The museum should choose an architect who has a flexible attitude to different approaches and solutions for achieving a stable indoor environment in the new building. Architects use graphics – detailed plans and drawings that are coded ways of presenting information – to represent their ideas.

The museum director should appoint a member of staff, ideally a conservator, to advise the museum on its environmental requirements. This person – who must be able to read detailed drawings and blueprints – should know the needs of the collection in depth, should be knowledgeable about the museum environment, and must be sufficiently familiar with the operation of the museum building to make a contribution to the success of the project.

The director should consult relevant museum staff about the requirements of the collection before drawing up a detailed brief. The development brief will benefit from a discussion with the architect. In the early stages of the brief, room profiles may help to focus the attention of client and architect on the special function of different rooms.

Consulting engineers may be appointed directly by the client or by the architect. The size of the project often dictates the approach. In a small scheme, it is often left to the architect to generate the design team, and for the client to approve. The design team generally consists of the architect, who leads the project, building services engineers, structural engineers and quantity surveyors. Museum designers may also be appointed early in the design process.

The selection of the contractor, who will become a core member of the project team, is important. Contractors and subcontractors become involved at the tendering stage of the construction. The tender list should be formulated following written submissions and interviews of suitable contractors. Tendering normally demonstrates whether the design meets the financial constraints imposed by the client, as interpreted by the architect following the agreed brief. The contractors tendering for the project should demonstrate the necessary management skills, experience and an adequate workforce prior to inclusion.

A written series of conditions tailored to meet the architects'/client's requirements for design, drawings, co-ordination and supervision should be prepared and used in conjunction with the appropriate Joint Contracts Tribunal form. Normally, the architect is responsible for co-ordinating works.

It is in the museum's interest that the design team adopt an integrated approach to environmental solutions, and the museum should be prepared to devote considerable time and persuasion to ensuring that this approach is accepted.

Box 2 The role of the client and the design team on a museum building project

mainly through windows; and (3) internal heat gains produced by people and lighting. A heavy-weight building with the internal surface of the mass of the fabric exposed will have a long thermal lag. In addition, correctly installed insulation can assist in damping out external climatic variations.

A long thermal lag is therefore desirable for environmental control purposes. Thermal insulation can increase the lag, but is only one of several important factors. The reduction of air leakage by carefully detailed construction, the thermal capacity of the structure, the thickness and location of insulating material within the structure, and the extent and location of glazing can all have a significant effect.

The installation of thermal insulation is a specialised area of work and should not be undertaken without professional advice. Incorrectly installed insulation can introduce new problems, such as condensation within the fabric.

Building insulation can help to improve the stability of the internal environment in two ways:

- by insulating the interior from external conditions; and

- by helping to control the internal environment if the environmental services are undersized and unable to cope with existing conditions.

An added benefit of building insulation is improved energy efficiency and a reduction in fuel costs.

When considering the application of insulation, particularly during the refurbishment of a building, the following measures need to be considered by the architect in consultation with the museum's conservator:

- the reduction of uncontrolled air leakage from the building. This should be investigated prior to insulation because it is easier, cheaper and more effective initially than insulation;

- the selection of an appropriate insulating material to ensure that no outgassing occurs from the material that is detrimental to the collection;

- whether the insulating material should be located externally or internally, or, in more recent building constructions, whether cavity insulation is possible;

- the problem of interstitial condensation within the building fabric can arise when internal relative humidity is high and the external temperature is very low, as on winter nights;

- cold-bridging, which short-circuits the efficacy of building insulation, can occur if the insulation is carelessly or inaccurately applied.

Before any measures are taken to improve the thermal insulation of existing buildings – especially older buildings, which can contain a considerable amount of timber in their construction – advice from a building scientist should be sought by the architect in order to establish the cause of environmental fluctuations and to determine whether insulation is advisable and where it should be located. Particular care must be taken where humidification is to be introduced in conjunction with building insulation work.

Box 3 Building insulation

See the checklist at the end of this chapter, pp. 51–2, for some of the problems insulation can bring.

Excessive light and heat

Glazing allows natural light and UV radiation into the building. It also affects the internal environment by causing heat gains and losses. The larger the area of unshaded glazing, the greater the adverse effect on the collection it illuminates. UV filtration should be applied to all glazing in these areas.

Conflict arises mainly in areas that are shared by both objects and people, such as exhibition spaces. Careful planning will reduce the adverse effects of glazing on the collection, while allowing the advantages of a naturally lit environment to be enjoyed by the public. For example, perforated metal shutters over windows cut down on light levels while still permitting relatively uninterrupted views to the exterior.

Windows are unnecessary in areas used exclusively for the storage of objects. They present both environmental and security risks.

Moisture in buildings

All buildings contain moisture, both as liquid water and as water vapour. Many building problems are associated with the presence of either too much or too little moisture. The presence of liquid water in the fabric of the building and excessive water vapour in the air inside are causes of major building failures, and will accelerate the decay of museum collections housed within.

The combined effects of heat and moisture

The principal factors that govern the control of climate within museum buildings are simple, but their interaction is complex because of the relationship between air temperature and airborne water vapour.

The study of the properties and behaviour of mixtures of air and water vapour is called psychrometry. The psychrometric chart is a set of graphs that allows changes in the environment to be understood, if enough environmental data are available.

The psychrometric chart is a moisture management tool. For the building services engineer, it provides a picture of the way in which air can change in response to alterations in pressure, moisture content and temperature of the atmosphere and can assist with the design of air-conditioning systems. Architects use the chart to avoid condensation within the fabric of buildings. And conservators use the psychrometric chart when analysing monitoring data.

See chapter 5, p. 70, for the analysis of monitoring data.

New buildings and the internal environment

The construction of a new building provides the best opportunity to realise a building's potential to establish a stable indoor climate. The extent to which the

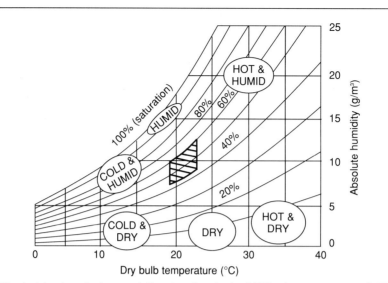

The hatched central zone delineates the desired RH tolerance range of 45 per cent to 60 per cent for mixed and hygroscopic materials. The temperature tolerance range of 19°C and 23°C is recommended by CIBSE (see figure 3). The circled descriptives indicate the conditions that exist in these areas on the psychrometric chart.

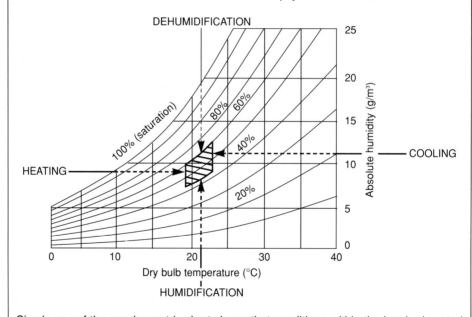

Simple use of the psychrometric chart shows that conditions within the hatched central zone can be achieved by heating cold areas (left), cooling warm areas (right), dehumidifying damp areas (top) and humidifying dry areas (bottom). Caution: in reality environmental problems are rarely this simple to solve; this example is given to show that a psychrometric chart is a useful tool.

Box 4 Using a psychrometric chart to investigate RH and temperature control

fabric of a new building can be designed to act as a climatic buffer should be thoroughly explored. This means producing a building which responds only gradually to changes in external climate and internal heat gains. In practice, this means a 'heavy-weight' building with controlled ventilation.

This gives a building a long thermal lag. If the building's structure provides a large measure of environmental stability, there will be less need for additional environmental control systems and an associated reduction in capital and running costs. Because the building itself provides a large measure of environmental stability, equipment malfunctions or failures will pose a proportionally smaller risk to objects.

Sunlight in new buildings

New buildings should be designed to prevent direct sunlight falling on objects. Indirect natural lighting can be achieved by the use of architectural shading devices, which allow only filtered or reflected sunlight to enter a space.

Shutters and other shading devices were discussed earlier in this chapter, p. 38.

Automatic blinds and louvres can be expensive and sometimes slow to respond to weather changes; they also need regular maintenance for maximum reliability. In addition, solar control glass can be used to reduce sunlight and internal solar heat gains. However, solar control glass will change colour rendering within the space.

Areas containing features such as conservatories, atria and glazed walls are difficult to control to the level required by collections. Where possible, these areas should be used mainly for the business or public activities of the museum rather than for the collection, though some objects such as sculpture, architectural fragments and some historic metalwork are relatively unaffected by the more variable conditions. Condensation on the cold surfaces of objects may be a danger if night temperatures in these areas fall significantly.

See the subsection on glazing earlier in this chapter, p. 38; see also the section on lighting in chapter 6, p. 88.

Existing buildings and the internal environment

Moisture

The rehabilitation of older buildings for museum use often reveals dampness that was tolerated or regarded as inevitable in the past. It may not be possible or desirable to eradicate damp completely, but, in a museum building, the cause and extent of water penetration must be diagnosed and treated quickly.

See the next section, 'Taking over an existing building', p. 48.

A building may be physically weakened if its fabric has suffered from the ingress of water over a number of years. Even after the cause of the problem has been diagnosed and treated, control of the internal environment will be difficult for

some time afterwards. A useful rule of thumb is that a building takes one year to dry for every 300 millimetres (one foot) of external wall thickness.

Ultimately, the extent of any damp control or eradication measures will depend on the relative merits and sensitivities of the building and the collection. For example, lengthy and costly treatment may be unavoidable in the case of an architecturally or historically important building – improvements that may only produce a gradual improvement of conditions for the collection over a number of years.

Improvements to the environmental systems may have to take account of a building's drying-out time. Environmental controls will probably continue to need adjustment, even after the period (known in the UK as the Defects Liability Period) during which a contractor is obliged to rectify malfunctions in a newly installed system.

Sunlight in older buildings

In an older building, more traditional forms of sunlight and daylight control may be appropriate. Shutters can help to reduce heat losses at night and can be closed to exclude daylight outside museum opening hours. Curtains, blinds, and other traditional shading devices may all be used during the day to filter the amount of light and heat entering the exhibition space.

There is, however, a problem – air turbulence – if an area contains high-level glazed features like lanterns and clerestories. The use of these spaces demands careful planning, sensitive exhibition design, and the judicious siting of vulnerable objects. For example, light-sensitive objects can be displayed behind screens or, more cleverly, in the shadow of other display devices. Internal shading devices such as false ceilings or pavilions will provide local control over light and also relative humidity. Climate-controlled display cases are another option.

Taking over an existing building

The first task when taking over an existing building is to provide a clean and pest-free environment and to eliminate the sources and routes by which liquid water can enter. These are direct rain penetration through the structure, faulty rainwater disposal, faulty plumbing, and rising damp. There may also be other local problems, such as flood risks or a high water table, that could create trouble – especially in basement spaces.

The second task is to ensure that building maintenance is seen as part of the integrated approach to the care of the collection. An annual inspection and maintenance programme, perhaps undertaken at a simple level by museum staff themselves, may mean that external consultants never have to be called in.

Alterations to the building should not be carried out without first considering the interdependence of internal and external influences on the environment. For example, sealing a building against outside variations may cause problems due

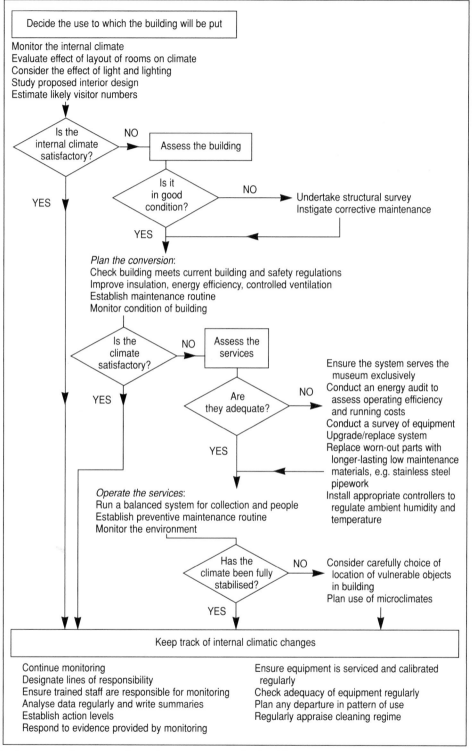

Decide the use to which the building will be put

Monitor the internal climate
Evaluate effect of layout of rooms on climate
Consider the effect of light and lighting
Study proposed interior design
Estimate likely visitor numbers

Is the internal climate satisfactory?
NO → Assess the building

Is it in good condition?
NO → Undertake structural survey
Instigate corrective maintenance

YES

YES

Plan the conversion:
Check building meets current building and safety regulations
Improve insulation, energy efficiency, controlled ventilation
Establish maintenance routine
Monitor condition of building

Is the climate satisfactory?
NO → Assess the services

YES

Are they adequate?
NO →

YES

Ensure the system serves the museum exclusively
Conduct an energy audit to assess operating efficiency and running costs
Conduct a survey of equipment
Upgrade/replace system
Replace worn-out parts with longer-lasting low maintenance materials, e.g. stainless steel pipework
Install appropriate controllers to regulate ambient humidity and temperature

Operate the services:
Run a balanced system for collection and people
Establish preventive maintenance routine
Monitor the environment

Has the climate been fully stabilised?
NO → Consider carefully choice of location of vulnerable objects in building
Plan use of microclimates

YES

Keep track of internal climatic changes

Continue monitoring
Designate lines of responsibility
Ensure trained staff are responsible for monitoring
Analyse data regularly and write summaries
Establish action levels
Respond to evidence provided by monitoring

Ensure equipment is serviced and calibrated regularly
Check adequacy of equipment regularly
Plan any departure in pattern of use
Regularly appraise cleaning regime

Box 5 A systematic approach to the conversion of a building to museum use

to internal sources of moisture and heat generation, and result in inadequate 'fresh' air for visitors.

Museums should define the critical and non-critical zones which require different levels of conditioning. Environmental services – heating, for example – should be provided to these two zones on separate circuits. The museum should have control over the operation of the building's environmental services – at least in the critical zone, where reliable and accurate operation is vital for the collection.

The concept of the critical zone was introduced earlier in this chapter in the section 'Environmental zoning', p. 39.

Control over environmental systems within its buildings must be a priority for a museum: often, the only option when taking over a building is to make improvements to existing environmental installations. This control should extend to:

- the operation of equipment, in order to maximise its use in meeting the needs of the collection; and
- the control system running the equipment, whether humidifiers, dehumidifiers, cooling plant or heating system, so that the control of relative humidity can be given priority.

A suitable target band of relative humidity is then set. But what target band should be specified? Should it be 2, 5 or 10 per cent either side of an absolute value? Should it be a broad band which excludes extremes? In reality tight specifications are often driven by the limits of performance of equipment, in the absence of absolute object-based standards. Over-specification is expensive and unnecessary, and ideally a target band should take on board the tolerance of a collection to environmental change. Environmental equipment should be designed and adjusted to produce an internal climate within these limits.

Improving the building fabric

Any weakness in the building structure should be identified and corrected: defects in the fabric of a building affect its ability to maintain a stable internal environment. Often poor design, poor manufacture, poor standards of work or poor maintenance need to be overcome.

Specialist advice may be necessary, as it is often difficult to evaluate the condition, potential, and limitations of a building and to diagnose the true causes of building failures. Sufficient funds will need to be allocated for the initial survey and/or feasibility study, and subsequent upgrading of a building, and to ensure that the appropriate environmental control system is installed and operating efficiently.

Some obstacles to improvement

All practical projects involve compromise, and the environmental design of museum buildings will usually fall short of the ideals outlined above. A completely new, purpose-built building for a collection is a rarity, and alterations to the fabric and overall appearance of an old building may be limited or prevented by planning regulations, unacceptable costs, and similar constraints.

This checklist has been adapted from information supplied by the Building Services Research and Information Association (BSRIA). The list is comprehensive to allow museums to decide which elements are relevant when compiling the information.

- *the project title*, the client's name, and the project location;

- *the background to the project* (the reason for having the survey done);

- *the support team* – the name, address, telephone number and fax number of: the client; architect; structural engineer; building services engineer; main or managing contractor; and other related groups (local government, planning authorities, electric supply authority, gas supply authority, water supply authority, public health department, intended building occupier/user);

- *the building*: a description of work carried out (e.g. new gallery or refurbishment); its status (e.g. a listed building); activities performed in building;

- *building details* – plans, elevations and sections detailing: gallery and room dimensions; total floor area; window heights; glazing type; building orientation; method and materials of construction; plant positions; services positions; room names and functions; hot and cold water points; position of incoming gas, electricity, telecommunications and water; U-values of elements (e.g. walls, roofs, floors where known); reflectance of surfaces (where known); positions of electrical supply points for machinery;

- *building occupancy details*: typical patterns of occupancy (continuous/intermittent); maximum number of staff; maximum number of visitors at any one time; specify regular opening hours; specify frequency of irregular opening hours;

- *building plant loads*: client's preference for particular fuel; pattern of usage of services; list of gas-burning equipment including kilowatt loads (e.g. central heating); list of electrical equipment, including voltages and kilowatt loads (e.g. permanent plant items, display lighting systems);

- *regular monitoring data collected in house*: type of equipment; location; maximum/minimum weekly RH and temperature; any other climatic data that may be of use to the consultant;

- *future*: change in exhibition layout; subdivision of spaces within gallery;

- *programme*: dates for the main elements of the programme (subject to discussion with surveyor); site visits (including monitoring); discussion (including evaluation); report; client's deadline for resolution of problems.

Box 6 Information to supply to a building consultant preparing for an environmental survey

Here are just some of the problems that may arise:

- The installation of secondary glazing, roof or wall insulation may be desirable but not possible for practical and aesthetic reasons.
- It can difficult to thread the connections for complex new services, such as climate control equipment, through an old building.
- The building may require different environmental conditions from the contents. For example, a controlled relative humidity that is correct for the objects may adversely affect the fabric of an old building.

- Isolated action sometimes has unforeseen and often harmful effects on both the building and its contents. For example, the incorrect use of insulating material, however possible to install, may encourage condensation in wall cavities and other interstitial spaces, leading to a serious weakening of the building fabric.
- Available space in existing buildings is often severely limited. Museums may therefore have to install equipment of a size to fit the available space, at the cost of optimum environmental performance or flexibility of control.

Since 'ideal' conditions are difficult to achieve, how far should an environmental specification be relaxed? How much compromise is acceptable? Should museums operating extensive environmental control equipment adopt summer and winter schedules, allowing summer temperatures to rise above average and winter temperatures to drop below average, in the interests of lower running costs? This pragmatic approach is acceptable if it is carried out in the knowledge of collection needs. If compromises are made, will the museum be laying itself open to the question: if the museum can be flexible to this extent and museum-wide environmental improvements are so expensive, are they necessary? It is often unrealistic to expect that these measures can be justified on conservation grounds alone. But other reasons – such as better display conditions and an improved circulation of visitors – can be added to environmental needs to create a good case for major renovation.

The monitoring programme

An' the gobble-uns 'ill git you
Ef you don't watch out!

J. W. Riley, *Little Orphant Annie*

The monitoring programme is an essential part of a museum's environmental strategy. All museum staff should be aware of the programme's aims and objectives, and its place in the strategy. When the programme is first devised, its aims should therefore be made explicit, and staff must be trained in the correct use of the monitoring equipment and in understanding the value of the collected information. Specialist advice from a conservator may also be needed.

See chapter 3, p. 22, for more on the environmental strategy.

What should be monitored, and why?

Unstable environmental conditions damage museum objects. Using measurements collected over many years, conservators and conservation scientists have been able to clarify and, to some extent, quantify the links between the deterioration of objects and causal factors like unstable relative humidity and temperature, or exposure to light.

Monitoring provides an early warning of the conditions likely to cause deterioration, and yields information on which environmental control measures can be based. It is the foundation on which a controlled museum environment is built. Data from the monitoring programme reveal ambient internal environmental conditions, and help to identify those factors causing inappropriate or unstable conditions. A museum with a monitoring programme can plan the allocation of funds to provide appropriate conditions for its collection, in the knowledge that its expenditure is based on sound evidence.

Where there is no monitoring programme, environmental control measures can be based only on fragments of information, ad hoc decisions, or even guesswork. In particular, it makes no sense to purchase what is often expensive environmental control equipment before a monitoring programme has provided the necessary

evidence – unless, of course, fire, flood or a similar disaster calls for emergency action.

What should be monitored?

Temperature and relative humidity

Relative humidity and temperature should be measured continuously indoors and outdoors, as part of a plan to safeguard the stability of the collection and the integrity of the building fabric. Data on these crucial physical indicators will expose any changes in the internal environment, provide an ongoing check that the building or environmental control systems have not failed in any way, and thus ensure the smooth operation of both systems.

Visible and ultraviolet light

Staff should regularly monitor both visible light and ultraviolet (UV) radiation levels, from both daylight and electric sources, and especially near objects with coloured surfaces. Whether by spot checks or permanent logging, monitoring is important to ensure an acceptable balance between conservation and display requirements – and to check that the lighting installation continues to function as it did when it was first installed. UV radiation should be monitored when displays are changed, whenever a lighting installation is altered or adjusted, and (every six months) behind UV filters on windows to check for deterioration.

Pests

Insect pests, and moulds and fungi, are hazards that can seriously affect the physical condition of a collection; their effect will become apparent very quickly. Monitoring for pests should not be performed in isolation, but as part of the pest prevention and control programme that all museums need to develop.

The control programme will assess all activities that might bring pests into the museum; every incoming object must be inspected, and any infested or even suspect material should be isolated to prevent the spread of infestation.

Pollution

Although pollution monitoring is not extensive in museums, a good programme will include an assessment of the pollution risks to the collection. Indoor pollutants have a greater potential for damage to objects in museums than external pollutants. They are more varied, and they can be present in higher concentrations because external pollutants are diluted by outdoor air.

Passive monitors are available that enable museums to check pollution concentrations indoors, making the collection of urban pollution data much cheaper and less labour-intensive than it was until recently. Nevertheless, it would be prudent for a museum to consider engaging an air-quality consultant every five years or so to make a more thorough assessment.

See the subsection on 'Measuring pollution levels' below, p. 63.

The main sources of museum pollutants are:

- emissions from building, decorating and furnishing materials;
- environmental systems (such as heating and air-conditioning);
- office equipment (such as photocopiers);
- the activities of staff and visitors;
- emissions from museum objects themselves;
- external, especially urban, pollutants.

Display and storage materials should also be routinely tested before use. Nor should particulate pollution – in the form of dust and dirt in both urban and rural surroundings – be overlooked; this can be detected initially by using the time-honoured test of running a white-gloved finger along horizontal surfaces (other than objects) in the display areas.

Visitor numbers

A record of visitor numbers is essential to an assessment of the internal environment. Figure 9 illustrates a way of collating this information in tabular and graph form to give a broad picture of trends, whereas figure 10 is a thermohygrograph chart that clearly shows the effect of visitors on the indoor environment. A large people-to-volume ratio can cause a marked increase in relative humidity and temperature within an enclosed space.

See the subsection 'People as an environmental problem' in chapter 2, p. 18.

Other useful data include the daily movement of people within the museum, and the numbers attending special events. A further class of people effects will not normally be monitored: visitors (and staff) can unwittingly bring pollutants into the museum, including perfumes and hair sprays, and residual dry-cleaning solvents in clothing, though, if the people-to-volume ratio is low, these pollutants will not be present in high enough concentrations to cause concern with collections.

Monitoring equipment and its availability

Environmental monitoring in museums will always be a compromise between what *should* be monitored and what *can* be monitored in terms of the main constraints of money, staff time and the availability of equipment. Museums often have to rely on equipment developed by the medical and engineering professions, or for use in industry, which is frequently expensive, or confusing for the layperson to operate. The selection of equipment can also be bewildering: in particular, the range of relative humidity and temperature monitoring equipment is particularly large, and is increasing.

Every museum should aim to own the best environmental monitoring equipment that it can afford *now*, while looking ahead to assess how labour-intensive a

Emissions from building materials

New drying concrete, foams in thermal insulation, glues, plywoods and other composite boards in partitioning and other furnishings, ageing paints and rubbers.

- *typical effects*: darkening on oil paint films, loss of strength of silk, discoloration of dyes and pigments, and loss of precision of hair hygrometers;
- *cause*: release of alkaline concrete particles, hydrogen sulphide, formaldehyde and hydrogen peroxide.

Environmental systems (heating, air-conditioning etc.)

Corrosion inhibiter or disinfection solutions in an air-conditioning system entering the air stream; exhaust air from kitchens, conservation laboratories, fumigation chambers or workshops entering museum owing to badly sited air intake ventilation duct; by-products from incomplete combustion of fuels owing to badly maintained heating system.

- *typical effects*: not known specifically;
- *cause*: sulphur dioxide, nitrogen oxides and carbon monoxide among others.

Other equipment

Improperly operating light fittings in display cases, electric photocopiers.

- *typical effects*: ozone-induced fading of some colourants even in the absence of light, and deterioration of rubber, textiles and plastics;
- *cause*: ozone.

Activities of staff and visitors

Bioeffluents and particulate matter from people, volatile compounds from cleaning materials.

- *typical effects*: soiling of surfaces;
- *cause*: carbon monoxide, carbon dioxide, hydrogen sulphide and ammonia.

Entry of outdoor pollutants

Combustion products of oil and coal in air and photochemically generated pollutants, partly owing to the weather and partly owing to vehicular emissions.

- *typical effects (sulphur dioxide)*: deterioration of paper; weakening of leather, hair, cotton, nylon, rayon, silk, gelatin, film base of negatives; fading on wool fabrics; fading and browning of silver images on photographs;
- *typical effects (nitrogen oxides)*: strength loss and fading of dyes in textiles (e.g. cotton); fading of natural pigments;
- *typical effects (ozone)*: fading and alteration of a range of artists' pigments including watercolours and traditional Japanese colourants, even in the absence of light, and of rubber, textiles and plastics;
- *typical effects (particulate matter)*: abrasion and soiling of surfaces.

Emissions from museum objects

Cellulose nitrate photographic materials, formalin in natural history specimens, degradation of proteins (e.g. hair and feathers), and past and present fumigants used with museum objects.

- *typical effects*: degradation of materials emitting volatile substances and other materials in the vicinity;
- *cause*: formaldehyde, ammonia, ethylene oxide, DDT and paranitrophenol.

Box 7 Sources and effects of pollutants found in museums

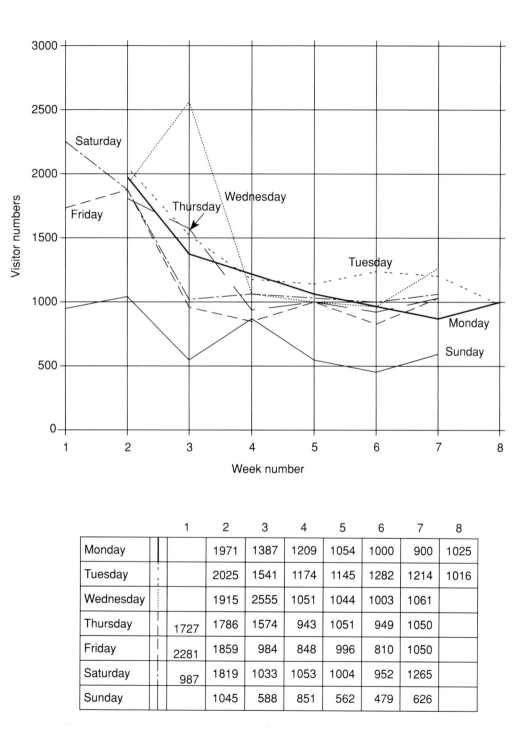

		1	2	3	4	5	6	7	8
Monday			1971	1387	1209	1054	1000	900	1025
Tuesday			2025	1541	1174	1145	1282	1214	1016
Wednesday			1915	2555	1051	1044	1003	1061	
Thursday		1727	1786	1574	943	1051	949	1050	
Friday		2281	1859	984	848	996	810	1050	
Saturday		987	1819	1033	1053	1004	952	1265	
Sunday			1045	588	851	562	479	626	

Figure 9 Example of a record of daily total visitor numbers

58

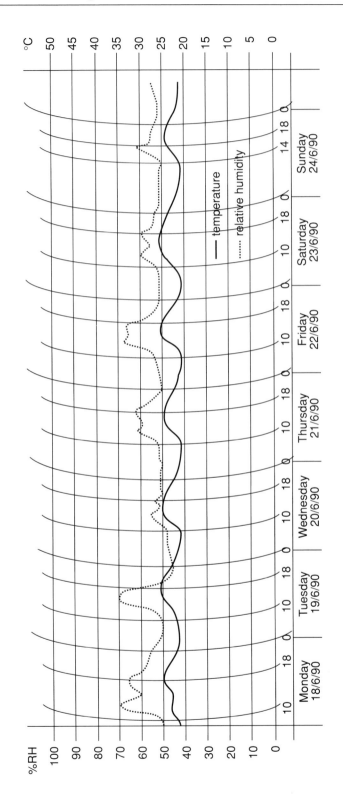
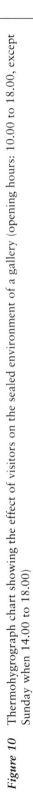

Figure 10 Thermohygrograph chart showing the effect of visitors on the sealed environment of a gallery (opening hours: 10.00 to 18.00, except Sunday when 14.00 to 18.00)

system may become if the number of instruments is gradually increased to monitor throughout the museum. A museum should also plan to provide appropriate staff training in the correct use and maintenance of the equipment, without which even the best gear is devalued. A conservator's advice may prove invaluable when trying to choose from the wide variety of monitoring equipment and sources of supply, and in order to put into perspective any unrealistic expectations of the performance of this equipment.

Humidity and temperature monitoring equipment

The quality and range of prices of humidity and temperature monitoring equipment can be made less daunting if it is broken down into categories, each of which will have strengths and weaknesses in particular applications. For example, there is a significant difference in operational efficiency and cost between continuously recording instruments and those used for spot-checks; but each type has its uses.

Museums need to have a record of environmental data, which requires a recording instrument capable of the long-term monitoring of ambient internal conditions; information from spot meters can be recorded only when an operator is there to take a reading and make a note of it, so readings are not taken at night and at weekends and crucial information can be missed. Even so, a spot meter – such as a dial hygrometer – is useful for spot-checking conditions in display cases. Electronic digital hygrometers, now that their price is coming down, may eventually replace mechanical hair hygrometers for random checks.

Whether mechanically, electrically, or electronically driven, a recording instrument capable of assembling and presenting data in graphical form makes interpretation much easier than one that produces data as lists of numbers. The most familiar 'graphical' instruments in museums are mechanically driven thermohygrographs and electronically driven dataloggers (see figure 11).

Thermohygrographs, dataloggers and beyond

An often-overlooked advantage of chart-recording thermohygrographs over their more esoteric electronic rivals is their accessibility, and the immediate significance of the information they produce. Mechanical thermohygrographs allow persons other than a conservator to be involved with monitoring in a museum.

The main disadvantages of thermohygrographs are the need for frequent accuracy checks, and the large number of recording charts that can be generated. By contrast, a datalogger enables the efficient manipulation of large amounts of data, something a thermohygrograph cannot provide. A datalogger is also more adaptable: since the recording interval on dataloggers can be varied, the amount of data produced can also be controlled. The flexibility of the software varies from logger to logger, though data can usually be exported to a spreadsheet program to make analysis easier.

The most recent development in museum monitoring is the use of radio telemetry – the transmission of computerised data using radio signals. Data are transmitted

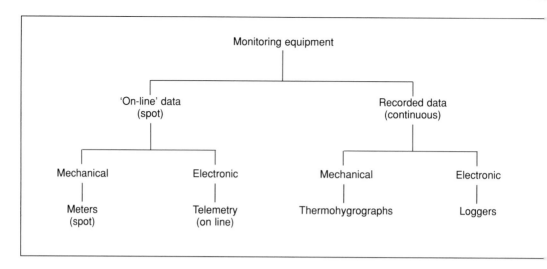

Figure 11 A classification of relative humidity and temperature monitoring equipment

from the recording site, usually somewhere near the objects, to a computer at a data collection site; the computer is often in the same building and may be dedicated (wholly committed) to its data collection role. Telemetry requires trained staff to process the data as they are transmitted to make full use of the system.

Developments in electronic data acquisition will continue into the foreseeable future. Museums should not wait for the next innovation before making a commitment to one particular system. Whatever the choice, it should be viewed as a long-term investment not only in equipment but also in staff training. There is no place for the purchase of the most recent equipment just because it happens to be new. The purchase of expensive logging systems should never be made in isolation; it must instead form part of the implementation of a monitoring programme, which in turn should be an integral part of the environmental strategy. Every purchase must be evaluated on its suitability for the museum's needs. It may be possible to borrow or hire suitable equipment before making a purchase, an arrangement that could also be used to evaluate the suitability of types of equipment before purchase. In the United Kingdom, some museum councils loan environmental monitoring equipment, though mechanical equipment is vulnerable to damage in transit and will always need recalibration before use. Thermohygrographs and some other equipment can be hired from commercial firms, but the cost of a few weeks' hire should be weighed against the cost of an outright purchase in case the latter makes more economic sense.

One final but important point: an independent monitoring system is valuable even in a museum where the environment is centralised and automated. The monitoring system acts as a 'watchdog', an independent guard against malfunctions in the control system that might otherwise go unnoticed.

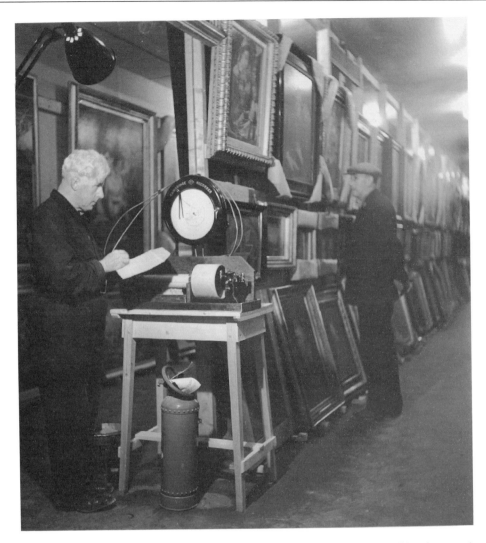

Plate 5 Taking routine readings of relative humidity is not new as demonstrated by the use of a wet and dry bulb 'recording hygrometer' in the Manod Quarry, Wales, where the National Gallery Collection was stored between 1939 and 1945.

Acknowledgement: Hulton Deutsch Collection Limited

Measuring visible light

Regular measurement of light is an essential part of the museum's monitoring programme. Monitoring methods range from the observation of the fading of a 'blue wool' sample from the International Standards Organisation (ISO) Blue Wool Standards to the permanent logging of light by photoreceptors linked to a computer.

Faded blue wool samples can present a convincing argument for the need to control light and UV radiation levels, but this qualitative approach is not a viable long-term method of monitoring light: while the blue wool fades, objects are being damaged by light. A more direct quantitative measurement is therefore needed, and light meters are a more readily available option.

Light meters

A light meter is a primary piece of equipment; without one, a museum cannot set light levels accurately. Every museum should own a meter and use it regularly.

Like many modern electronic measuring devices, light meters are available in both analogue and digital versions. The display of an analogue meter consists of a pointer moving across a scale; the more robust digital meters have a numerical display and are now widely available. Whichever kind of meter is chosen, it is important that the photocell is both cosine-corrected (a means of avoiding errors in the measurement of incident light) and colour-corrected.

Many museums will depend on routine spot-checks and the associated written records, rather than expensive electronic loggers. (Datasheet 1, p. 138, is a typical spot reading record form for both visible light and ultraviolet radiation.) Light meters can be used to give an immediate reading of light levels (in terms of 'illuminance', the amount of light falling on a unit area, measured in lux). They can also provide a long-term record of variations when light levels are controlled within an annual maximum, known as the 'maximum cumulative light exposure value' (measured in lux hours).

In the vicinity of vulnerable objects, monitoring can be linked with a time control – perhaps a simple time clock linked into the lighting system. In large lighting installations, monitoring and control can be operated by building management systems or lighting control systems.

Exposure to light can be measured directly, using an integrating light meter that measures the cumulative dose of light. Light loggers and building management systems will not measure the cumulative doses of light but will register when particular peaks in levels occur, making it easier to discover the cause of high light levels. Light loggers can be set up to monitor spot values at very frequent intervals; maxima and minima can be related to the time they occur and to external conditions if daylight is being used.

Measuring ultraviolet radiation

Two types of UV monitors are available. One measures absolute UV levels (in microwatts); the other measures the proportion of UV radiation to visible light

The rate of light damage to an object is proportional to its exposure to light. If its illuminance is doubled, its exposure time should be halved.

To reduce light damage, both illuminance and exposure time should be reduced. Exposure (in lux hours) is a measure produced by multiplying illuminance (in lux) by time (in hours). The exposure of objects to light should be based on the concept of maximum lux hours per annum.

Exposure values will vary from museum to museum. They are equivalent to the total amount of light falling on an object during opening hours over one year (assuming that blackout facilities are available after hours).

This approach has several advantages, all of which depend on rigorous monitoring to ensure that the annual maximum cumulative value is not exceeded, though it must not be used as a reason for increasing the level of illuminance. Two particular advantages are that:

- it is flexible, allowing light levels to be varied;

- it is especially valuable when used with daylight, which is difficult to control on a minute-by-minute basis;

- it allows passive control in circumstances where it is not possible to reduce light levels or blackout a space after hours because a decision can be made to take objects off display when the annual maximum light exposure value has been reached.

Box 8 How to calculate an annual maximum light exposure value (in lux hours)

emitted by a source (in microwatts per lumen). The second type allows measurements to be taken irrespective of the distance from the source, and is the better choice for museums considering the purchase of a UV monitor.

A UV monitor is useful for checking the continued effectiveness of filters intended to block ultraviolet radiation – though as the preferred type of monitor measures UV radiation in relation to the amount of visible light present, it is advisable to take a visible light spot reading at the same time.

The total amount of UV radiation falling on an object can be calculated from the readings of the proportional UV monitor and the conventional light meter. This may be important in some circumstances: for example, the proportion of UV radiation levels in a room with blue blinds at the windows may appear to be higher when the blinds are closed than when they are open. The absolute levels of both UV and visible radiation are lower when the blinds are closed, but the colour of the blinds emphasises the 'blueness' of the light and its UV content appears to be higher.

Measuring pollution levels

Comprehensive pollution monitoring requires gas analysers and other very expensive equipment that few museums can afford. Unless pollution levels are

The ultraviolet (UV) monitor most commonly used in museums measures the *proportion* of UV radiation in visible light. However, it is often important to find the *full* dose of UV radiation incident on a surface. The procedure for this is as follows:

A reading is taken using the monitor. This reading is in microwatts per lumen – that is, the proportion of UV radiation in microwatts for every lumen of light.

Next, a reading of illuminance in lux (that is, lumens per square metre) is taken using a light meter. The readings from the UV monitor and the light meter are then multiplied together. The result – in microwatts per square metre – is the ultraviolet radiation incident on the surface.

(In terms of older units: 1 candle at a distance of 1 foot will illuminate a surface of 1 square metre to approximately 10 lux; that is 10 lux are approximately equal to 1 foot candle.)

Box 9 How to calculate the total dose of UV radiation on the surface of an object

so critical to the collection that continuous monitoring is necessary, most museums will have to call in outside assistance for a full-scale survey. Five-yearly surveys can be commissioned from commercial laboratories to measure urban pollution levels; recommended target gases include sulphur dioxide, the nitrogen oxides, ozone, and dust concentrations at different heights above the ground.

For a list of laboratories able to perform pollution surveys, see 'Sources of other information' below, p. 154.

There is an alternative, however: indoor pollutant concentrations can be measured using inexpensive passive non-mechanical samplers. Pollution samplers for museum use should have the following features:

- the ability to detect pollutants down to parts per billion;
- the ability to function in the low air velocities common in museum spaces;
- reproducibility (the ability to perform to the same degree of accuracy time and time again);
- high percentage recovery (pollutants can be extracted from the sampler);
- low interference from other airborne substances.

Passive samplers will not yield the detailed information obtainable from sophisticated sampling and assay gear, but their data output will be invaluable when, say, decisions are being made on whether the museum requires centralised gaseous and particulate filtration.

Pests

Pest monitoring is inseparable from pest prevention and, where necessary, eradication. There is usually no time for a leisurely survey of numbers and species before action is contemplated; instead, likely routes of pest entry are monitored

for any sign of infestation, which if found is immediately followed by the appropriate remedy.

A monitoring programme should first assess the risk to the collection, and then examine the building and its use for suitable pest entry points or breeding conditions. Any infestation should be tracked back to its source, and assessed for its extent. Pest entry can be aided by physical means – for example, if the building fabric is damaged – or by certain patterns of use and human behaviour – for example, on flowers brought into the museum.

Monitoring should be concentrated on areas where the risk to the collection is highest – a process that can be made more efficient if the life cycle of the target pest is known, enabling the right time of year to be chosen for the greatest vigilance. Corrective building maintenance and good housekeeping will be preventive measures associated with the monitoring programme; another is the use of traps.

Traps can perform several functions. In their obvious roles, they can prevent infestation, or provide a remedy against it. But they also act as pest monitors: if a correctly set trap in a vulnerable area remains free of the target species during its active period, there is a good chance that the species is absent. Sticky and other non-toxic traps are available that are safe to handle. Traps should be inspected regularly and a record made of all finds.

Mould and fungi will grow as a result of poor environmental conditions within the museum, such as high humidity caused by weak air circulation and bad ventilation. To prevent mould growth, ventilation rates should not be less than 0.75 metres per second. Monitoring for mould and fungal growth therefore begins with the monitoring of temperature and relative humidity.

Museum staff will probably want to enlist specialist advice when setting up a programme of pest detection and control, particularly for the identification of pest species and knowledge of their life cycles.

Checking, calibrating and servicing equipment

Incorrect use and poor maintenance are the causes of many common problems with monitoring equipment. Before sending equipment for a service or repair, check that it is being correctly used. Simple checks may save money.

Humidity and temperature monitors

The greater the fluctuation of ambient relative humidity and temperature, the more likely is the accuracy of mechanical recording instruments to be affected; mechanical equipment should therefore be checked more frequently under these conditions – at least once a week for correct operation, with a calibration check every month and a full service annually. Mechanical instruments should be handled carefully because their accuracy can also be affected by movement.

Calibration of mechanical instruments is best done in-house, and preferably in situ, using a reference instrument that can give readings unaffected by human

The complexity and operation of the equipment listed below will vary from type to type. Training in their correct use should be sought from in-house conservators, external advisers, the equipment suppliers and the accompanying instruction manual. It can be easy to miss the obvious causes of a malfunction. The following questions are intended to isolate quickly the cause of simple problems.

Whirling hygrometers

- Is the whirling hygrometer whirled at arm's length, and until the temperature readings remain steady?
- Is the wet bulb temperature reading taken before the dry bulb temperature?
- Are the readings checked by repeating the operation three times?
- Is the sleeve over the wet bulb thermometer changed regularly?
- Is distilled water used at all times?

Aspirated hygrometers

- Is the sleeve over the wet bulb thermometer changed regularly?
- Is the sleeve soaked with distilled water before a reading is taken?
- In a clockwork-driven hygrometer, is the motor fully wound before use?

Mechanical hygrometers

- Is the element regenerated and the dial calibrated once a month?
- Is it kept free of dust and dirt?
- Is there anything which can cause it to give an unrepresentative reading? (For example, the hygrometer in a display case may give a lower RH reading if it is affected by light sources radiating heat.)

Electronic thermohygrometers

- Is the instrument carried in its case to protect the sensor against changes in ambient conditions?
- Are the following conditions avoided: direct contact with water; direct sunlight; gaseous and dust-polluted atmospheres; contact with heat sources; touching the sensor; breathing on the sensor?
- Can ambient conditions be adjusted before a reading is taken?
- Is the instrument checked regularly for accuracy of readings using a NAMAS-accredited 'sensor check'?

Mechanical thermohygrographs

- Does the graph paper correspond with the timing of the clock – that is 1-day, 7-day or 31-day graph paper – and has it been fitted correctly around the drum?
- Has the drum engaged the drive mechanism?
- Is the clock wound up when the chart is changed?
- Are the relative humidity and temperature charts correctly positioned, and do the pens touch the chart?
- Is the thermohygrograph operating with the relative humidity and temperature arms free of each other?

Box 10 How to ensure the correct use of temperature and humidity monitoring equipment

- Is the ink from the pens flowing freely?
- Is the instrument in general kept clean, and is the hair element in particular intact, taut and clean?
- Is the thermohygrograph calibrated once a month?

Box 10 continued

error. The most accurate of these instruments is the dewpoint condensation meter, but museums are unlikely to have access to one. This is of little practical importance: as so many of the instruments used in museums have built-in inaccuracies, the use of such an accurate reference source would amount to overkill.

A more practical calibration aid is the aspirated psychrometer, which works on the same principle as the whirling hygrometers that are so familiar in the museum environment. Ordinary whirling hygrometers are greatly affected by operator error and body heat, but the wet and dry bulbs of the aspirated hygrometer are shielded from radiant heat, and the instrument is either clockwork or electrically driven for more accurate readings. Relative humidity sensors on electronic instruments should always be checked before use. RH calibration, however, is a difficult and often inexact science. Even laboratories offering calibration certification of instruments under the National Measurement Accreditation Service (NAMAS) of the National Physical Laboratory in the UK can achieve accuracies of only 1.5 to 3 per cent of the RH value being measured. Thus, even when using a NAMAS-certified reference instrument for calibration, it may not be possible to improve on a difference of 3 to 6 per cent between two instruments. Depending on circumstances either a NAMAS-certified reference instrument or a NAMAS-certified salts calibration device may be used to check the drift in accuracy of sensors. Neither mechanical nor electronic instruments should be adjusted after calibration unless there are properly laid down procedures to record the values before and after adjustment.

Light meters

The photocells associated with light meters and loggers are generally stable, but the associated circuitry tends to slip out of calibration. Light measuring equipment should be calibrated at least annually. In the UK, this should be carried out by a NAMAS-accredited photometric laboratory, either directly or by returning the meter to the supplier. It is economical to calibrate one reference instrument only and to check any other instruments in use against it.

UV monitors

A UV monitor should be regularly checked by taking a reading in front of a 60 watt tungsten lamp. This reading should be approximately 75 microwatts per lumen. Should the reading be near 100 microwatts per lumen, the instrument should be returned to the manufacturer for checking.

Measurement of illuminances is commonly undertaken with a simple portable instrument calibrated in lux and consisting of a photosensitive cell suitably cosine and colour-corrected. There are several different types of light meters, which vary in sensitivity, complexity, and method of operation. Training in their correct use should be sought from a conservator, the equipment suppliers, and the accompanying instruction manual. A reading taken with a meter held at right angles to the lamp will be higher than a reading taken with the meter parallel to the horizontal plane of an object and this in turn will be higher than a reading taken with a meter held parallel to the vertical surface of an object.

The most appropriate plane for measurement would be at right angles to the lamp if possible. Since this may be difficult if the aim of lamps vary widely throughout the museum, a more useful general measurement might be the horizontal illuminance over the display, although this will give a higher reading for objects displayed vertically.

It can be easy to misuse a meter or to miss the obvious causes of a malfunction. The following questions are intended to isolate quickly the cause of simple problems.

- Is the meter zeroed and the battery checked before use?

- Is the light level being read off a suitable scale?

- Is the meter being held correctly?

- Are there any obstacles – including the observer! – between the photocell and the light source when readings are being taken?

- Is the calibration of the meter checked once a year, either by arrangement with a photometric laboratory (a reputable supplier should have access to one) or against another calibrated meter?

Box 11 How to ensure the correct use of light meters

Who should maintain equipment?

If museum staff can service mechanical equipment, the considerable expense of a maintenance contract for mechanical equipment is avoided. Provided care is taken and time is available, there is no reason why competent staff who routinely use monitoring equipment should not also service it. Essential prerequisites for in-house maintenance are instruction or service manuals, and the availability of spare parts. Repair and reassembly will be easier if notes or sketches are made as the instrument is dismantled. A record of calibrations and a service history are useful if an instrument is sold – when a monitoring system is replaced, for example.

However, the in-house repairer should be aware of his or her limits: outside help will sometimes be needed, though this need not be restricted to specialist equipment firms – for example, clock repairers may be used for the repair or calibration of clockwork motors. A warning: museums using their own staff for servicing and repairs should charge themselves for the time it takes. In-house servicing is not cost-free.

The limits of amateur repairers will be reached fairly quickly in the case of electronic equipment, which – though more reliable than its mechanical counterparts

– can be expensive to service. Fault-finding commonly follows complex procedures and depends on sophisticated test gear, and parts – now often modules or complete circuit boards – are more often replaced than repaired. One consequence is that electronic equipment usually has to be returned to the manufacturer for servicing and repair.

The data

How much data should be collected?

Which parameters . . . ?

An ideal monitoring programme will provide continuously recorded information on the main environmental parameters critical to the collection. This will require a preliminary stage of intensive monitoring across the whole range of environmental parameters in order to identify which ones may be causing specific problems. Hazards will vary from collection to collection, but the principle environmental parameters – light, relative humidity and temperature – should always be measured.

Equipment designed to measure relative humidity and temperature is usually designed for continuous monitoring; by contrast, most museums will probably rely on spot readings for light levels, so a continuous record will demand scrupulous record-keeping. The need for data on pests, pollution and other parameters will depend on the museum's assessment of factors such as the collection's vulnerability to insect pests, and the desired indoor air quality. From time to time, short-term intensive monitoring may also be necessary to identify other causes of environmental problems – for example, the effects of seasonal weather changes or periods of intense human activity.

. . . And for how long?

The time aspect of monitoring has two dimensions: the length of the programme – should it run for six months? – and the sampling rate – should measurements be made every half-hour or every day, for example?

The length of the programme will depend on its purpose: a preliminary survey will not last as long as the museum's main long-term programme. As a rough guide, for the hazards known to be a threat to the collection, it is advisable to collect data over a continuous period of twelve months.

It is less easy to give a general figure for sampling intervals. There may be no choice: the recording intervals of some types of equipment – thermohygrographs, for example – cannot be altered. But other types of gear are very adaptable: dataloggers can be set to record at a range of intervals from a few seconds up to twenty-four hours, though in practice not all of this range is usable. Logging should not repeat within fifteen minutes because all sensors need time to respond to environmental changes. (The response time of a sensor is the time it takes to return to its original value after a controlled change in humidity.)

A logging interval of once every hour for relative humidity and temperature will achieve a good balance between the demand for data and the response lag of sensors. More intensive recording can be justified only if there is a clear purpose, such as the measurement of rapid fluctuations caused by an unusual event in the monitored space. Spot readings of light levels need to be tied to a strict measurement regime, otherwise light levels may drift from their desired settings, or the readings may be distorted by erratic or unusual peaks. Mistakes here may allow light damage to go unnoticed.

A systematic spot reading programme for light and UV radiation is likely to meet both museum conservation and energy conservation requirements if it adopts the following measures:

- Daylight must be monitored frequently enough to demonstrate the pattern of variations caused by the time of day and weather conditions.
- Levels of both daylight and electric light on objects will require spot checks during the setting up of an exhibition, weekly during its duration, and before the exhibition is dismantled.
- During an exhibition, routine checks of electric lighting control settings and values will inform conservation, design and installation staff that the conditions required by the objects are being met.
- UV radiation measurements should be conducted whenever a lighting installation is altered, and every six months if filters are applied to windows, to ensure that UV filtration remains satisfactory.

See the subsections 'Measuring visible light' and 'Measuring ultraviolet radiation', both on p. 62 earlier in this chapter.

Summarising and analysing the data

There is no point in simply accumulating data if there are no plans to process them. A museum should keep all raw data and summarise them in a form that is easy to interpret, intelligible to staff and accessible to consultants.

Setting the baseline

Each museum will have to define its own acceptable environmental limits in discussion, ideally in consultation with a conservator familiar with the condition of the collection and the building in which it is housed. Most museums aim to achieve a stable ambient environment in display and storage areas, but knowledge is not yet sufficiently advanced to say whether 'stable' conditions permit no variation in relative humidity and temperature against time, or instead allow some limited fluctuations.

Fluctuations will occur in all museums, so staff must decide on an acceptable level and range of environmental variation, based on: (1) their knowledge of the collection's condition; (2) the environment to which the objects have become accustomed; (3) the accuracy of the monitoring equipment in use; and (4) the evidence provided by the available monitoring data. Realistically, exceptional circumstances can be expected to cause excursions outside

the acceptable band of environmental fluctuations for about 10 per cent of the time.

Responding to the evidence

There are two main levels of response to the information provided by monitoring data:

- *Instant response*: Action is taken as soon as conditions stray outside the museum's predetermined control limits. Everyone working in the museum should know who is in charge of the monitoring programme or responsible for particular elements of it. For each monitoring site, the programme will show the appropriate – always pre-planned – response to any variation from the tolerance range set for that site. Staff members should know whether they should take action themselves or report changes to the person in charge of monitoring who, as manager of the activity, will take the appropriate action.
- *Periodic analysis*: Batches of data are analysed in detail, quarterly or more frequently. Regular detailed analysis, set against knowledge of the building and its use-patterns, makes it easier to interpret data in the light of events that may have caused abnormal environmental fluctuations. If the different sources of data are collated and compared, recurring cycles of change and their causes can be investigated. For example, a rise in indoor humidity could have many possible causes, including heavy rain, cleaners using water to clean floors, an influx of visitors, and switching off the heating system. The analysis will uncover seasonal trends and, where necessary, will enable a plan for improvements to be devised.

Collating and summarising the raw data

Summaries of spot readings

Analysis begins with a simple summary of the raw data – usually in the form of minima and maxima. One advantage of such a summary is that it demonstrates the buffering effectiveness of a substantial building against changes in the weather.

Carefully recorded spot readings of relative humidity, temperature, light and UV, taken at least daily in vulnerable areas, are a common form for manually collected raw data. This kind of data needs organisation to be effective, a process best accomplished using the printed forms in Datasheets 1 and 2, pp. 138, 139, rather than 'free form' notes that may vary from one staff member to the next. Daily readings can be recorded on the forms, but no more than one week's worth of data should be accumulated on each.

Spot data can also be recorded on charts designed to display a longer time span. Datasheet 3, p. 140, is a form suitable for recording the weekly minimum and maximum readings of relative humidity, temperature and light over a period of one year, from which the mean of the minimum and the maximum readings

can be derived if they are needed. The resulting chart will show the year's environmental trends at a glance and, like the other summaries of spot readings, can be compared to the output of continuously recording instruments for a deeper view of these trends.

Computer-aided analysis

The output from electronic dataloggers can be input directly into dedicated computer programmes, with the advantages of speed, efficiency and accuracy, and freedom from errors when compared to manual processing. Data can be manipulated more easily, and the information may be summarised and presented on the computer screen or as a numerical or graphical print-out. It is important always to check before purchase that software can be used to analyse data in the format required.

Building services data and other sources of information

Building services engineers routinely collect information on building control systems, though they often dispose of raw data that are more than twelve months old. Museums should retain the raw monitoring data for the previous twelve months in case more detailed examination is needed; older data should be stored in an easily retrievable format. Never send original records if data are requested by third parties such as prospective borrowers or lending institutions. Good sharp photocopies, with the curves indicating relative humidity and temperature clearly marked, will be acceptable.

Other information for collation with monitoring data may be collected from a variety of sources that will vary with local circumstances. For example, representative weather data may be provided by the local university, meteorological station, or flying club.

Reviewing the monitoring programme

The monitoring programme must itself be monitored. Periodic reviews should aim to discover whether the programme is still providing useful information, especially when the museum or gallery is contemplating major changes that could affect the collection, such as alterations to an exhibition design. In addition, the programme's scope and effectiveness should always be reviewed after building alterations.

When the monitoring programme was first set up, it should have addressed at least the following key questions:

- What should be monitored, and why?
- How much data should be collected?
- Have plans for routine analysis and interpretation of data been made; what will happen to the data after processing?
- What equipment is needed; what is already available?

- Is training available on the use of the chosen equipment; are servicing, maintenance and calibration going to require special attention?
- Who is responsible for monitoring, and does the person report to senior management?
- Has a suitable budget been allocated?

At each programme review, these questions can be asked again. But the success or failure of the programme can be set in sharper relief with the aid of an additional set of questions:

- *Equipment*: is there enough to meet the programme objectives; is it still fulfilling its function, regularly serviced and calibrated, and in the right place?
- *Data*: is enough time devoted to data analysis and record keeping; and what information is extracted from the data?
- *Training*: is there still adequate training provision for staff responsible for monitoring?
- *Finance*: is the monitoring budget adequate?
- *Protection*: do the programme results show that there is acceptable environmental protection for both the permanent collection and borrowed objects?

A flow chart setting the monitoring programme in the context of its use and accomplishments may be useful during the programme review process (Box 12).

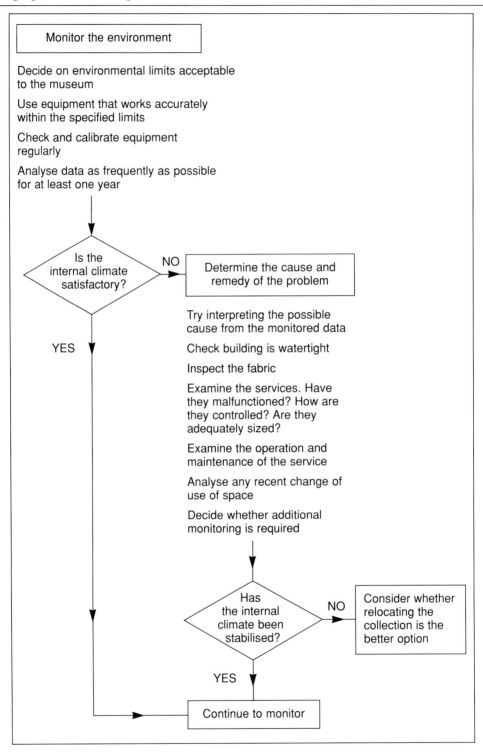

Monitor the environment

Decide on environmental limits acceptable to the museum

Use equipment that works accurately within the specified limits

Check and calibrate equipment regularly

Analyse data as frequently as possible for at least one year

Is the internal climate satisfactory?

NO → Determine the cause and remedy of the problem

Try interpreting the possible cause from the monitored data

Check building is watertight

Inspect the fabric

Examine the services. Have they malfunctioned? How are they controlled? Are they adequately sized?

Examine the operation and maintenance of the service

Analyse any recent change of use of space

Decide whether additional monitoring is required

YES

Has the internal climate been stabilised?

NO → Consider whether relocating the collection is the better option

YES

Continue to monitor

Box 12 Establishing an appropriate environment using environmental monitoring data

Part 3

Controlling the display environment

6

Controlling from the centre: building management and environmental conditioning

> I do not like ducts, I do not like pipes. I hate them really thoroughly, but because I hate them thoroughly I feel that they have to be given their place. If I hated them and took no care, I think that they would invade the building and completely destroy it. I want to correct any notion you may have that I am in love with that kind of thing.
>
> Louis Kahn, *World Architecture* 1, London 1964

Centralised environmental systems are characterised by museum-wide systems of control and regulation. The two most important components of this kind of system are the air-conditioning plant and the building management system – both described later in this chapter. Be careful of the terminology: building-wide centrally controlled systems are not necessarily synonymous with air-conditioning. Mechanical ventilation is a familiar form of centralised environmental control that should not be confused with full air-conditioning.

A central control system is one response to a building that cannot provide enough passive control on its own. The museum building may have a short thermal lag or be poorly insulated; there may be too much unshaded glazing or too little ventilation control; or the problem may be external air pollution, or excessive internal heat and moisture gains from large numbers of people and heat-producing light sources.

These problems can be attacked by other means, however; and new buildings will be designed to reduce their effects to a minimum. An expensive, complex and space-hungry central control system is not a quick fix. A bankrupt museum is not a safe environment for any object.

Is a centralised system really necessary?

If full environmental control is never an automatic choice – or necessarily the best option – what are the alternatives? At the very least, there must be a cost-comparison with partial air-conditioning and a non-conditioned building. (Table 1 lists some comparative running costs obtained from a 1991 English survey.) Does the whole building need full environmental control to reach into its furthest corner? And if the building really is so bad that a powerful system

is the only way to make it tolerable, why is the museum still there? How much would a move or a new building cost?

Table 1 Museum energy use, 1991

Environmental control with year-round usage	Running cost (£ per square metre per year)
More than 70% air-conditioning	11.64
Less than 70% air-conditioning	9.11
Not air-conditioned	5.94

Source: Oreszczyn, Mullany and Riain (1994)

An expensive option

Centralised systems are always expensive. First, there is the considerable capital outlay, and with an existing building the cost of disruptive alterations. Then there are high operating costs of energy consumption and maintenance. And in the future, by which time the collection will have become accustomed to its lavishly controlled environment, there will be replacement costs. If a high degree of flexibility – more control within different areas – is required of mechanical services, there is a cost to be paid in operational efficiency and running costs.

Maintenance and replacement costs over the life of a system are more difficult to predict than running costs, and there are few published data from museums. Cost data are available from air-conditioned commercial offices, however, and provide a good first estimate. A recent survey of sixty offices in the UK concluded that annual running costs and maintenance costs are very nearly the same; in the summer of 1989, for example, average annual air-conditioning running costs and maintenance costs for the surveyed offices were £11.21 and £10.56 per square metre, respectively.

Air-conditioning systems

The largest, most obvious – and often the most expensive – component of a modern centralised control scheme is the air-conditioning system. Air-conditioning is a permanently installed system of providing and maintaining an internal atmospheric condition within predetermined limits, irrespective of external conditions. This is a specialist area of environmental control requiring the permanent attention of building services engineers. As a rule of thumb, it costs about four times as much to air-condition a building, even without humid-ification, as it does simply to heat it.

A confusion of terms

The term 'air-conditioning' is often used without a clear understanding of what it implies. To building services engineers, it is synonymous with refrigeration, that is cooling and dehumidification, but need not imply full control over relative humidity. On the other hand, museums often use the term to refer to a ducted system of conditioned air, with priority control over relative humidity in areas where the collection is housed. Beware of confusion, particularly at the planning stage of an air-conditioning project.

Full air-conditioning

'Full air-conditioning' describes a system that is capable of a comprehensive range of conditioning. Within the limits imposed by the design specification, the full system can:

- clean the air by filtration;
- control the air temperature by heating and cooling;
- control the moisture content of the air, either by humidification or dehumidification; and
- distribute the air to where it is needed.

Air-conditioning can be centralised or decentralised. The choice will depend on the available space to site all the equipment and the environmental zoning that is planned within the building.

All types of systems are unavoidably bulky; even where components like boilers, refrigeration units, fans, and filters can be reduced in size, the distribution ducting must retain its bulk. Large volumes of air at or near atmospheric pressure cannot be distributed through small-bore pipes.

When is full air-conditioning necessary?

Full air-conditioning can counter the effects of a polluted site or a severe climate. In temperate climates, a good building will buffer extremes of climate, leaving pollution – particularly in urban areas – as the most likely 'push' factor in favour of a full system. The chief 'pull' factor is the potential for very precise control of relative humidity, temperature and ventilation rates over large volumes of air; only full air-conditioning can achieve this.

There are disadvantages, besides the glaring issue of high costs: the plant and ducting eat up space, which in most museums is often in short supply; there is the risk that objects will be damaged if the system goes wrong; and there may be health risks, highlighted in recent years by outbreaks of Legionnaires' disease.

As every site is different, feasibility is another issue. An existing building may be unable to cope with the plant and ducting, particularly if it is historically or architecturally significant and legally protected against extensive alteration. External factors may also make a proposed system less viable: the air intakes

Box 13 Typical air-conditioning system configurations

will have to take account of the prevailing wind direction, and kept away from potential pollution caused by restaurant or cafe services, car exhausts at parking sites, and the proximity of adjacent factories.

System requirements

A museum's management will install an air-conditioning system only if:

- the costs are sustainable;
- the system is designed to meet the needs of the collection; and
- the spatial impact of the system is tolerable.

The control set-point, that is, the value to which an automatic control must be pre-set so that a desired value is achieved – and the allowable variation from this pre-set level – will primarily reflect the conditions required by the collection, though many museums have to compromise in the face of the equipment's accuracy limits, and restrictions on capital, running and maintenance costs.

The new system must also be easy to operate and maintain, or its performance will drift and costs will escalate. It is easy to blame the equipment when it goes wrong or fails to perform to specification. Sometimes the equipment is to blame; ageing systems may be inefficient and prone to breakdown, and replacement will be the most cost-effective solution. But other possible causes should not be overlooked – these include faulty commissioning (see below), lack of maintenance, and failure to calibrate the control system. Museum staff should make it their business to know the operating sequence of an air-conditioning plant in order to be able to tell at least whether equipment is running.

Testing and commissioning the system

Thorough testing of new buildings or services takes time, which must not be swallowed up by other activities running behind schedule. Unless all commissioning tests are fully carried out, there is a danger that the museum will take over a development that does not meet the intended performance targets.

Commissioning tests are not all esoteric technical checks; there are many accessible trials that can and should be performed in the presence of museum staff, for example in a new building extension:

- Shutting down the air-conditioning plant, monitoring conditions and then measuring how quickly the plant can re-establish the required set levels after it is switched on again.
- Using simulated loads, testing the environmental control systems under load conditions before objects are installed in new exhibition spaces. (Thermal loads are simulated by arrays of 60 watt lamps distributed evenly about each room, each lamp representing the heat given off by one person. Moisture evaporating from people is simulated by electric kettles wired to release a person-equivalent amount of water vapour into the air.)

Under the Joint Contracts Tribunal, a 'Practical Completion Certificate' is issued by the architect once the system is installed, commissioned and running

satisfactorily; after this has been signed by a person authorised by the museum (the architect, or the curator managing the project, for example), the contractor is required to correct defects which appear during the 'Defects Liability Period', normally twelve months from the issue of the certificate. It makes sense therefore to give the contractor responsibility also for routine servicing and maintenance during the period.

The certificate should not be signed on behalf of the client before the completion of the contract terms; before the building has been inspected, and system testing and commissioning are complete; or before the museum, as client, has agreed that all is well. The end of the commissioning process is reached when the commissioning sheet is issued; this verifies that the installation complies with the design requirements. The museum should insist on being provided with comprehensive operation and maintenance (O & M) manuals for all of the installed services, both for new and refurbishment projects and this should be specified in the contract. The manuals must be explicit in their detailed content, and the installation subcontractor must include 'as fitted' drawings showing the system in situ – manufacturer's component drawings will not suffice.

In practice, O & M manuals can be difficult to obtain; those that are provided, unless they have been supplied under the terms of the contract, often contain insufficient and even incorrect information. A Practical Completion Certificate should not be issued until the O & M manuals are received, checked by the consultants and the museum for the client's use.

Training and operating procedures

An air-conditioning system will require trained personnel on the museum staff to ensure its smooth operation. The staff who will operate the new system will need appropriate technical training, which could usefully begin during equipment installation – especially where the system is extensive or complex. These staff members are crucial to the successful operation of the system. Effective training demands adequate time and resources, which should be written into the original tender conditions for the air-conditioning project. Other staff such as conservators and curators will benefit from demonstration sessions, using the O & M manuals as reference.

Ideally, a museum should have direct control over its environmental systems, which should be regulated from within the building. Contracting out the day-to-day management of environmental systems must not imply opting out of responsibility for their performance. In a large institution, control and maintenance of the system will probably be vested in a building manager, who will need to confer regularly with the curatorial or conservation staff; they will provide him or her with assessments of the exhibition and storage environments.

Sooner or later, the system will suffer a partial or total breakdown; this will not be the best time to start thinking about what to do next. The emergency procedure should be in place right from the start, as should procedures to cover planned shut-downs for maintenance and repair.

Plate 6 Air-conditioning equipment requires regular inspection and servicing if it is to maintain its
design performance.
Acknowledgement: National Museum of Photography, Film and Television, Bradford

Shut-down procedures, whether for emergency purposes or not, must aim to preserve environmental stability for as long as possible, particularly in the critical zone. Simple measures can be very effective: isolate affected areas by shutting the doors, and exclude the public from these areas until control is restored. Where an extensive system is being used to compensate for a poor building, shut-downs will have a marked effect: the building's weak buffering ability will allow a more rapid – and a potentially more damaging – environmental change. Under these circumstances, it is almost essential to include back-up equipment at the design stage.

Space: where will it all go?

Centralised control systems now almost universally employ air-conditioning equipment. This occupies large volumes of space, which cannot be recouped by skimping on the size of the plant. The heating and cooling capacity, the supply and extract fans, the humidifier and dehumidifier capacities, the filtration systems must all be large enough to deal with the expected load. An undersized system will be perpetually straining to meet the set-point conditions, and will suffer from poor accuracy and reliability. On the other hand, an oversized system running almost continuously on partial loads will present the museum with correspondingly oversized energy bills.

Volume, height and weight

The space requirements of a full air-conditioning plant can be designed into a new museum building – with compromises from both the architect and the consulting engineer. Museums in older buildings are less fortunate. Once again, there is no published information on the space required by air-conditioning plant as a percentage of the floor area in museums, but office and laboratory data suggest that up to 15 per cent of the volume of a building may be needed for full air-conditioning plant and ducting.

Ducting simply takes up space, but there are other problem dimensions, particularly height and weight. Hot and cold water storage tanks, boilers, refrigeration units, AHU (air handling units) can be tall and are always heavy.

Water tanks in suitable housings at roof level provide a good head of water, but in a museum the risk of leaks outweighs any advantages with the result that pressurisation vessels are sometimes placed in the basement and serviced by pumps and leakage alarm systems. Some of the measures that can be taken to avoid water leaks are: using microbore systems of pipes, ensuring that there are no joins in the pipework under floors and installing a leak detection system. Mains-fed hot and cold water services eliminate the need for water storage tanks. Mains water systems save on costs and space, and also improve safety as they are less prone to bacterial infection. Some water supply authorities require users to hold water in tanks. This reserve storage can be an advantage when supplies are interrupted – safeguarding the water supply to the environmental

control systems, and minimising the disruption to museum activities such as restaurant and toilet facilities.

The size of the AHU will depend on the volume of air it has to move; it too can be sited on the roof, where the air is cleaner, at the expense of additional ducting and weatherproofing. Even boilers can be moved upwards, away from their traditional home in the basement, in order to prevent their large diameter flues from penetrating floors and occupying space. Safe floor and roof loadings must, of course, be assessed before any equipment can migrate to the roof or upper floors.

Air-conditioning in historic buildings

Space for equipment is hard to find in museums occupying buildings with historic interiors. Here, the system's designers must minimise visual intrusion and structural alteration, a demand that often calls for innovative approaches in both design and installation. Each building will have to be considered as an individual and legal and planning requirements will reduce the possibilities still further, but there are some general guidelines:

- Obtrusive equipment such as external condensers and fresh air intake louvres must be carefully sited; the large size of AHUs, for example, means that they will almost certainly have to be located outside the building.
- Vertical runs of pipes, ducts and cables can be installed in cupboards and wall cavities.
- To minimise disruption, the original services should be used wherever possible.

Nevertheless, the installation of extensive control systems will always cause some disturbance to the historic house museum; it is the museum's responsibility to decide whether the installation is absolutely necessary, or whether conditions for the collection can be relaxed instead so that the impact of extensive control equipment on the fabric of the building is reduced. Because the historic building is the 'largest object in the collection', it may be more appropriate to seek a compromise between the needs of the contents, the building and its occupants. The best solution may be to forgo the provision of tightly controlled conditions for the building's contents.

Indoor air quality

Normal outdoor air contains widely varying concentrations of particulate matter and pollutants produced by natural processes of erosion and evaporation, and by human activity – particularly from combustion emissions and uncleaned industrial waste gases. There are also indoor contaminants generated by building, decorating and furnishing materials, and again by human activity; these include odorants, non-odorous gases and particulates.

See the subsection 'Measuring pollution levels' in chapter 5, p. 63.

Museum air must be clean. The question is, how clean? What would the cost implications be of accepting that all pollutants are harmful and that, therefore, there is no acceptable threshold? There are undoubtedly types of objects that are highly vulnerable to pollutants; it is equally true that an undirected 'filter anything and everything' decision will prove intolerably expensive. Air quality must depend on the level of protection required by the objects. Unfortunately, not enough is yet known about the precise effects of a range of pollutants on museum objects, so conservators are faced with an array of different recommendations for permissible pollutant concentrations and appropriate filter grades. When planning an air-conditioning system, it is important to establish whether filtration is needed by carrying out a pollution survey of the site. After appropriate measures are taken, monitoring of internal pollutant levels should be carried out in a similar way to monitoring relative humidity and temperature to check that the measures are giving the desired result.

Filtration systems

Air-conditioning and mechanical ventilation systems are designed to accept filters at suitable points in the air path. Filters come in a variety of types and degrees of fineness; some are mechanical – simple meshes that block particles of a certain size – others are 'active' or absorption filters – in which harmful gases are absorbed by special fillings, typically activated charcoal.

In practice, filters are installed in sets, increasing in fineness in the downstream direction. A very fine mechanical filter will stop all particles down to the size of its mesh, but if used on its own would soon become clogged or damaged by larger debris. A coarse filter is therefore installed first, followed by a sequence of other filters determined by the incoming air quality and the intended degree of protection. An ideal sequence is: coarse pre-filter, main particulate filter, gaseous pollution filter and lastly a fine particulate filter. Replacements must be installed in the same order.

Filters can be very expensive to maintain, so a good case must be made for their use. Although some can be recharged by the manufacturers, most are disposable and should be changed, as part of a regular maintenance programme, by the museum's own or contracted-in building personnel. The pressure drop across a filter is much better guide to its condition than the elapsed time since the last service; filters – and indeed any other disposable components of an environmental control system – that are replaced on a rigid time interval basis may still be serviceable, resulting in wastage and unnecessary costs.

Other methods of pollution control

In many museums, air filtration may be impossible or simply uneconomic, yet some simple housekeeping practices can reduce pollution to acceptable levels:

- If mechanical ventilation is available, it can be adjusted to produce a slightly positive (greater than ambient) air pressure in the exhibition

All filters installed as part of a larger air handling system should be monitored for pressure drop, and not simply changed on a fixed time-interval basis. Filters should have positive sealing frame mechanisms, so that all incoming air passes through the filter; this allows monitoring instruments to read positively and ensures the best filter performance and air quality.

Particulate filters

The particulate filtration system most commonly used in museums is Eurovent 4/5, with coarse and fine filter grades in the categories EU1 to EU9.

Under the Eurovent system, 'coarse' filter grades range from EU1 to EU4, and 'fine' filters from EU5 to EU9. The ultra-fine high efficiency filters in the range EU10 to EU14 are rarely used outside the clinical and surgical environments.

For museums on severely polluted sites, the following recommendations still apply:

• particulates to be removed to 80 per cent efficiency on Eurovent 4/5;

• sulphur dioxide and nitrogen dioxide to be removed to below 10 micrograms per cubic metre;

• ozone to be removed to below 2 micrograms per cubic metre.

(Note: Eurovent is the European Committee of Manufacturers of Air Handling Equipment.)

Gaseous pollution

Methods that have been used to remove gaseous pollutants are alkaline washes, activated carbon, copper impregnated activated carbon and potassium permanganate on activated alumina filters. Activated carbon filters are preferred by many museums, and tests have indicated that they are reliable.

Box 14 Basic filtration guide

galleries, which will help to keep dirt out; air movements will be outwards, not inwards. (This remedy may lead to higher than expected energy bills.)

• Good building maintenance, housekeeping and museum practices will prevent the generation of particulate pollution such as dust and grit.

• Dirt brought in by visitors on outdoor clothing can be limited by the provision of cloakrooms, and the use of large looped-pile mats in exterior doorways.

• Materials sensitive to gaseous pollution should be located far away from entrances. Well-regulated ventilation in the exhibition spaces will help to dilute gaseous pollutant concentrations, but filtration provides the only effective control of external gaseous pollution.

• Particularly vulnerable objects can be protected by a well-sealed display case containing an absorbent activated carbon material. All construction materials must be tested for stability before use.

See the subsection 'Safe materials and testing' in chapter 8, p. 111, for the need for safe materials in sealed display cases.

Let there be light – but not too much

A successful lighting scheme harmonises a number of mutually dependent factors. The design will have a visual impact on the building, gallery and display architecture. The mode of lighting will affect the appearance of the scheme. Capital and operating costs, energy efficiency and maintenance are important considerations and the design must minimise the damage that can be done to the objects on display. All museum objects are damaged by light to a greater or lesser extent. The extent of damage depends on the sensitivity of the object, the composition of the light, the level of light and the exposure time. Freedom from light damage can only be guaranteed by complete darkness, a condition that can only be approached in closed storage areas; lighting in these areas should only be used for safe access to, and retrieval of, the stored objects. But in display spaces within galleries and museums, lighting presents a more difficult problem. Most lighting in the museum is provided for the benefit of the visitor and to enhance the beauty of the object, without which the institution's principal functions are lost. So how can the opposing claims of the collection and the visitor be reconciled?

How much light?

Lighting levels are often a compromise between conflicting requirements. Objects need to be free from the effects of ultraviolet (UV) radiation, excess visible light and any associated heat; visitors need enough light to view objects in comfort, in sufficient detail and with correct colour discrimination, and for moving about the museum. There is some empirical information on suitable light levels: about 200 lux of well-directed light will meet the visitor's needs; but much lower levels – perhaps 50 lux – used to view light-sensitive objects like watercolours may not be sufficient to meet these needs. As a rule of thumb a sixty-year-old person requires about ten times as much light as a sixteen-year-old.

See the sections 'Measuring visible light' and 'Measuring ultraviolet radiation', both on p. 62 in chapter 5.

Levels of illuminance have to be related to length of exposure to be of any use in conservation planning – hence the importance of the cumulative annual exposure, usually expressed ,in lux hours. There is no general agreement on target levels of annual exposure of museum objects to light; every museum should work out a realistic lux hour exposure value, based on its opening hours and the level of control it intends to maintain. For example, from the viewing illuminance levels quoted above:

- For a museum open fifty-two weeks a year, six days a week, seven hours a day (annual total 2184 hours), the target should be 450,000 lux hours for objects lit at 200 lux, 100,000 lux hours for objects lit at 50 lux.

The target figures are simply rounded values obtained by multiplying the desired illuminance by the annual exposure in hours, so a watercolour gallery

opening for only 1000 hours per year may fix a target of 50,000 (50 × 1000) lux hours per annum. Any extra illuminance required – for private viewings or corporate entertainment, for example – would need to be offset by reduced opening hours or some other means of keeping within the target annual exposure limits, such as removing light-sensitive items off display for short periods to compensate.

Types of lighting

Daylight

Daylight, the traditional lighting medium, costs nothing but is difficult to control especially at low light levels; it is widely variable, diffuse, and contains a significant proportion of UV radiation. Because it is perceived as a 'cool' light source, high levels are sometimes needed to create a pleasing effect. But it is these inconvenient and harmful properties that also make it attractive; the widespread practice of shutting out all daylight from museums and galleries is now being revised in some of the larger institutions, where it has been carefully reintroduced in certain areas. The cumulative annual exposure value can be applied for objects displayed in daylit conditions. In the UK, daylight data produced by the Building Research Establishment quantifies the illuminance variation throughout the year. This can help a museum plan the display of light-sensitive items, since daylight availability, though symmetrical about the end of June, is lower between July and December than between January and June.

Reflected light

Many traditional top-lit galleries with historic interiors use reflected and diffused daylight to illuminate the exhibition space; translucent false ceilings create a uniform, if subdued, light on the wall space. Other devices are now used to reflect light in other kinds of interiors, allowing a measure of control over daylight without affecting the variability that visitors often appreciate. Careful monitoring will show whether some parts of the display area are receiving a higher level of light than others, an effect that can be countered by a number of measures, such as rotating objects between lighter and darker display areas, or standing light-sensitive objects in the shadow of more robust objects.

Electric light

The controllability of electric light is its overwhelming conservation advantage: illuminance, exposure and the position of the light source can all be precisely controlled. Careful and informed lighting design will produce a display that is both pleasing to visitors and relatively safe for objects.

Contrast effects and room colours can complicate things for the lighting designer and unless handled carefully can give rise to adaptation difficulties – and complaints. Dark walls and light walls will create very different effects under the same lighting; as a general rule, light, reflective surfaces will reduce

the lighting demand. Contrast effects are very important: for example, a dark painting hung against a light wall will appear almost as a silhouette, difficult to see in any detail. Here, the problem is poor display design; a lighter object against the light walls would reduce the foreground/background contrast and create a far better effect without the need to increase light levels. As a general rule, taking data from office studies as a guide, the background illuminance should not be less than one-third of the object illuminance.

Maintenance provisions are an integral part of any lighting scheme – and lighting maintenance is more than just replacing dead bulbs. Wiring and lampholders deteriorate with time, especially near hot bulbs; fittings should be accessible and easy to open and not prone to collect dust and debris, as 'difficult' installations will tend to be neglected as time goes by. Remember too that lamps don't simply fail; they also age, often producing less light and correspondingly more heat, or a change in colour-temperature, in the process. Even lamp replacement is not as simple as it sounds: replacement bulbs and tubes should be clearly identified with precise lamp specifications listed in maintenance schedules and held in sufficient numbers to prevent mistaken or 'temporary' substitution by the wrong types.

Mixed lighting

Natural lighting is rarely the only form of illumination in a museum space. Where daylight is used to create a sense of time and space, electric lighting will still be needed after dark, and to highlight objects or special areas. The effect will be more harmonious if the colour-temperatures of the lamps complement that of daylight: for example, a pool of 'yellow' tungsten light may clash with the cool 'blue' of natural light.

The concept of the annual exposure limit is very important in mixed lighting schemes, with the proviso that both sources of light are added together to produce the actual exposure total. Daylight's high UV content will also need to be monitored, particularly if natural light is being readmitted to a previously all-electric space.

Controlling visible light

Extinction is the simplest form of control for visible light: daylight can be blacked out, and electric lights switched off. Daylight control devices include blinds, curtains, shutters and manual or automatic louvres. The choice will depend on cost and aesthetic considerations, and control can be total – a full blackout, recommended for closed periods during daylight hours – or partial – adjusting light levels to suit time of day or time of year.

Electric lighting can be dimmed as well as switched off, though not all lamps are suitable: their intensity will drop, but their colour changes too. Which bulbs and tubes are suitable for dimming is something best discussed with a lighting specialist. Control can be programmed, and partially or totally automated, perhaps as part of a building management system (BMS); there are also various

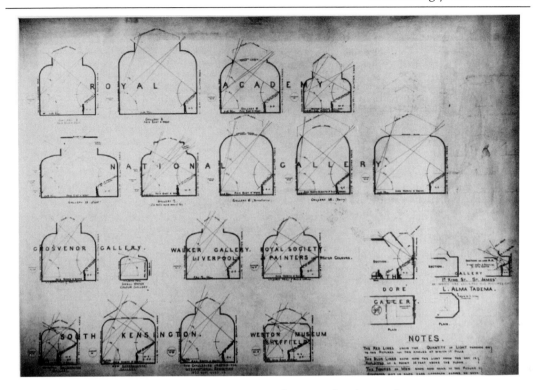

Plate 7 The study and use of daylighting in galleries began in the nineteenth century.

Acknowledgement: Sheffield Archives, Sheffield City Council ref. AP 207/3/6

There is some evidence that, at low light levels, viewers prefer 'yellow' or 'warm' lamps (that is, lamps with a low colour temperature) rather than 'blue' or 'cool' lamps (lamps with a high colour temperature). But the use of lamps of a low colour temperature, while satisfying this preference, has to be balanced by the need for good colour perception of the object on display. This is achieved by using light sources that have good colour rendering properties.

Colour rendering is the effect that different light sources have on the way that the colours of surfaces are perceived (see diagram A). It encompasses the effect of light emission from a source, light absorption and reflectance of surfaces, and human perception. Colour appearance is defined as the apparent colour of light that a source emits as seen directly by the human eye, and can range from a 'warm' to a 'cool' colour. There are both 'warm' and 'cool' lamps available that have good colour rendering properties. The choice will depend on the effect that the display designer wishes to achieve – after, of course, ensuring that all conservation requirements have been met.

The colour rendering properties of an electric light source are dependent on the spectral power distribution curve of the lamp. Spectral power distribution is the relative power of the light in different parts of the spectrum. Diagram B is the curve for an incandescent light source, which is strongest at the red end of the spectrum. Diagram C is the curve for fluorescent light source, which has characteristic mercury peaks in an otherwise smooth curve.

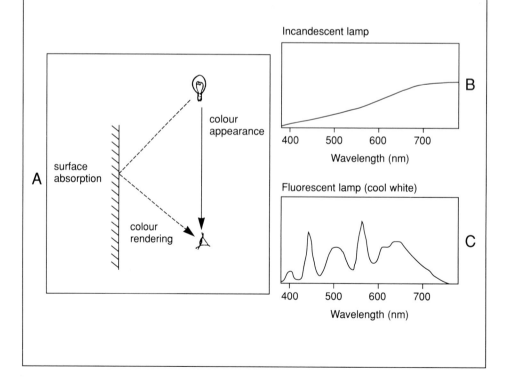

Box 15 Colour perception at low light levels

manual or semi-automatic options, like time-limited switches to operate fore-ground lighting, or the use of photocell detectors to switch lights on only when visitors enter a space. These can be mounted unobtrusively in a lamp fitting and wired back to a BMS.

See the section on BMS later in this chapter, p. 94.

Controlling UV

UV radiation is particularly harmful to museum objects, but unlike visible light it has no practical value: visitors do not need it to see, and it should therefore be eliminated as far as possible. UV will be reduced by reflections from interior surfaces, so indirect daylight will be safer than the full brilliance of natural light. The surface reflection effect is much enhanced by the use of titanium white paint, whose titanium oxide pigment absorbs a large proportion of the UV radiation.

The UV filter is the primary control method, and the nearer to the source the better: the window, rather than the glazing of a display cabinet, for example. The performance specification of a UV filter should be as follows:

- For a curve normalised to 100 per cent at 550 nanometres, transmission of UV radiation should be less than 1 per cent between 320 and 380 nanometres and less than 50 per cent at 400 nanometres.

Filters take many forms, some replacing and others supplementing existing glazing, including films, laminate glasses, plastic films and special varnishes. On large panes of glass, a film lasts longer than a varnish because the thermal expansion of glass can cause a varnish to craze. Varnishes are better applied to leaded panes. Filter films may also be applied to electric lighting sources, such as fluorescent tubes, a process more likely to be within the capabilities of museum staff than the more specialised filtration of glazed areas. Unfortunately, all types of filters have a limited life, typically between five and fifteen years, so monitoring and regular replacement are essential.

See 'Measuring ultraviolet radiation' in chapter 5, p. 62.

Ordinary low-power tungsten filament lamps are not usually filtered, as their UV content is small (about 75 microwatts per lumen, which is the generally accepted safe limit for UV emission from a light source in the museum environment); tubular fluorescent lamps that limit UV emission to 50 microwatts per lumen are also available, and similarly avoid the need for filters. All other types of lamp require UV filtration, and even 'safe' types should have filters fitted where the illuminance level rises above the 200 or 50 lux limits described above. Fluorescent tubes can be wrapped with UV-absorbing films, and tungsten halogen lamps need heat-resistant glass filters to absorb the UV they generate.

Filters can be placed close to objects, particularly where the object is both vulnerable to light and likely to move from one environment to another. For example, watercolours will carry their own protection if glazed with a

UV-absorbing material before a loan. UV-controlled acrylic sheet is the most commonly used filtered glazing material, and comes in two grades: the slightly yellow 'museum' grade, which absorbs 99 per cent of UV radiation in the 250 to 400 nanometre band, is the more protective of the two.

Building management systems

Truly centralised regulation of environmental control systems has recently become a practical reality, thanks to microprocessor technology. Microprocessors are now the main control component in a wide range of environmental equipment, from air-conditioning systems to transportable humidifiers.

The building management system (BMS) extends microprocessor control throughout the building, and beyond, to regulate virtually any number of services, from monitoring the internal environment to controlling lighting, heating, ventilation and air-conditioning systems, plant and energy management, and leak detection and response. Monitoring and control systems can even be interlinked, producing an automated system of self-regulating building control.

BMSs can integrate many other functions. Plant and equipment status can be monitored, and breakdowns or unexpected environmental variations reported; the system can be programmed to give priority to relative humidity control in display areas, but temperature in the museum's commercial area. A BMS can also monitor and record the status of security and fire alarms, though it is wise to keep alarm and environmental systems on separate circuits.

Is BMS a worthwhile investment?

A BMS installation is expensive: it will involve computer hardware and specialised software; a cable network around the building, together with suitable interfacing units; and sensors (for monitoring) and actuators (for controlling). Costs will vary with the complexity of the system, and whether the system is going into a new building or an existing one. It requires proper commissioning and trained and dedicated staff who fully understand the system to ensure smooth operation. Extensive environmental systems such as air-conditioning in new buildings will nowadays almost certainly be under BMS control.

Quoted equipment costs may not cover the building work associated with installation, which may be extensive and disruptive in an existing building; it may therefore be sensible to defer the work until other refurbishment – electrical rewiring, say – is due. Alternatively, a simple BMS could be installed to overcome the problems caused by the uncoordinated operation of existing equipment.

The system will need detailed planning, as every BMS is tailored to its own location and environmental equipment. When planning the system, do take the opportunity to extend it to as many areas as possible: transportable equipment

can be brought into the network, provided there are interfaces near all potential operation sites; and remote stores and other sites can be linked through dedicated lines, the telephone system, or radiotelemetry.

Radiotelemetry is discussed in chapter 5, p. 59, off-site storage in chapter 9, p. 121.

Specialist advice on a potential project will be needed from the start. There has to be a clear design brief, accessible to all interested parties, including:

- the software designer (who may not know anything about psychrometry, or the demands on a museum environment);
- the subcontractor who will install the system;
- the commissioning agent, who will test the installation and operation of the system;
- the museum, whose staff must be trained to operate the system.

While BMSs appear to provide a solution to the problem of co-ordinating and controlling a number of different functions within a museum, their complexity can make them unmanageable for the majority of museums – especially those that fail to recognise the need for highly skilled and trained staff to ensure the smooth day-to-day operation of a BMS.

Asset management systems

BMS installations can be enhanced by another layer of control in the form of a maintenance management programme, also called an asset management system. Particularly suited to large museums, the programme monitors the duty cycles of all equipment, including main and stand-by systems, so that maintenance can be related to time in service rather an arbitrary calendar date. This brings substantial savings, especially for large installations, as infrequently used equipment is not subjected to unnecessary maintenance.

Energy efficiency and environmental control

For the collection's sake, a large, centralised environmental control system often has to run continuously for twenty-four hours a day, seven days a week. If its energy consumption is too high, the simplest 'cure' – shut-down – is not a realistic option, since museums are conditioned primarily for objects not for people. The alternative is to improve efficiency – to obtain the same environment at a lower energy cost. This can be done through zoning of critical and uncritical areas particularly since approximately 30 per cent of the floor area of museum buildings is not used for the display or storage of objects.

Up-to-date air-conditioning systems under BMS control can be fine-tuned to achieve a balance between energy cost and acceptable environmental controls. Savings can be made if the BMS is programmed to allow 'free cooling' (unaided by the refrigeration plant) whenever outdoor ambient conditions are suitable; if frequency inverters are installed to adjust fan speeds; and a high level of air

recirculation is used in storage areas and at night in display areas. But there are other more general measures available to all museums, whatever their size and control methods.

The energy audit

There can be no energy savings, nor any increase in efficiency, without prior knowledge of how energy is currently used. An energy audit is the essential first step; by monitoring when, where, how – and how much – energy is used, it reveals a museum's energy consumption patterns. The audit can also answer several more general questions:

- What is the cheapest available energy tariff that the museum should use?
- Is all the energy consumed efficiently converted?
- How can energy distribution losses be minimised?
- How can the pattern of demand be optimised?
- How can improved maintenance scheduling enable equipment to run more efficiently?
- Is any energy recovery equipment provided?

Energy-efficient lighting

Good conservation practice will tend to reduce the amount of energy consumed at the same time as it reduces the exposure of objects to electric lighting. But the power/light relationship is not a simple one, and complicates the work of museum staff trying to control both light exposure and power consumption.

Remember that most lamps are rated in watts, the unit of electrical power; the light output of the device may not be printed on the lamp or its packaging, forcing recourse to direct measurement or the manufacturer's data sheets. Some types of lamp are better at converting electricity into light than others, so the replacement of a 40 watt tungsten filament bulb by a 40 watt fluorescent tube, say, will not mean that the object receives the same illuminance (or heat, or correct colour rendering).

Even lamps of the same type exhibit different characteristics, which can complicate substitution. Long-life tungsten filament lamps are a good example: replacing a 100 watt tungsten filament lamp by a long-life 100 watt equivalent is at first sight a cost-conscious act – fewer bulbs will be used in the long run. Unfortunately, long-life filaments achieve their durability by an increase in mechanical strength; the thicker filament better survives thermal and physical shocks, but is less efficient at converting electrical power into light. The result of the substitution is therefore less light – and more heat – for the same power consumption.

Lamps in areas such as offices, corridors, shops and lavatories can give way to more efficient alternatives, such as compact low-power fluorescent lamps. Conventional fluorescent tubes and their fittings can be replaced with more efficient 'multiband' or 'triphosphor' types, and regulated by efficient high-frequency controllers that allow dimming and instant starting, and eliminate

flicker; advice from a lighting specialist or electrical engineer may be needed here. Automatic and visitor-activated lighting systems will also save energy by cutting power consumption in unoccupied spaces – though here again there is a hidden problem: the life of lamps is shortened and ageing accelerated by the repeated shock of frequent switching. The problem can be largely avoided by dimming instead of simple switching.

During hours when the museum is staffed but not open to visitors, staff routinely require access to galleries. In a new or refurbished installation, it is therefore wise to include a separate, dedicated lighting circuit for staff working on objects in the display areas, or engaged in cleaning or maintenance.

See Datasheet 4, pp. 141–4, for a summary of the available types of lamp and their characteristics.

The bulk purchase of utilities

Large energy consumers can often obtain bulk supply agreements that reduce the unit cost of energy. In Britain, bulk agreements are available for buildings using more than 25,000 therms (2637.5 gigajoules) of gas per year, and (since 1992) for buildings taking in excess of 100 kilowatts of electricity annually. Many museums of only modest size may qualify: for example, the Museum of Childhood at Bethnal Green, London, with a floor area of about 4500 square metres, just qualifies for the bulk gas rate.

Where an individual museum is fairly large but unable to claim favourable terms, collective agreements with other local institutions may be the answer, and should be investigated – a collective arrangement is already in operation for the National Museums based in South Kensington, London. Commercial energy management companies may be able to help small museums, and there are also a number of government-sponsored schemes that can assist the smaller user. Energy savings are still possible even when there is little spare capital to invest in new, energy-efficient equipment, and paybacks can be as short as a few months for some measures.

7

Control where it's needed: room-based environmental systems

I hate to keep things long in case they go mouldy from overkeeping.
Miguel Cervantes, *Don Quixote*

For many museums, centralised systems and building-wide environmental control will be unattainable: perhaps the collection is too small to justify a large expense; or the building cannot be altered because it is old, historically important, or shared with another user. Whatever the reason, it is still possible to offer visitors a pleasing environment that conforms to the best principles of preventive conservation. Environmental management is not an all-or-nothing matter that can be resolved only by the expenditure of vast amounts of money.

At all scales and levels of resources, large and small, the approach to environmental management remains the same: discover the needs of the objects in the collection; monitor the existing environment, especially for relative humidity, temperature and light levels; and improve conditions that do not match the targets. When the centralised option of full and flexible control is not available, the solution will lie with a combination of existing building services and individual control units.

Heating and lighting equipment will probably already be in place; there may be scope for adding or replacing lighting circuits, or supplementing the existing heating system with portable units. Even where a museum's control over an existing building is very small, there is probably some potential for improving the lighting and heating controls. Relative humidity control presents a difficult problem; here, existing building services offer limited improvements in control, and transportable humidifiers and dehumidifiers will be needed.

Maintaining environmental stability in old or converted buildings can be difficult and time-consuming when using transportable control units. Independent units need delicate adjustment to achieve a level of wider co-ordination, and their integral sensors have hitherto been crude, often creating a localised climate around the units themselves. Fortunately, the development of microprocessor controls will bring a new order of reliability and co-ordination to room-based environmental equipment (figure 12). The new generation of electronic controllers can be positioned away from the immediate influence of the unit,

and should enable individual units to be interlinked – which will at least banish the common (and absurd) spectacle of a humidifier and a dehumidifier battling for control of the same space.

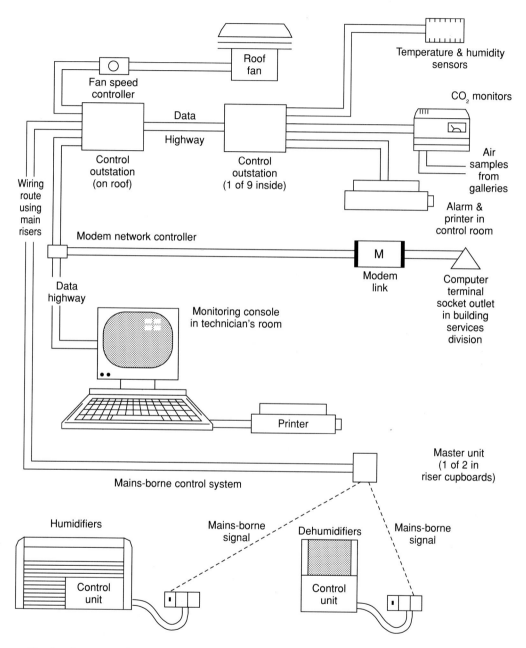

Figure 12 Synchronising the operation of a variety of independent environmental control equipment within a space can be a complex and time-consuming task.

Acknowledgement: Courtauld Institute Galleries, University of London

In refurbished buildings where some permanently installed climate control equipment can be used, it may be possible to install a simple BMS networking the operation of otherwise independent equipment. Even a modest scheme, perhaps controlling central heating, ventilation plant and transportable humidity control units, would provide an improvement in environmental stability.

Building management systems are discussed in a separate section towards the end of chapter 6, p. 94.

Environmental control can also affect the building itself – something that may be particularly important where a museum shares an old building with another user. Where the museum and the other occupier maintain different environments in their respective spaces, and the museum requires tight humidity control, then if the other user turns off all the heating at night in winter and there is no vapour barrier in the walls that separate them, moisture may travel through the fabric and cause damage by interstitial condensation.

Controlling humidity

In the absence of an air-conditioning system, humidity is controlled by humidifiers, which add moisture to the air, and dehumidifiers, which remove it. There are several different kinds of both types of machine, each with advantages and disadvantages that will affect their suitability for a particular application. The type of unit has to be addressed at the planning stage of an installation, because it will determine whether, for example, units have to be plumbed into the mains water supply. Free-standing units may have reservoirs of water that need to be manually filled or emptied at regular intervals, so staff supervision may be a factor. Size is another variable: humidifier and dehumidifier capacities must be correctly matched to the volume of air and the air exchange rate of the room.

One very important consideration is the potential health risk: bacteria breed in water that is allowed to stand at room temperature, bringing a remote risk of the notorious Legionnaires' disease, and a much higher risk of the influenza-like 'humidifier fever'. An assessment of the risk and a strategy for illness prevention will be needed for all water-using environmental control equipment.

Another cause for vigilance is a more familiar one where water is stored near museum objects: the danger of leaks and flooding. The water supply, whether from unit reservoirs or a mains source, must always be carefully managed, especially where the units are located on upper floors. If the units do not have a fail-safe device, leak detectors must be installed.

Humidifiers

Humidifiers increase the moisture content of the air by atomising water or by evaporating it. Atomising and ultrasonic humidifiers use the former approach, physically breaking the water into tiny droplets, so that whatever is in solution

What equipment can present a significant risk to health if not run and maintained correctly?

Air-conditioning equipment that uses wet cooling towers and/or spray (air washers) humidification; spray and spinning-disc (atomising) humidifiers; condensate trays under cooling coils within air handling units.

What equipment presents a negligible risk if it is run and maintained correctly?

Air-conditioning equipment that uses air-cooled condensers and/or steam humidification; evaporative humidifiers.

What are the risks?

The facts regarding potential health risks associated with the use of water-based equipment can be summarised as follows:

• All illnesses caused by water-borne bacteria are preventable.

• There is a considerable difference between Legionnaires' disease and humidifier fever. No case has been recorded to date of humidifiers causing an outbreak of Legionnaires' disease. The potential risk to health from Legionella bacteria through the use of portable humidifiers is very small, though there is conceivably a risk if the water temperature rises above 20°C and if dirty or recirculated water is used. Legionnaires' disease can be fatal.

• Humidifier fever is an illness caused by inhaling water contaminated with micro-organisms and/or organic material from humidifiers and air washes. It is characterised by influenza-like symptoms that abate with a break in exposure and increase on re-exposure. Strict operational and maintenance precautions need to be taken to eliminate these health risks.

What precautions need to be taken to minimise these risks?

Three basic measures are recommended to prevent the formation of biofilms and the colonisation of climate control equipment by water-borne bacteria:

• Check on the location and the number of pieces of equipment.

• Run and maintain the equipment responsibly through a well-organised routine that includes record-keeping.

• Designate at least one member of staff to be trained to inspect, clean, and disinfect the equipment.

Should biocides be used routinely?

The use of biocides in portable humidifiers is not a satisfactory solution for a number of reasons:

• Information related to inhalation toxicology is not available. It is not known whether users of buildings can be safely exposed to biocides over a long period of time.

• Non-volatile biocides can be carried by water droplets into the air.

• Bacteria can become resistant to biocides, so the chemicals that work will need to be varied.

• It is difficult to ensure quality control and accurate biocide dosing. There is no simple answer to how frequently biocide dosing should be performed.

• Biocides do not replace the regular maintenance procedures of inspection, cleaning, and disinfection.

Box 16 Health risks from water-based environmental control equipment

The evaporative humidifiers commonly used in museums and galleries pose a negligible health risk. Therefore routine inspection, cleaning, and disinfection are recommended in preference to the use of biocides.

Important: reference should be made to CIBSE TM13/1991, HSC Approved Codes of Practice, and HSE, *The Control of Legionellosis*, as detailed in the bibliography, for comprehensive guidance on this matter.

Box 16 *continued*

in the water supplied to the unit will find its way into the conditioned air. Distilled or demineralised water should therefore be used in these humidifiers, as any hard water salts in tap water, for example, would be distributed unchanged into the environment. Faulty humidifiers of this type can still go on emitting moisture into the air, and where plumbed into a water supply could produce serious condensation on nearby surfaces.

As their name suggests, evaporative and steam humidifiers convert water into vapour before dispersing it, and therefore avoid the problem of water-borne mineral contamination. Tap water can be used but entails frequent cleaning of the equipment, so water softening may be necessary in hard water districts. Evaporative humidifiers, the type most frequently used in museums, evaporate water from a small reservoir under the apparatus or from the water supply, depending on type. Larger evaporative units also incorporate a fan and temperature control, and air filters that need to be kept clean to maintain air flow and the required humidification effect. Unfortunately, evaporative units are less effective in naturally ventilated spaces, and do not reliably provide accurate control.

Although evaporative humidifiers are less likely to cause humidifier-related illness than atomising types, they still require particular care in cleaning, maintenance and inspection. Biocide treatments programmes may be advisable, but specialist advice should be sought first. Steam humidifiers are often recommended on health and safety grounds, because they present less of a health risk than other types when correctly operated and maintained. Free-standing steam humidifiers are available but are not widely used in museums, principally because they emit steam into the space being conditioned. Most existing steam humidification equipment is part of larger permanent installations, where the steam is mixed with air in the duct before being diffused into the space.

One final caveat: the introduction of humidification in a historic building requires very careful planning. There could be a risk of structural problems associated with a change in the moisture equilibrium of the fabric, particularly where structural timber is concerned.

Dehumidifiers

There are two main types of dehumidifiers used in museums. The more costly desiccant type draws moist air over a drying agent carried on a rotating drum.

Water-based equipment used in environmental control includes large-scale ducted air-conditioning plants, portable units such as humidifiers, and domestic hot water supplies. Arrangements must be made for dealing with all risks. A maintenance routine needs to be set up that will survive changes of senior management staff and contractors.

Assess the risk to staff and visitors

There is negligible risk from steam and evaporative humidification. The risk lies with spray and spinning disc (atomising) humidification and water-cooled air-conditioning. Therefore:

- When planning an installation, choose steam or evaporative humidification.

- When operating an existing installation with spray or spinning disc (atomising) humid-ification, obtain advice on planning the operation and maintenance of the equipment.

- Draw up an operational manual – and scrupulously follow it. Manufacturers' and suppliers' literature does not constitute an operational manual or the basis for training of staff in the maintenance of equipment.

- Set up a maintenance procedure. Maintenance of equipment can be labour-intensive. Allocate responsibility for the equipment. Is cleaning and maintenance to be done in-house or by contractors?

- If the work is done in-house, provide appropriate training to staff in charge of the equipment. Ensure that vigilance does not break down when the regular person in charge is away. Provide a mask with positive pressure and gloves as protection.

- If the work is done under contract by a water treatment company, ensure that a written contract clearly identifies the demarcation of responsibility: who is responsible for what, what work (including water analysis) is done, how information is recorded and who receives it.

Good practice

- Use clean mains water, and not a recirculated water supply. Units may need descaling if mains water is used.

- Use a system continuously to avoid stagnant water, which encourages bacteria to grow. If the system is not used continuously, make sure that it is drained and left empty of water. If reservoirs of water are allowed to stand, they can be seeded by bacteria within a few hours.

- Clean and disinfect the system regularly; the frequency may be determined by inspection using dip-slides (see below). A thorough disinfection routine using chlorine (for example, diluted household bleach) should be carried out regularly to all parts of the system. Chlorine is a practical and inexpensive alternative to the use of biocides, but all traces must be eliminated before the equipment is operated in the vicinity of museum objects. Chlorine can also affect the metal parts of equipment.

- Between routine cleaning, a check should be kept on bacteriological contamination. Inspect the system weekly for the first signs of fouling. Monitor the reservoir for contamination using dip-slides (see below). More frequent observation of the dip-slides should register any general rise in bacterial contamination, which is a sign that all is not well with routine maintenance. In this event, the equipment should be immediately withdrawn from use, pending analysis and identification of the bacteria by a specialist.

- Avoid water temperatures between 20°C and 50°C (to prevent any risk of Legionnaires' disease).

Box 17 A strategy for illness prevention and the control management of water-based equipment

> • Maintain records of inspection, cleaning and disinfection of equipment as evidence of responsible operation.
>
> Further advice can be sought, after the above procedures have been organised, from the Health and Safety Executive's factory inspectors' area office. The importance of the procedures must be kept alive in the minds of all staff, without exception. Outbreak control must be managed through a planned maintenance routine.
>
> **The use of dip-slides**
>
> Proprietary dip-slides coated with a layer of nutrient should be used to monitor numbers of bacteria and fungi, and given forty-eight hours to incubate. They may be obtained from Boots Pharmaceutical Company plc, Microcheck Dipslides, Nottingham NG2 3AA.

Box 17 *continued*

The desiccant – preferably silica gel – is continually regenerated by warmed air, which should be then vented externally with its load of moisture at a safe distance from the space under treatment. The warm air required to regenerate the desiccant can raise ambient temperature near the unit by about 2°C when in operation.

Refrigerant dehumidifiers condense excess moisture out of the air by drawing it across refrigerant pipes; the water is collected in a pan, and the cooled dry air is warmed back to ambient temperature by heating coils before being returned to the room. The production of water means that the pan will need to be emptied regularly to avoid bacteriological contamination, flooding or the unit switching itself off when full; or a machine in a permanent position can be plumbed in to a suitable drain.

Desiccant dehumidifiers ordinarily use more energy than refrigerant types, but are more effective at lower temperatures because the drying agent's moisture capacity increases. In practice, the desiccant unit's higher running costs are offset by the additional energy refrigerant units use to auto-defrost their coils to retain efficiency at lower temperatures. For this reason refrigerant dehumidifiers should preferably not be used in spaces which are unheated in winter. At normal ambient internal conditions in the UK both types work well, the desiccant type being particularly useful because it does not need to be plumbed in to a drain.

Controllers

The simple humidistat

A humidistat is to humidity control what a thermostat is to temperature control. The simple humidistat often fitted to transportable humidifiers and dehumidifiers consists of a humidity sensor coupled to a switch. The sensor may be no more than a fibrous membrane – which should not be adjusted – and control is not particularly accurate; when the humidity rises to the set-point,

the dehumidifier switches on (or the humidifier switches off), and vice versa when the humidity drops below the required point. The desired humidity is therefore only approximated by a sequence of on–off operations.

Control is made even more unreliable by the physical position of the humidistat; in the majority of transportable units, and in some wall-mounted steam units, it is close to the source of humidification. This is an unfortunate side-effect of transportability, which requires that a machine has its own sensor built in, but the effect is similar to that of a central heating thermostat mounted next to a radiator. The humidity in the room as a whole changes only slowly, whereas the humidity 'seen' by the sensor is influenced by the peculiar conditions near the unit. The result is poor environmental control, and wasted energy whenever the 'misled' units run for longer than the general humidity level requires.

Microprocessor-based controllers

Microprocessors bring an improved accuracy to the sensor system of trans-portable humidity control units. Their 'intelligence' means that they are programmed to look beyond the immediate humidity reading, resulting in a more accurate control of the environmental conditions and less sharp variations from the set-point. Compact and reliable microprocessor-based controllers are gradually replacing crude humidistats, and are already fitted as standard in some large transportable humidifiers.

Museum-specific controllers

The most recent development is a museum-specific microprocessor-based elec-tronic controller. Mounted away from the unit it controls, the device is designed to measure and control ambient humidity. The unit can be a humidifier, a dehu-midifier or an electric radiator, which is controlled to give priority to humidity control while varying ambient temperature.

With the arrival of this new and advanced technology, it is now possible for controllers to regulate the flow temperatures of hot water and to control the heating valves on some conventional systems to give priority to ambient humidity, or more locally to synchronise the operation of a humidifier and a dehumidifier within the same space.

Heating

Heat can damage museum objects – either directly, through a simple excess, or indirectly, when it is suddenly introduced to a previously unheated space and destabilises the relative humidity. Existing heating and proposed new systems alike must therefore be carefully assessed as part of the museum's environmental strategy.

Heat has two – usually incompatible – functions in the museum environment:

- 'conservation heating', which draws on psychrometric principles to control relative humidity using heat;

- 'comfort heating', designed to provide pleasant surroundings for staff and visitors.

See the subsection on museum-specific controllers above, p. 105; psychrometry was introduced in 'The combined effects of heat and moisture' in chapter 4, p. 45.

Heating can reduce high ambient relative humidity: empirical studies have shown that, in the UK, heating to a temperature of about 5°C above outside conditions is enough to reduce relative humidity below 65 per cent, which is the critical level for the growth of mould and fungi; but this is practicable only in unoccupied areas in a building that do not need to be heated to comfort conditions. Because this 5° difference has been achieved by experimentation, this temperature difference may have to be increased if there is damp present in the fabric of the space. In these conditions, dehumidification and not heating is the answer during the summer – and even then the space must ideally be unoccupied, and the windows and doors draughtproofed and kept closed, before high ambient humidity levels can be reduced satisfactorily. Dehumidification rather than heating to control relative humidity is cheaper to run but it does require a space to be sealed or a room to be located away from the effect of external conditions for it to achieve the desired result.

The familiar conflict between object needs and people needs soon arises, particularly in the exhibition areas: in a closed space, heat gains from people and lighting, quite apart from any heating services, cause a rise in temperature which in turn reduces relative humidity unless moisture is introduced from another source. Low relative humidity can damage many objects, so the temperature required for visitors' comfort in exhibition areas often entails some form of humidification during the winter heating season.

Providing and controlling heat

Modern heating systems will probably be based on the design of conventional domestic systems using water-filled radiators serviced by a central boiler. The heating system boiler should be separate from the water heating boiler and its distribution system. Radiator spurs should be capable of being shut off independently, and leak detection equipment is desirable; although leak detection and response sensors are expensive, they may one day earn their keep – especially if water pipes pass through areas in the critical zone. Temperature control will probably be managed by thermostats.

'Conservation heating' attempts as far as possible to manage the system so that it produces the desired level of ambient relative humidity, which reduces the need for dedicated humidity control equipment. The conservation approach is provided by dedicated humidity and temperature sensors; these feed information back to the heating system through the controllers, which may be both weather-compensating controllers located outside to measure the external temperature and regulate the flow temperature of the water in the system, and humidistatic controllers near the radiators in the system. The cost of this kind of pragmatic engineering system will vary with its complexity. A simple BMS

installation may be justified, for example, in a store housing thousands of objects, or in an old museum building where the only form of environmental control is the existing heating system. However this is likely to require dedicated and trained staff to operate it. Any alterations to an existing heating system must include, as a priority, separate heating circuits for the critical and non-critical zones.

BMS systems are described towards the end of chapter 6, p. 94; environmental zoning was introduced in chapter 4, p. 39.

Ideally, the heating system in the critical zone will never be turned off. If it is under 'intelligent' control, the temperature changes for an annual cycle can be programmed. For example, for the transition between the unheated and heated season to give the most stable possible temperature in northern temperate climates – and after advice from a building services or control engineer – the heating is turned on in the autumn at the same temperature as external conditions; the temperature setting is then incremented weekly by equal fractions of a degree to maintain as stable a temperature indoors during the coldest months as in the autumn. After a steady phase during January and February, the setting is decremented at the same weekly rate until the spring, when it is turned off. This procedure slows down – as far as is practicable – the adverse impact of a sudden temperature change on indoor relative humidity, but it still provides conditions that meet human comfort needs.

Where simple controllers on radiators are installed, they should be set to the autumn temperature throughout the year; this ensures that the heating will switch on only when the indoor temperature drops below the autumn ambient level. This type of control does not produce as much stability and more 'cycling' of the ambient relative humidity is likely, but it is cheap and easy to install. One advantage of old cast iron radiators is the slowness with which they heat up and cool down. This limited control can be lost if heat loss takes place along the system due to the fact that pipes are not lagged: all heating pipes, not only the ones hidden from sight should be insulated.

The need for regulated ventilation

If a museum only had to care about the collection, ventilation rates could be reduced to a minimum to stabilise the internal environment. But a museum also welcomes the public, sometimes in very large numbers, and is an employer of staff. The air circulating inside the building therefore has to perform several functions: the basis of human respiration and thermal comfort, the dilution and removal of airborne pollutants, a medium for waste moisture and heat – indeed, it is the principal vehicle for the whole indoor environment.

Correct ventilation is the provision of sufficient air to a space to meet the criteria associated with its use. As usual, the museum is faced with conflicting requirements of humans and objects in many of its spaces, and ventilation is also the subject of a mass of laws and regulations in most developed countries.

There is unlikely to be much freedom to ignore the requirements of the visitor in favour of the collection, and most ventilation problems will involve, first, the satisfaction of human needs and the appropriate legislation, followed by the establishment of the best available conditions for the collection. A building services engineer and a conservator will probably be needed to resolve any conflicting requirements.

Air change rates and general ventilation requirements, allowable pollution concentrations, carbon dioxide levels and other standards can usually be found in legislation governing health and safety in workplaces and public spaces; no ventilation provision can be created without knowledge of the appropriate rules. For example, a British health and safety regulation specifies that the long-term (eight hours) exposure limit for carbon dioxide is 0.5 per cent by volume (5000 parts per million), which requires approximately 2 litres of fresh air per second per person to achieve the required dilution.

Ventilation is another area where microprocessors can achieve a whole new order of control. BMS and other computerised control networks can be designed to monitor air quality through carbon dioxide sensors and adjust air volume dampers or fan speeds accordingly, thereby creating a versatile, energy-efficient system of control capable of coping with widely varying visitor numbers and patterns of use. BMS-controlled ventilation can be as complex as full air-conditioning or as simple as fans located in the lined chimney flues of historic buildings.

See the BMS section in chapter 6, p. 94, for the scope of BMS systems.

8

On the spot: local control

In a heavy shower, the attendants are obliged to hasten with oil skin and
tarpaulin, and put them over the objects where the rain drips in.
 Select Committee 1860, para. 421, from John Physick,
 The Building of the Victoria and Albert Museum

Buildings converted to museum use present special problems that often require
a flexible approach to environmental monitoring and control. Grand plans
incorporating a fully centralised control system are usually out of the question,
and even transportable units can be beyond the resources of small local or
specialised museums and galleries. Relative humidity control may have to be
referred to a conservation consultant, but the most obvious 'self-help' solution
for vulnerable objects is localised control in the form of enclosed display cases
and frames.

Display cases

The display case is the single most important aid to the preservation of museum
materials on exhibition. Whatever its size, from the large display cabinet down
to the smallest glazed and backed frame, the case acts as a barrier to ambient
conditions, buffering fluctuations in relative humidity and temperature.

There is currently no generally recognised standard to help users and manufac-
turers specify display cases in terms of their environmental performance. It is
therefore vital, both when buying new cases and when improving old ones, to
determine the level of environmental protection the case can provide. Here are
three key questions:

- Has the case has been tested for air leakage, by air pressurisation or tracer
 gas test for example, and are the results available?
- Have the construction and display materials been tested for chemical
 stability according to a recognised method?
- Can a buffering material such as silica gel be installed to improve the
 stability of the internal environment – and be reconditioned without
 disturbing the objects in the case?

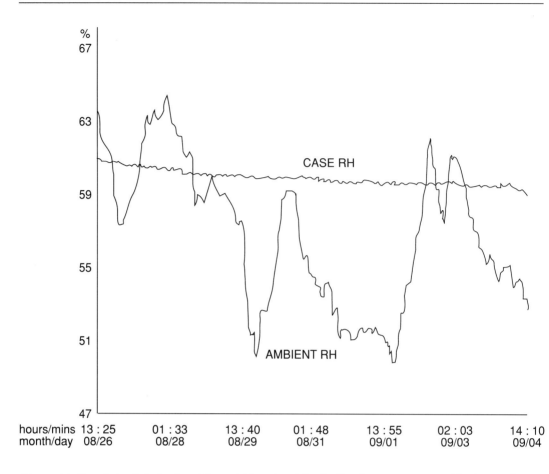

Figure 13, Graph 1 Relative humidity, within a humidity-buffered case, is more stable than ambient relative humidity

Air leakage: proving the case

The best measure of a case's environmental buffering ability is its air leakage rate; the lower the rate, the more stable the environment inside the case. Tests carried out in 1990 using the tracer gas measurement technique showed that a typical display case has a leakage rate of between 1.5 and 2 air changes per day, which probably provides enough protection for many museum objects. However there are many cases that are 'tighter' and many that are 'leakier' and only measurement will distinguish the difference.

The hygrometric half-life is an alternative measure of the environmental performance of a display case. It is both cheap and practical for any museum with access to humidity measuring instruments and a means of increasing the humidity inside the case under test. While measurement of the hygrometric half-life can be done by the museum itself, the more accurate tracer gas method should be performed by somebody familiar with the operation of specialised equipment and the interpretation of results.

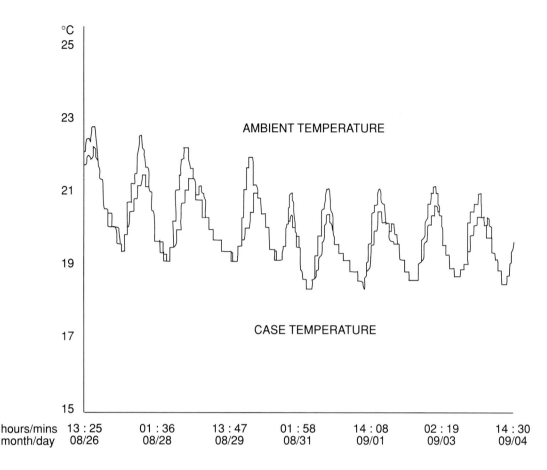

Figure 13, Graph 2 Temperature within a humidity-buffered case tends to track ambient temperature (Herbert Art Gallery and Museum, Coventry)

There is no point in providing more protection than objects demand. Expensive high-performance cases will be needed only for very vulnerable objects in poorly controlled display spaces. For a mixed display, the case should match the environmental requirements of the more vulnerable objects. At the lower end of the protection scale, some objects may need only physical protection: many glass objects, for example, will survive well in human thermal comfort conditions, requiring no more than a physical barrier against accidental damage.

Safe materials and testing

The sealed display case is a potential pollutant trap. Volatile substances and vapours are common in the larger indoor environment, but are diluted by the frequent air changes of a good ventilation system. Inside a case, where air changes are kept to a minimum, harmful concentrations can build up.

111

The hygrometric half-life is the time taken for the relative humidity (RH) in the case to drop to the average of the ambient RH and the initial value of the case RH.

Method

- The case is placed in stable RH and temperature conditions, and the RH and temperature both inside and outside the case are measured using thermohygrographs or a datalogger.
- The RH inside the case is raised artificially above ambient conditions using a humidifier.
- The humidifier is disconnected and the decline of the RH inside the case to ambient levels is recorded. This may take a few minutes if the case is leaky, or a few days or even weeks if the case is well-constructed.

An example

If the measured case RH is 60 per cent and ambient RH is 40 per cent, the average of the two is 50 per cent. The time taken for the case RH to drop from 60 per cent to 50 per cent is the hygrometric half-life of the case.

Box 18 How to establish the buffering effectiveness of a display case by measuring its hygrometric half-life

All case and display materials – and objects too – must therefore be chemically stable and as non-corrosive as possible. Some species of wood, composite boards, adhesives, sealants, paints and lacquers may emit substances harmful to a wide range of museum objects: oil paints or solvent-borne paint systems that need baking to cure should never be used on cases.

Always test

The initial choice of materials will be made on the basis of general guidelines, such as those included in this book, and specifications provided by manufacturers and analysts. But this is not enough. All potential case materials must be tested before use and replacements or further supplies sampled to ensure that nothing has changed – manufacturers can and do alter the specification of products without notice. Testing will also reveal whether a material that is unsafe for a permanent installation can with certain precautions be used in a temporary exhibition. Materials testing services may be offered by large museums, some museum councils and museum services, and commercial laboratories; their advice should be taken before any variant usage is planned.

See 'Sources of other information', below, p. 154 for a list of testing services.

Getting absorbed in the case

There is another defence against materials that is not completely safe: absorbent substances placed in the case to soak up pollutants. There are not yet any

The following information must be used only as a general guide to materials that are considered safer than most others and to materials that should be avoided. Even the safer materials can be made unsafe by special finishes such as fire-retardant coatings, and manufacturers can and do change the composition of products without notification. It is always advisable to test a sample of a material before use.

Safer display and storage materials

- *natural vegetable fibres*: cotton, flax, hemp, jute, linen, sisal;

- *natural protein fibres*: silk;

- *synthetic materials*: acrylic polymer solution (as an adhesive), ceramics, charcoal cloth, factory-coated Melamine chipboard, glass, methymethacrylate copolymer (Perspex), inorganic pigments, metals, nylon 6, nylon 66, polycarbonate, polyester, polyethylene, polyethylene terephthalate (Melinex), terylene, two-part polyurethane lacquer, Sundaela K quality hardboard (if restricted to a maximum six months of continuous use).

Unsuitable materials

- *materials containing sulphur* : cashmere, felt, hair, leather, mohair, parchment, some dyes, rubber adhesives, viscose rayon, vulcanised rubber, wool;

- *materials containing chlorides*: polyvinyl chloride (PVC);

- *materials containing organic acids*: blockboard, cardboard, cellulose acetate fibres, cellulose nitrate, chipboard, lacquers, protein-based glues, PVA emulsion adhesives, resins used as binders in composite boards, sawdust, some drying oils in air-drying paints, one-component silicone sealants (before setting), wood (least acidic: Norway spruce, Douglas fir, Parana pine, mahogany; intermediate acidity: ash, beech, birch, elm; most acidic: larch, oak, sweet chestnut, teak; the acidity level of even the least acidic wood increases with time).

Box 19 A guide to suitable and unsuitable display and storage materials

definitive data on the pollutant-specific absorptive capability of the available absorbent materials. So far, activated charcoal, alumina and zinc oxide pellets have been used, and have proved best at absorbing organic acid vapours and impurities, and gases such as ammonia. Absorbent materials must, of course, be replaced regularly; not only does their effectiveness fall as they become saturated, but – worse – the contaminants they contain may be resorbed by the air in the case.

Microclimates: the environment in miniature

Microclimates can develop anywhere in a museum, and often where they are least welcome. There may be an uncontrolled area of condensation in one corner of a room, for example, or a warm spot near a light fitting. But microclimates can also be created deliberately, and the display case provides an ideal container. Cases, cabinets and frames can be viewed simply as buffers, partially

protecting their contents from fluctuations in the larger environment. The microclimate approach takes the process a stage further, conditioning the case's internal environment to maintain the required level of relative humidity and temperature regardless of ambient conditions.

The microclimatically controlled display case can overcome many obstacles, including fluctuating or incorrect relative humidity levels, and a case's otherwise poor buffering capacity. Here are some typical applications:

- the long-term display of objects that would otherwise be subjected to unstable ambient conditions;
- the unavoidable rapid movement of moisture-sensitive objects to a different environment;
- the isolation of moisture-sensitive objects under controlled conditions when the main climate control equipment is faulty or shut down for servicing;
- to bring objects accidentally subjected to wetting into slow equilibrium with ambient conditions; and
- the manipulation of an object's moisture content as a stage in its conservation treatment.

Microclimates can be set up using active or passive control, or a combination of the two. Both methods are suitable for individual display cases, but linked groups of cases or boxes are best put under active control.

Active control

Active control always involves some form of energy input, usually through electrically driven climate control equipment. Control units, which can be small humidifiers, dehumidifiers, or filtered mechanical ventilating systems, are installed inside or outside the case, depending on the relative sizes of case and unit. Air can be ducted through a hood via a hose; and power and water supplies will be needed, the latter either in mains or reservoir form and preferably purified. The position of electrical and other service inlets and outlets will probably restrict the freedom of exhibition designers: aesthetics, for example, may clash with these practicalities.

Active control demands active supervision; there must be a conscientiously followed and effective maintenance programme, and contingency plans for system breakdowns and power failures – all of which make active control a labour-intensive and potentially expensive option. Might a back-up system – an extra expense – be justifiable where specially sensitive objects are concerned? And are the units easily accessible for maintenance, so that objects need not be moved at every service? If these requirements are not met, the objective – providing environmental continuity – is defeated.

A case's air leakage rate will determine the speed at which a power failure or breakdown will destabilise the microclimate; where the case is a poor buffer, and the ambient environment is unstable, any vulnerable object in the case could soon be put under some stress. Active humidification presents another

risk: if a dehumidifier runs out of control, relative humidity inside the case may drop to approximately 30 per cent, but a comparable humidifier failure could push relative humidity up to dangerous levels.

Passive control

Passive control of the display case environment depends on conditioned natural or synthetic buffer materials, such as silica gel. The buffer absorbs moisture when the ambient relative humidity is high and desorbs moisture when it is low, smoothing out variations in humidity. Properly selected and conditioned, a buffer material can be used to alter ambient relative humidity; separate batches of silica gel, for example, can be conditioned to different relative humidity levels and then blended together before use to the level of relative humidity required for the objects in the case.

Saturated salt solutions have been used to regulate relative humidity, and may appear to promise a cheap method of microclimatic control. Unfortunately, cheapness is probably the only advantage of this simple approach: large containers of the solution can be messy and awkward to handle; salts can 'creep' from containers as a result of temperature variations; solutions cannot be regenerated, and do not maintain a uniform relative humidity over the whole

Conditioning silica gel

Dry silica gel can be conditioned to the required relative humidity (RH) by spreading it thinly not more than 25 millimetres deep in trays, in an atmosphere where ambient RH is similar to that to which the gel is to be conditioned. Silica gel can take days or even weeks to condition, depending on the quantity, but the process can be speeded up with the use of fans and a humidifier set at the required RH.

A check on progress should be made periodically. This can be done by determining the moisture content and percentage RH of the silica gel, either by measuring its increase in weight, or by taking a sample of the gel and closing it in a polyethylene bag with a calibrated hair hygrometer until the reading has stabilised. A direct measurement of the RH to which the gel has been conditioned can be made. Silica gel can also be oven-dried at between 150° and 180°C for two hours.

Calculating the quality of silica gel

The empirically determined quantity of silica gel required to buffer ambient RH is 20 kilograms per cubic metre of display case volume. The effectiveness and duration of a microclimate using a buffer material are influenced by a number of factors brought together in the formula:

$T = 4 (M \times B)/N$ days,

where T is the half-life of the case, M is the specific moisture reservoir of the buffer material, B is the quantity of buffer material in kilograms per cubic metre of case volume and N is the number of air changes per day.

Box 20 Silica gel as a buffer

volume of air in the case. Nor is the method suitable for fine control, as its accuracy is temperature-sensitive.

Several natural materials have been tested for their suitability as buffer materials. Preliminary tests have shown that the absorption response times of rice seed, wheat seed and soybean to ambient relative humidity are not inferior to that of silica gel, and the smaller the particle size, the quicker the response to RH changes. The main use of these materials would be in circumstances where conventional buffers are not available. They must be handled with great care, and used in an emergency only; if neglected, natural materials can be attacked by pests which will not discriminate between the material and objects in the vicinity. Further work is needed to evolve workable methods of conditioning, and protection against insects, before these materials can be more widely used.

In general, passively controlled microclimatic systems enjoy several advantages over their more sophisticated active counterparts:

- There is control of humidity where it is needed – in the immediate surroundings of the object – and it is independent of ambient conditions in the gallery; this flexibility gives more freedom to the exhibition designer in the siting of display cases.
- They allow a finer degree of control than any commonly available active equipment.
- They are energy efficient in their use of 'low-tech' equipment.
- There is no equipment to break down, perhaps causing a rapid rise, fall or fluctuation in relative humidity.
- There is a gradual drift towards gallery conditions as the buffer becomes exhausted, rather than the abrupt and stressful change caused by active equipment failure.
- There is no noise or vibration.
- Passive systems are less expensive to maintain than active systems of control.

Environmental control at the level of the display case – even when its labour-intensive aspects are taken into account – remains very much cheaper than centralised or room-wide conditioning. Operation and maintenance are also easier, and therefore cheaper: museum staff can manage and service display cases, especially those under passive control, whereas gallery-wide permanently installed systems need trained building services engineers to operate and maintain them.

Throwing light on the case

Many display cabinets and cases use internal electric lighting; without it, the objects they contain may not be revealed in sufficient detail and colour. One drawback of internal lighting is the potential loss of control over light levels that can result from the case lights being permanently switched on during

visitor hours. Daylight or the gallery's main lighting system can be effective alternatives, and where these sources are used low-tech solutions such as blinds or curtains over the cases will provide a simple means of exposure control.

The most obvious way to illuminate a display case is to mount a light source inside it, but for aesthetic and design reasons museums sometimes prefer an external source. The external source also brings a conservation bonus in that there is no significant heating effect unless the lamp is very close to the case. But the approach demands great care from the designer who sets the lamps: poorly set light sources can cause distracting reflections from the glass of the case and bright spots from lamps and windows – whether seen directly or reflected off surfaces in the field of view – produce an irritating glare. Because the eye uses the brightest surface it sees as the reference point, glare can reduce the visibility of the illuminated object, and may even produce headaches in some people.

Traditional remedies for glare and reflections include the use of non-reflective glass, changing the angle of the glass, screening or moving the light source and giving the visitor a choice of angles from which to view the display. A more recent approach uses indirect lighting: specially positioned lights illuminate the gallery's internal architecture to provide both ambient and subject lighting.

The inner light: internally lit display cases

The internally illuminated display case provides an island of light that is independent of the ambient lighting in the gallery. Often providing a pleasant contrast with its surroundings, it serves to attract visitors and to draw their attention to the objects. Several types of lamp have been successfully used in cases and cabinets, especially the tungsten filament and the tungsten halogen incandescent lamps, and tubular fluorescent (low-pressure mercury) and metal halide (high-pressure mercury) discharge lamps. The amount of light (as opposed to heat) given off by tubular fluorescent and metal halide lamps is greater than that from tungsten filament lamps, for example.

See the subsection on electric lighting in chapter 6, p. 89, and Datasheet 4, pp. 141–4.

Light levels can be coarsely controlled in steps by changing the lamp for an equivalent type of a different rating; finer control may be achieved electrically or by using filters. Electrical control relies on dimmers of the correct type for the lamp in use; layers of neutral density filters – which should leave the colour of the light largely unchanged – will also reduce light to the required level.

There are two major problems that a good internal lighting system will overcome: maintenance access, and heat. The access problem is best solved by arranging separate compartments for lighting and display. This simple and effective solution means that the lighting unit can be serviced or bulbs changed without disturbing either the objects in the case or their surrounding micro-climate. A sealed glass or plastic barrier incorporating a UV-absorbing filter should divide the display area from the lighting compartment.

See the subsection 'Controlling UV' in chapter 6, p. 93.

Light as a source of heat

All lamps produce heat – some types, particularly tungsten filament lamps, produce it in large quantities. A lamp placed in direct contact with the air inside a display case will start to heat it, and when it is switched off, the air cools down, destabilising the temperature and with it the relative humidity of the all-important microclimate. This has been known to create over time a small, though significant, daily air exchange with ambient conditions. Lighting control gear such as dimmers and transformers also produces heat, and will need to be sited with as much care as the lamp itself.

The separation of lamp space and object space, so important for maintenance, also has conservation benefits. A separate lamphouse or lighting unit can be ventilated by louvres or a fan without any worries about the airtight display space itself. Cool-running lamp types, provided their colour and other characteristics are suitable, will obviously be a safer choice – though the control gear, which is a potential source of heat, should be sited away from the display area.

One more important heat-related effect is thermal pumping, caused by the rise and fall of temperature associated with the on–off cycling of lights; this will tend to force air into and out of the case, and can override its virtually airtight seal. Cool-running, segregated lighting units will help to reduce thermal pumping as much as other heating effects.

Fibre optic fittings are increasingly being used for display case lighting, and offer the great advantages of a remote light source, and the elimination of UV radiation and heat. Bundles of optical fibres 'conduct' the light from the source, which is typically a tungsten halogen or metal halide lamp, to the display case interior. The display area is therefore widely separated from the lamp and its attendant control gear. One source can supply several outlets; a single bundle of fibres may divide into branches, each one 'piping' the light to different display cases, or to many points within the same case.

Part 4

Storage and transportation: managing hidden stresses

Out of sight, not out of mind

> The art treasures of the National Gallery . . . are safely stored in an underground working, with between 200 and 300 feet of rock cover, which is impregnable to air attack . . . the staff, like the crew of a ship, give ceaseless attention to the machinery which controls the temperature . . .
>
> 'Art Treasures Safe 300 Feet Deep in Caves',
> 1 February 1943

No museum or gallery has enough display space for more than a fraction of the objects in its care. Anything not displayed has to be stored, so the storage regime, and the environmental condition of storage spaces, are crucial to the preservation of the collection. It is also true that most objects will move between spaces, at least within the museum: the collection changes, and objects move from display into store and back again, or are loaned out, or are removed for restoration. The environmental continuity of the most vulnerable objects when moved into, around and out of storage is therefore a fundamental requirement of any museum store.

The principles of safe storage

The safe storage of objects requires their separation from the outdoor environment. For most museum objects, this condition will be mandatory, though there are some apparent exceptions – large industrial and transport exhibits, including cranes, bridges, railway engines, aircraft and boats may be kept, albeit temporarily, outdoors unless they are unique or otherwise important examples of their type. Arguably, these are only apparent exceptions because the most rugged outdoor exhibit will still need protection from the weather in the form of special exterior paintwork, grease, tarpaulins, hard stands and sheds – compare the condition of a restored and protected railway engine with that of its derelict and rusted counterpart standing unprotected in scrapyard sidings.

A museum should therefore plan to provide a weather cover for even the most robust objects as soon as resources permit. The minimum storage requirement can be stated quite simply: a clean, watertight, accessible and pest-free space.

Controlling the storage environment

The role of environmental systems in a store is to supplement the environmental function of the building fabric; the idea that systems might completely take over environmental control is a recent development. Long-term storage of collections can be more cost-effective if both the control systems and the building are used to improve the internal environment of a store.

Storage spaces in existing buildings can suffer from high relative humidity. Heating, dehumidification or both will control the problem, but the types of systems that are installed will depend partly on whether permanent staff work there, on the nature of the collection housed within the store, and whether the insulation or draughtproofing of the building can be improved.

Heating

Heating a store economically requires a high standard of air-tightness and building insulation, ideally in excess of the minimum requirements in the current building regulations. Costs could otherwise be high, especially if electricity is used to run the heating system.

Continuous background heating should be provided for the bulk storage of objects made of metal where the risk of condensation on cold surfaces is high. In winter, in stores that are not regularly used, temperature regulation can stabilise ambient relative humidity. By keeping the temperature about 5°C above external ambient conditions, relative humidity can be kept below 65 per cent. In theory, this heat-only approach will also work in the summer months, but the elevated high temperatures that could result should be avoided near objects.

Dehumidification

Dehumidification may be used to reduce the ambient relative humidity in a store housing a mixed collection. It may be cheaper to prepare the building for dehumidification than for heating, because it can be both cheaper and easier to draughtproof windows and doors than to insulate the fabric of a building.

See the feature on building insulation in chapter 4, p. 44.

If draught-proofing can reduce air movement between the exterior and interior of a building to less than one air change per hour, then the running costs of a dehumidification system can be between a quarter to a third of the cost of running a heating system, assuming that the aim of both is to control internal relative humidity. When choosing a dehumidification system for use in storage spaces, remember the following principles:

- Desiccant dehumidifiers are generally recommended for use at low ambient temperatures.
- Refrigerant dehumidifiers are also suitable, and may be fitted with automatic defrost to prevent icing at low ambient temperatures.
- Whatever type of dehumidifier is used, it should be permanently plumbed in – not dependent on staff emptying containers.

Box 21 Improving storage conditions within an existing building

The dangers of glazing

Windows and roof lights in storage spaces are pointless, and may even be harmful. They are poor buffers against the external climate, allowing large heat losses and gains, and are a security risk. The simplest solution is to brick up windows and to replace roof lights with plain roofing; this will help to stabilise the environment, but may be ruled out by planning regulations, aesthetic considerations or the possibility of the space reverting to display or other uses. A less drastic remedy is to board up windows on the inside, but this introduces the risk of condensation damage to the window frames.

Condensation on boarded windows occurs on the cold inside surface of the glazing behind the boarding when warm moisture-laden air from the room leaks into the gap between the window and the boarding. It can be prevented by improving the seals around the boarding to stop the air from the room migrating into the gap, and by venting the gap to the exterior. Additionally surface treatment can reduce heat gains and losses: a reflective film applied to the outer surface of the boarding will reflect external heat and stop it entering the room. If the gap between the window and the boarding is less than 25 millimetres, air convection currents in the intervening space can be avoided and condensation thereby reduced.

Unshaded glazing also allows daylight to enter the store. Light has no place in museum storage spaces, unless people are working in them to return or retrieve objects, so it should be possible to extinguish all natural and artificial light sources when the store is unoccupied. When the store is occupied, comparatively low lighting levels can be enhanced and made more useful for staff if walls and shelving are painted white.

If staff spend a significant amount of time in the store, particularly over an extended period, then the level of light should be controlled, based on the calculation of the annual light exposure value. This value has both light level and time dimensions, so a higher illuminance could be used for examining objects, for example, if most of the time the store is in darkness.

See the subsections 'Measuring visible light' and 'Measuring ultraviolet radiation', both on p. 62 in chapter 5.

Types of stores

On-site stores

Stores within museum buildings tend to be located wherever space is available; worse, storage is sometimes the use of last resort, pushed into areas incapable of supporting any other museum functions. This implicit downgrading of storage often happens in buildings that are converted to museum use, but can also occur in purpose-built museums where the collection has outgrown the space originally designated for storage.

The marginal areas of a building are likely to be those most difficult to control environmentally. Basements are vulnerable to damp, and attics to large temperature fluctuations; both extremes of space are often used to house cisterns and water tanks, boilers and fuel stores, hot and cold water pipes, drains and many kinds of cables – all of which can create areas of localised heat and damp.

The use of marginal spaces should be phased out as soon as possible, but if storage must continue, there should be routine and rigorous inspection of the fabric of the building and the services that run through these areas.

Off-site stores

The environment in a dedicated off-site storage area can often be controlled more effectively and consistently through environmental zoning, particularly if the building is large or awkward to manage. Otherwise, the principles of safe storage, environmental control and efficient use of space apply equally to off-site and on-site storage.

Off-site stores do suffer from one particular problem: distance. Even where the store is relatively close to the main museum site, most forms of access, and environmental monitoring in particular, will involve regular toing and froing between the sites. If a spot-reading regime is in operation, time-consuming daily visits will be unavoidable. Electronic methods, however, can make life much easier.

Dataloggers and up-to-date building management systems provide electronic data output that can be monitored from a distance. The connection between the remote site and the museum can be by dedicated data lines, by the public telephone network (using a modem – modulator/demodulator – at both ends to convert the digital signals to and from a telephone-compatible analogue form), or by radiotelemetry. Telemetry needs no cable connections between the sites, so may be the most promising development for the future. However, while new technology may ease access to environmental data, this should not replace routine inspection visits to stores.

Dataloggers and radiotelemetry were introduced in chapter 5, p. 59, and BMS in chapter 6, p. 94.

Collection-related storage

The term 'storage' is most obviously used to refer to spaces housing the collection, but can also denote collection-related storage. This takes many forms, from temporary spaces for objects in transit to rooms housing packing material. But conditions have to be controlled as effectively in collection-related areas as in any other museum storage area. Ideally, environmental conditions in a temporary storage area will be adjustable, to suit the requirements of objects moving between different environmental conditions. Some examples:

- There may a packing/unpacking area for processing loans between the museum and other centres (though if loans are uncommon, it may be unnecessary to dedicate an area exclusively to this function).

125

- Museums with collections vulnerable to pest damage may operate a small quarantine store, where objects suspected of harbouring pests can be isolated and examined.
- There may be a separate area for the storage of packing materials, storage supplies and equipment, and display furniture. Perhaps surprisingly, conditions here must be controlled too: if packing and display materials are stored in the same general conditions as the collection, they will acquire equilibrium with the same environment. Better buffering is the result: when the packed object enters a hostile environment, the mismatch is between the packing and the environment, not between the packing and the object.

Visible or closed storage?

Storage may be either 'closed' – the traditional store, open only to museum staff – or 'visible' – open to visitors. Visible storage thus combines two functions that are normally considered to be separate – display and storage. A growing trend, visible storage allows an ever-increasing number of people to have access for longer periods to areas traditionally used exclusively by museum staff.

Visible storage turns a storage space into a display space, and therefore demands the same level of environmental controls that is provided for objects in dedicated display areas. Display in storage spaces obviously means an increase in light levels, and all the temperature and relative humidity problems that visitors bring in their wake. To make matters worse, storage spaces may be cramped and ill-suited to visitor access. Visible storage may be appropriate only:

- for stable objects;
- where visitor numbers are controlled;
- where the space is large enough to allow the unhindered circulation of visitors without endangering objects; and
- where the appropriate level of environmental control can be implemented.

The efficient utilisation of storage space

Organising storage by material

It is easier and cheaper to provide environmental controls if storage areas are assigned to objects according to their material composition. Unfortunately, this may be feasible only when planning a new store, or for parts of the collection made of easily identified homogeneous materials such as paper or textile. Conditions in existing stores of mixed collections – social history objects, for example – will represent a compromise, probably based on the requirements of the main material type.

A separate section of the store could be designated for minority materials with special environmental needs. Small quantities of archaeological iron or other particularly vulnerable objects can be safely held in locally controlled storage boxes.

Plate 8 The construction of a new store provides the opportunity to incorporate sound principles of construction at the design stage.

Acknowledgement: Winchester City Record Office

127

Storage in difficult buildings

Aircraft hangars and industrial buildings are increasingly being used for off-site storage of museum objects. These and other non-purpose-built facilities may offer large amounts of space, but usually present environmental control difficulties – often because of the sheer scale of the building and its large air volume.

A hangar, for example, is usually a tall, thin-walled structure enclosing a very large internal volume – a space that it would be hopelessly uneconomic to try to control building-wide for relative humidity and temperature. Environmental zoning offers the only realistic energy-efficient solution and provides environmental control where it is required.

In a zoning scheme, a controlled and stable environment is set up in a core area of the building; this is where the most sensitive and vulnerable objects will be stored. Depending on the needs of the remaining objects, other zones can follow, grouped around the controlled core. The outermost zone, next to the external walls of the building, enjoys only coarse control of relative humidity and temperature and is where the most robust objects can be stored. If strict control over humidity is required anywhere in the building, this can be provided through active control, using permanently installed or transportable equipment and/or microclimatically controlled storage boxes.

If the museum has some control over the building's structure and fittings, make sure that water and waste pipes are routed well away from collection storage areas; or, failing this, install leak detectors and keep objects off the floor and away from walls. External doors can be hung in pairs to provide a kind of airlock between the indoor and outdoor environments; for this to work, the doors must be far enough apart to prevent people routinely holding both sets open at the same time. Loading and unloading points can be environmentally protected by a draughtproofed up-and-over door made out of an insulating material sandwiched between metal plates; the draughtproofing material will need regular maintenance.

Potential storage space

Space is usually at a premium, so museums are frequently forced to look for new on-site and off-site storage areas. Museum staff must evaluate the potential use and environmental control needs of any new space for objects or people, especially before acquiring new premises. One further point: when planning, extending or reorganising collection stores, be sure to evaluate the suitability of the space to meet both current and projected future permanent storage needs. Space is soon outgrown.

Transportation: the moving environment

And moveth all together, if it move at all.
William Wordsworth (1770–1850), *Resolution and Independence*, xi

The practicalities of environmental continuity are challenged most when objects are moved from their permanent location. Any movement of objects – even over very short distances – must be planned meticulously. Success demands the correct equipment, appropriate technology and well-trained staff. A combination of factors may arise that may cause accidents to happen: working against the clock and staff working for longer hours than desirable, combined with handling of objects that may have never been moved before increases the risk of damage.

The rigours of movement

The movement of museum objects is an everyday occurrence, and takes place at every possible scale – across rooms and across continents. Short journeys within a museum can provide an element of environmental risk, but here the main threat is of physical damage caused by unplanned handling and movement, a lack of awareness of structural weaknesses in objects that appear sound – and, perhaps, complacency in the face of an often trivial-seeming activity. Long journeys pose more obvious challenges.

Before an object is moved it must be assessed by a conservator or by a curator with some knowledge of conservation. What are the implications of the move for the physical well-being of the object? What precautions should be taken to safeguard the integrity of the object while it is being moved? What are its environmental needs? Can it be moved at all?

A strategy for movement

Objects are at constant risk of environmental damage from the moment they are moved from their permanent location until they are returned. However, if objects are properly packed, the risk of physical damage is greatest at the collection and delivery points, rather than during transport. The better the

packing, the less the risk to objects of environmental and physical damage. A lender should always review the collection, unloading and unpacking procedures of a potential borrower, whose packing materials and procedures will also need careful scrutiny – remember that the object will eventually be returned or sent on from the same place.

Wherever possible, consignments should be accompanied by trained couriers, who will make sure that the full transport plan is carried out. Couriers – whose training should include appropriate elements of preventive conservation and collection care – increase the lender's control over the transport process; they are not there simply as insurance to deal with emergencies caused by poor planning or packing.

Planning ahead

As in all other aspects of the environmental care of the collection, good planning is essential for the safe movement of museum objects. No part of the transportation strategy should be altered in isolation; if one aspect changes, the others will need to be re-evaluated. For example, a crate may be increased in height to accommodate a deeper insulation layer, but cannot now enter the building at its destination.

Buildings not originally intended for museum use can present handling and loading difficulties. Plans for a new museum or a large centralised off-site storage building should consider an all-weather covered loading dock capable of accommodating the main types of vehicle likely to use it.

Predicting the outdoor environment

Long distance transport will probably involve transit through different climate zones. When planning a long journey, try to obtain general information on the local weather, the weather during transit and the weather at the destination; be prepared for the worst. Crates and vehicles must protect their contents against the worst climatic extremes likely to be encountered, especially if much of the journey is by road.

Packing materials and crates

Crates, cases and packing materials not only protect their contents from physical damage; they act as buffers against the external environment, performing, in miniature, the same function as the museum building. The kinds of packing materials and crates used will depend on a number of factors:

- the method of transport (air, road, rail, sea);
- the duration of the journey (hours, days, weeks);
- the number of venues involved (is the journey a simple one-way trip; or is the object 'on tour'?); and
- the type of objects.

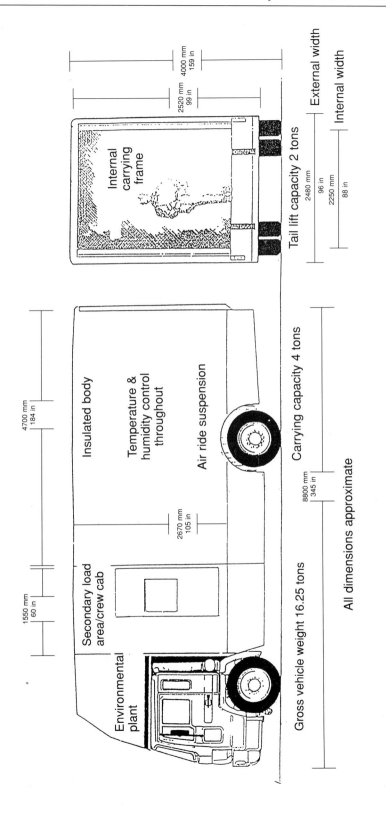

4000 mm
159 in

2520 mm
99 in

External width

Internal carrying frame

Internal width

Tail lift capacity 2 tons

2480 mm
96 in

2250 mm
88 in

4700 mm
184 in

Insulated body

Temperature & humidity control throughout

Air ride suspension

Carrying capacity 4 tons

1550 mm
60 in

2670 mm
105 in

Secondary load area/crew cab

8800 mm
345 in

Environmental plant

All dimensions approximate

Gross vehicle weight 16.25 tons

Figure 14 The requirements of vehicles that are becoming standard for transporting museum objects are illustrated by this drawing of the Yorkshire and Humberside Museums Council vehicle.

Acknowledgement: Yorkshire and Humberside Museums Council

131

Packing can range from soft wrapping, through travelling frames, to lined cases with reinforced corners; the more fragile the packing, the more care and supervision will be needed to guard against damage. Where the journey regime is difficult, or the object is specially vulnerable, a full-scale crate is essential. Each of the following conditions calls for the use of a crate:

- whenever the objects are likely to be beyond the direct control of the sending museum for all or part of the journey;
- if the journey includes an overnight stay;
- whenever the journey involves airport handling and transportation;
- where objects are fragile or environmentally sensitive.

The good crate guide

The design of crates has come a long way since the days of the splintering softwood box. Transport crates are now high-performance mobile enclosures, developed to meet demanding specifications and several fundamental principles:

- Because the crate is a substitute building, it must achieve the same kind of protection against the ingress – and egress – of air and water. In short, a crate must be a leakproof enclosure.
- A crate's outer shell must be tough and proof against the roughest handling. Large crates will need to stand clear of the ground on feet or battens to provide access for fork-lift trucks, slings and other lifting gear.
- External fittings like fasteners and handles should be simple and reliable. Crates for air transport will require pressure seals; signs warning against careless handling should be clearly stencilled on the outside.

Packing and crating against physical damage

On most journeys, objects suffer the most intense shocks and vibrations during handling. Careful packing can provide some defences.

How to pack the crate

Make sure that the weight is evenly distributed, and keep large crates upright. Vibration effects will be reduced if the structure of the crate is stiffened and the object is placed at the centre of gravity of the crate and well-cushioned against shocks. Fragile objects can be protected against new stresses if they are packed in a similar orientation to the one they normally occupy on display or in store.

Inside the crate, the innermost layer should consist of thermal insulation material. This will be followed by a layer of foam cushioning designed to attenuate the effects of vibration and shock; the thickness and disposition of the foam around the object will depend on the weight of the object, the surface area of the object resting on the foam beneath, and the maximum drop height likely to be experienced during the journey. The last layer, next to the outer wall of the crate, is the vapour barrier; this continuous screen of heavy-duty polyethylene

will exclude water and pollutants and help to stabilise the moisture content of hygroscopic materials inside the crate.

Transport effects on crates

No crate, however robust and well-packed, can protect its contents against every eventuality. Objects can still be damaged by the shock of violent handling when crates are dropped, toppled or suddenly tilted. Different forms of transport will also place different stresses on crates.

On road journeys, variable rate air-ride suspension vehicles protect loads against vibration in transit, reducing the need for heavy crates to achieve the same degree of protection. An air-ride suspension vehicle should always be preferred over one with a conventional suspension. Where an air-suspended vehicle is not available, a vehicle normally used for light loads is better than a heavy goods vehicle. Museum loads are usually light, whereas heavy vehicle suspensions are optimised for heavy loads and produce a stiff, juddering ride under light loadings.

Aircraft present different challenges to the design of crates. On large aircraft the crate can be containerised, though it may shift if the container has no internal ties. Alternatively, crates can be palletised, covered in polyethylene and netted.

Small aircraft of the kind used for short-haul, shuttle and feeder services are not usually capable of palletised shipment, and will probably have no ties in the cargo space. Whatever the other advantages of air transport may be, this lack of suitable safe stowage may tilt the balance in favour of road transport for short or inland journeys.

How to get it there: methods of transport

Air

Air transport is fast, but the lender or transport organiser does not have complete control of conditions at every point on the journey. Crates may be left standing exposed to the weather at airports or stored in damp warehouses. On the aircraft itself, altitude changes cause the pressure in the cargo hold to drop to as low as 25 per cent of atmospheric pressure at sea level; at the same time, the hold temperature may drop to 0°C and relative humidity to 10 per cent.

Inside a good packing crate the relative humidity should remain unchanged from the time of packing for up to twenty-four hours. Crates transported to and from overseas should be allowed to acclimatise for at least twenty-four hours before being opened.

Road

Road vehicles can be fitted with conditioning equipment to control the environment of the cargo space. Conditioning facilities vary: some vehicles offer full

control over relative humidity and temperature, others provide heating and cooling and yet others heating only. Some loads do not require fully conditioned vehicles: for example, a vehicle carrying properly crated objects should be insulated, and able to heat and cool the cargo space, but need not be fully climate-controlled if the crate composition is designed to stabilise internal relative humidity. In other circumstances, the shortcomings of partial conditioning may be more obvious: a vehicle that can only heat its cargo space will not cope with increases in temperature caused by solar gain. All conditioning systems are only as good as their state of maintenance will allow, so controls should be in good working order – and tamper-proof.

Rail

Objects transported as rail cargo experience similar problems to those transported by road, though the character of the 'ride' is different. Temperature control over the intended journey route may be more difficult to organise, particularly if the load is small. The whole journey will not be conducted by rail, so there will also be additional handling, with its associated risks, as the objects are transferred to and from road vehicles. Very small items can be taken as hand luggage on passenger trains.

Sea

Sea transport is less popular than it once was. Although ships are suited to the carriage of bulky items, voyages tend to be relatively long and therefore increase the time during which objects are subject to the stress of transit. Conditions in cargo holds are generally stable, but levels of relative humidity are normally high. Sea transport is still a viable form of transport for very large objects made of stable materials.

Monitoring and controlling the moving environment

Who is responsible for the moving environment?

When a museum borrows an artefact or specimen, it takes responsibility for providing the level of environmental control agreed with the lender. The onus is on the borrower to prove that these conditions are being met – and monitoring is the only reliable source of proof. Ideally, environmental monitoring and control will begin as soon as the object leaves its permanent location and will not stop until the object is safely returned.

No loan should be agreed without a full assessment of the environmental and security risks to the object. The lender must establish that the borrower is fit to receive the object – preferably aided in the case of an institutional borrower by the evidence of a facilities report drawn up by the borrower's representative, and an environmental questionnaire supported by environmental records. A conservator representing the lending institution should help to decide whether an object is physically fit to travel.

Environmental continuity

Environmental continuity, the guiding principle of preventive conservation, is constantly threatened when an object is moved. Transporting objects therefore requires much more than simple protection against physical damage.

In the simplest case, where the source and destination conditions are the same, the problem is one of maintaining environmental stability by duplicating these conditions inside the packing throughout the journey – and maintaining them during unpacking and packing, on display and in temporary storage. Environmental tagging is invaluable here, as each vulnerable object will carry a reminder of the conditions it requires. Once again, environmental monitoring provides the evidence that these conditions are being maintained for the duration of the loan.

See the subsection 'Environmental tagging' in chapter 3, p. 26.

Different or unstable conditions

Life becomes more complicated when the source and destination conditions are different. Lenders often stipulate a tighter band of environmental control than can be maintained in the collection's permanent home. This may not be as wise as it first appears: stricter conditions will certainly keep the object safe at its temporary site, but what happens when it returns home? An object's rate of decay will probably reduce when it is moved to a tightly controlled environment; unfortunately, when it returns to the original broadly controlled site, the environmental change may actually accelerate decay. It is far better for the object if the lender stipulates conditions for transit and loan that mirror conditions in the home institution.

Environmental mismatches between source and destination are an even bigger problem where the object has been kept in an unstable environment. Never try to replicate these unstable conditions, in the name of environmental continuity, during transit and at the destination site. The borrower and lender must agree in advance on any appropriate modifications designed to smooth out fluctuations. The lender should then take the opportunity to improve the home environment before the object returns from loan.

Change, and most especially the speed at which it occurs, is the danger: the faster the change, the greater the risk of physical damage to an object. The risk can be reduced by some simple precautions:

- Lender and borrower can formally agree a period of at least twenty-four hours for objects to acclimatise inside the wrapping or crate.
- The schedule for transport and exhibition installation must allow the acclimatisation period to run its course.
- Wrappings, packing materials and crates should be stored in similar environmental conditions to the objects, both at source and destination. Special vigilance may be needed for touring exhibitions, during which objects will be packed and unpacked many times.

- A borrower must always obtain the lender's permission before altering any aspect of the object or the packing procedure.

See the subsection 'Collection-related storage' in chapter 9, p. 125, for more on the storage of packing materials.

Measuring on the move

In theory, monitoring instruments used in static environments can be pressed into service for measuring the mobile environment. The vital parameters of relative humidity and temperature cannot be measured on the move using recording thermohygrographs; in common with other mechanical instruments, thermohygrographs are vulnerable to vibration and physical shocks, which upset calibration, so solid state dataloggers should be used instead. The physical stresses that crates and their contents experience in transit can also be monitored with the aid of simple mechanical impact detectors.

Where objects have been properly packed, it may be possible to check the environmental conditions they experienced while on loan. Good packaging will preserve this climate by sealing it inside the crate. Before the returned object is unpacked, the lender can insert a humidity sensor inside the package to sample relative humidity and temperature.

Controlling on the move

Control technology is developing to the point where it will soon be possible to provide dynamic rather than static control in transport vehicles. At present, vehicle climate control systems are static – the required environmental parameters are pre-set, and the system simply maintains them. A dynamic system under microprocessor control will allow the environment to undergo continuous controlled change. At the start of the journey, the vehicle's cargo space could be programmed to provide the conditions at the lending institution; during transit, the environment would gradually change to approach conditions at the destination. A long journey would allow the full acclimatisation of objects that are just soft-wrapped to be accomplished in transit; on shorter trips, the process would have to be completed at the destination.

Insurance and paperwork

Documentation

Complete documentation of the condition of the object before and after transport is critical to identifying risks, preventing damage, and maintaining good lender–borrower relations. Documentation is also valuable when trying to assign the causes of damage: without it, a difficult process is turned into an impossible one.

Condition reports compiled before objects leave their permanent home should record any existing defects; new damage will then be easier to spot, and – with

luck – an attempt can be made to trace this back to its cause. But it is extremely difficult to distinguish between existing and new damage – even with the aid of sophisticated instrumentation, the latest methods of examination or an experienced conservator. Sometimes a pre-existing defect is made worse during a loan, but it is often impossible to decide whether the damage is the result of an inherent weakness in the object, poor packing or transport, or the borrower's standards of care.

Insurance

Insurance policies are beginning to reflect an increased awareness of environmental effects on loaned objects.

Good packaging, capable of maintaining a stable internal environment for the object, is expensive – certainly more expensive than careless wrapping with poor materials. Add to this the cost of monitoring and control in transit, well-trained staff and climate-controlled packaging stores, and the expense rises still further. But savings on these essentials will increase other costs – objects may suffer physical damage, which in turn will severely strain the goodwill that has so far existed between lenders and borrowers at both national and international levels.

Datasheet 1
Record form, spot readings of light and ultraviolet radiation

Site: _____

No. of hours exposure per week: _____

Blackout facilities: Yes ☐ No ☐

Type of lighting[1]: D ☐ E ☐ C ☐

Monitoring equipment: _____

Last calibration: _____

Person taking readings: _____

	Site plan of measurements (for horizontal readings)

	Site elevation of measurements (for vertical readings)

		Ultraviolet radiation[2]			*Visible light (lux)*[3]		
Date	*Time*	*site*	*reading*	*site*	*reading*	*Weather*	

Notes

[1] D = daylight, E = electric, C = combination of both

[2] Take the weekly maximum UV radiation reading. Calculate the dose of UV radiation. (See Box 9.)

Weekly dose of UV radiation: _____ running total: _____

[3] Take the weekly maximum visible light reading. Calculate the maximum light exposure value of the site. (See Box 8.)

Weekly maximum light exposure: _____ running total: _____

Datasheet 2
Record form, spot readings of relative humidity and temperature

Site: _____ Site plan of measurements

Monitoring equipment: _____

Last calibration: _____

Person taking readings: _____

Date	Time	Relative humidity		Temperature		Weather
		site	reading	site	reading	

Weekly minimum relative humidity: _____

Weekly maximum relative humidity: _____

Length of time: _____ of steepest rise/fall in RH: _____

Weekly minimum temperature: _____

Weekly maximum temperature: _____

Length of time: _____ of steepest rise/fall in temperature: _____

Datasheet 3

Summary of weekly minimum and maximum relative humidity, temperature and light readings[1] over twelve months

[1]Data obtained from spot readings using a whirling hygrometeror, aspirated psychrometer, or electronic hygrometer or recorded readings using a thermohygrograph and light meter

It is possible to use this information to assist in deciding whether heating or cooling, humidification or dehumidification are needed. Take a psychrometric chart and on it plot the recommended minima and maxima for relative humidity and temperature. Shade the area created by these plots on the psychrometric chart. Then plot the actual weekly minima and maxima for relative humidity and temperature from the above, to check whether it falls within the shaded area. Those plots which fall outside the shaded area should indicate whether heating or cooling, humidification or dehumidification are needed. (See Box 4.)

Location: _____

Key:
Maximum Mean of max.
Minimum Mean of min.

Datasheet 4
Lamp characteristics

Characteristics	*Tungsten filament*	*Tungsten halogen*
Lamp prefix	GLS, R, PAR	TH
Diagram		
Construction	Tungsten filament heated to incandescence in a glass envelope filled with inert gas.	Tungsten filament heated to incandescence in a small envelope containing halogen.
Operation	Immediate full light output. Operates in all positions. Sensitive to small voltage changes. Light output declines with time. Shield against UV and ventilate heat.	Immediate full light output. Restricted operating positions. Sensitive to small voltage changes. No decline in output with time. Glass shield needed to suppress UV.
Power consumption (watts)	15–1000	10–250 (low voltage/single ended) 600–800 (compact linear/double ended) 500–1500 (linear/double ended)
Efficacy (lumens/watt)	8–18	18–24
Nominal life (hours)	1000–2000	2000–4000
Colour appearance/temperature[1]	Warm (2900K–3300K[1])	Warm (3000K–3300K)
Colour rendering[2]	Good (IA)	Good (IA)
Ultraviolet content range (µW/lumens)	~75	49–127
Control gear	No	No (but may require transformer)
Example of application	General use and display	Display and floodlighting

Datasheet 4

Datasheet 4 continued

Characteristics	Low pressure mercury discharge lamps (tubular fluorescent)		Low power compact fluorescent
	Multiband or triphosphors	Halophosphates or ordinary phosphates	
Lamp prefix	MCF	MCF	SL, PL, 2D, 2L
Diagram			
Construction and operation	Electric discharge in a low pressure mercury atmosphere contained in a glass tube internally coated with one or a number of phosphors.		Similar to tubular fluorescent, using multiband or triphosphors to allow tube to be shaped; integral control gear.
Power consumption (watts)	20–80 (depending on tube length)		9–35 (depends on type)
Efficacy (lumens/watt)	Approx. 60–95		50–75
Nominal life (hours)	5000–12,000		5000–10,000
Colour appearance/temperature[1]	Warm Intermediate Cool (depending on type)	(2700K–3000K) (3500K) (4000K)	Same as for tubular fluorescent.
Colour rendering[2]	Good (1A–1B)[2]	Fair (2–3)[2]	Good (1B)[2]
UV content range (µW/lumens)	43–87	81–85	43–87
Control gear	High frequency	Low frequency	Integral high frequency control gear.
	Yes, instant to fast start and restrike time		
Example of application	Multiband and triphosphors are replacing halophosphates (ordinary phosphates) for display lighting owing to		Non-critical zones such as office, corridors, lavatories, shops.

142

Characteristics	High pressure sodium	High pressure mercury		
		Metal halide	(Fluorescent)	Tungsten (blended)
Lamp prefix	SON	MBI, MBIF	MBF	MBTF, MBTFR
Diagram				
Construction	Electric discharge in a high pressure sodium atmosphere, in an arc tube contained in a diffusing or clear outer envelope.	Electric discharge in a high pressure mercury atmosphere with metal halide additives in an arc tube, sometimes contained within a fluorescent-coated glass.	Electric discharge in a high pressure mercury atmosphere contained in an arc tube within a fluorescent-coated glass tube.	Electric discharge in a high pressure mercury atmosphere contained in an arc tube, with a tungsten filament heated to incandescence all contained in a fluorescent glass tube.
Operation	Run-up time: 4–7 mins. Re-ignition within one minute with external ignitor. Operates in any position.	Run-up time: 5 mins. Re-ignition after about 10 mins unless special circuits are used. Restricted operating position.	Run-up time: 4 mins. Re-ignition after about 10 mins unless special circuits are used. Operates in any position.	Some light output immediately. Run-up time: 4 mins. Re-ignition about 10 mins. Operating position restricted.
Power consumption (watts)	50–1000 (lamp without control gear)	250–2000 (lamp without control gear)	50–2000 (lamp without control gear)	100–500
Efficacy (lumens/watt)	67–121	66–84	36–54	10–26
Nominal life (hours)	6000–12,000	5000–10,000	5000–10,000	5000–8000
Colour appearance/temperature[1]	Warm (2000K–3300K)	Various (warm, intermediate, cool)	Intermediate (3300K–5300K)	Intermediate (3300K–5300K)
Colour rendering[2]	Fair to good (2 to 4)[2]	Wide range – generally good[2]	Fair (3)[2]	Fair (3)[2]
Ultraviolet content range (µW/lumens)	30–70	150–600	50–100	95–100
Control gear	Yes	Yes	Yes (simple ballast circuit)	No

Datasheet 4 continued

Characteristics	High pressure sodium	High pressure mercury		
		Metal halide	*(Fluorescent)*	*Tungsten (blended)*
Lamp prefix	SON	MBI, MBIF	MBF	MBTF, MBTFR
Example of application	High level interior display lighting and area floodlighting.	General lighting in high bay areas and floodlighting.	Area floodlighting.	Replacement for tungsten filament where lamp life is important and access is difficult.

CRI	Colour rendering groups
90	1A
80–90	1B
60–80	2
40–60	3
20–40	4

(CIBS, *Code for Interior Lighting*, 1984)

[1]See Glossary for definition of term.
[2]See Glossary for definition of term. How a lamp renders coloured objects is compared to a reference source. As the colour rendering of a lamp approaches that of the reference source, the Colour Rendering Index (CRI) approaches 100. (Lighting Industry Federation, *Lamp Guide*, 1990.)

Glossary

absolute humidity The amount of water vapour (in grams) in 1 cubic metre of air. Unlike **relative humidity** (q.v.), absolute humidity does not vary with temperature changes.

activated charcoal Material used as a filter when necessary to remove gaseous pollution and odours. Odorous and polluted air passes through a filter medium of high retentive granular carbon, the pollutant being removed by retention in its cellular structure.

air-conditioning A system of providing and maintaining an internal atmospheric condition within predetermined limits, irrespective of external conditions.

air handling unit (AHU) A broad term covering factory-assembled equipment capable of carrying out several or all of the following functions of air: filtration, cooling, heating, humidification, dehumidification and circulation.

annual maximum exposure value Exposure (in lux hours) is a measure produced by multiplying illuminance (in lux) by time (in hours).

asset management system Software programme which registers the description, history and costs of items (from equipment to furniture) owned by an organisation. It can be a stand-alone system or linked to a building management system (BMS). Its functions can include full costs and depreciation values of equipment, and a full programme of planned preventive maintenance either programmed on a calendar basis or if linked to a BMS, on a condition basis.

buffer material A material that responds to changes in ambient relative humidity by taking up and releasing moisture.

building management system (BMS) A computerised control system that can be programmed to provide monitoring of the internal environment, control of lighting, heating, ventilation and air-conditioning systems, and plant and energy management. Its use can be extended to include leak detection and response.

calibration An appropriate method of checking the accuracy of a measuring instrument against a recognised standard.

collection-related storage Space for the storage of equipment, furniture or materials used in contact with objects on display, storage and during packing and handling.

colour appearance The apparent colour of light that a lamp emits (e.g. warm, cool). Colour appearance can be expressed as colour temperature, which can range from a warm colour (having a low colour temperature) to a cool colour (having a high colour temperature). Colour appearance gives no indication of **colour rendering** (q.v.).

colour rendering The appearance of surface colour when illuminated by light from a given source. It encompasses the effect of light emission from a source, light absorption and reflectance of surfaces, and human perception. It indicates how a lamp renders coloured objects compared to a reference source of approximately the same colour temperature. As the colour rendering approaches the reference source, the Colour Rendering Index (CRI) approaches 100.

commissioning Testing a system and taking it from a state of static completion to full operation in accordance with the design specifications.

condensation When a given volume of air is at **saturation** (q.v.) point, and the temperature remains unchanged while more moisture is added to the air, this extra moisture will not vaporise. It will condense on cold surfaces as droplets. If instead no moisture is added to a volume of air at saturation point but the temperature drops, condensation will also form as the excess moisture in the air condenses on to cold surfaces. For localised condensation,

145

saturation and a surface colder than the surrounding air are necessary.

conservation audit A predetermined assessment programme of the collection, the monitoring procedures, the buildings and environmental systems to identify long-term collection needs and the resources required to meet them.

conservation heating A method by which space heating is used to control ambient relative humidity, with temperature allowed to fluctuate within preset limits.

control set-point The value to which an automatic control of a mechanical system must be pre-set in order that a given desired value is achieved.

conversion A major change in the function and use of an existing building or space.

corrective maintenance This is carried out after failure has occurred and is intended to restore an item to a state in which it can perform its required function.

cosine correction A good light meter will have a photocell which is cosine-corrected. This means that it is designed with an angular correction which allows the meter to compensate for light falling on the cell at different angles.

critical zone A term referring to object-priority areas in a museum, such as exhibition spaces and stores.

datalogger An instrument which collects, records and processes data electronically.

Defects Liability Period Time (usually a twelve-month period) after completion of a building project during which a contractor can rectify defects. Normally 5 per cent of the contract value is retained for the duration of this period.

dehumidification The process of extracting moisture from the air in a controlled manner.

design occupancy The number of people and activities for which an environmental system has been designed.

efficacy (of a lamp) The light output of a lamp, compared to the power that it consumes, usually expressed in lumens per watt.

electromagnetic spectrum The complete range of electromagnetic radiation, from radio waves – those with the longest wavelength – through microwaves, the **infrared** (q.v.), visible light, **ultraviolet** (q.v.) radiation and X-rays to gamma rays – those with the shortest wavelength. In general, the shorter the wavelength, the more damaging is the radiation.

energy audit A full programme of analysis of how energy is used, including the pattern of use and the cost of fuel. Depending on how extensive the audit is, it may include an overview of heat loss through the building fabric and an analysis of

fuel tariffs and negotiations with utility companies. Recommendations for improvements often form part of this audit.

environmental continuity The practice by which objects which have reached equilibrium with their environment, are maintained as far as possible in these conditions which promote their stability at all times, even when objects are moved.

environmental tagging A method of recognising quickly and easily the environmental requirements of a particular object. It could take the form of a label or bar code attached to the object at all times. It is a physical reminder of the conditions in which an object should be kept if its **environmental continuity** (q.v.) is to be maintained.

evaporation The process by which liquid water becomes water vapour and is present in the air as atmospheric moisture.

exclusive The approach to environmental control which provides tight localised control in display cases and storage boxes and ambient comfort control in the rooms.

fibre optic lighting Glass or plastic internally reflecting fibres are grouped into bundles of tails which are assembled into a fibre optic harness attached to an auxiliary tungsten halogen or metal halide light source. Light from the source is reflected along the fibres and is emitted from the tip of each tail. Fibre optic lighting is low in ultraviolet radiation and heat.

humidification The process by which moisture is added to the air in a controlled manner. The three main practical methods are by atomising water droplets into the air, evaporation or steam-injection.

humidistat A controller which responds to changes in humidity in an enclosed space and which is employed to control ambient relative humidity.

hygrometer An instrument capable of a direct reading of relative humidity. Its operation relies upon an element possessing hygroscopic characteristics of linear variation relative to the moisture content of the air and which is mechanically transmitted to a pointer moving across a suitably calibrated scale.

hygrometric half-life The hygrometric half-life is the time taken for the **relative humidity** (RH) (q.v.) in a closed box to drop to the average of the starting values of the ambient and the box's internal RH.

hygroscopic The ability of a substance or material to absorb and desorb moisture from the air.

ideal conditions This is often used to describe tight control over relative humidity and temperature specific to different materials. Trying to achieve

ideal conditions can impose an intolerable burden on a museum's resources and the need for tight control must be fully justified before a decision is made. In reality, ideal conditions often represent the starting position from which an informed and pragmatic compromise, taking into consideration other factors such as space and resources, is achieved.

illuminance The amount of luminous flux reaching a surface. The unit of measurement is the lux, an SI unit equal to 1 lumen per square metre; 1 candle at a distance of 1 foot will illuminate a surface of 1 square metre to approximately 10 lux (10 lux = 1 foot candle).

infrared radiation This band of radiation lies between radio waves and visible light. It has a longer wavelength than **ultraviolet** (UV) (q.v.) radiation, which means that it is less damaging. In air, infrared radiation is converted mainly to heat. It can be measured using a thermometer.

inorganic materials Materials that have a mineral origin, such as ceramics, glass, stone and metals.

interstitial condensation The liquification of water from the air at a point within the building fabric which has a lower temperature than its surroundings.

interventive conservation The processes by which objects which have suffered damage or decay are treated and made stable in a laboratory, studio or workshop.

Kelvin temperature scale (K) Devised by Lord Kelvin in order to provide a temperature scale having no dependency upon the physical characteristics of any substance. Zero Kelvin is equivalent to −273.15°C.

lux See **illuminance**.

microprocessor A single integrated circuit which acts as the central processing unit in a small computer.

modem A device used to convert the digital information used by a computer to and from the analogue form used by most telephone lines, in order to transfer information between the computer and remote sites.

moisture equilibrium If the quantity of humidity present in air is in balance with the quantity of moisture present in a **hygroscopic** (q.v.) material such as paper or wood, the material is said to be in equilibrium with the surrounding air.

O & M manual An operation and maintenance manual which explains clearly and in detail, the working and servicing requirements of equipment. It should be updated periodically to reflect work that has been done. It should include names and addresses of suppliers and drawings and diagrams where necessary.

off-site storage Storage facilities which are located away from the main museum site.

organic materials Materials that have an animal or vegetable origin, such as leather, textile and wood.

passive monitor A device which requires no energy input to check on any one of a number of conditions, such as pollution.

performance testing A subset of **commissioning** (q.v.) that goes beyond normal balancing of the system after it is fully installed. Simulated occupancy is the most important aspect of performance testing. During the testing, the plant is subjected to both typical and extreme operating conditions to iron out problems that simple commissioning would not uncover. Performance testing models the interaction of the occupants and their activities, the system, and the space.

Practical Completion Certificate This is a certificate which is issued by a project manager on behalf of a client to state that the work has been completed in accordance with contract specifications.

preventive conservation A term used to describe the broad function of care of a museum collection. It requires both technical and management skills, and an understanding of how its preservation may be affected by the way it is used by people within and outside the museum.

preventive maintenance This is carried out at predetermined intervals and is intended to reduce the probability of failure.

psychrometric chart A set of graphs combined on a single chart to plot the relationships between temperature, air pressure and moisture content to specify relative humidity.

psychrometry The study of the properties and behaviour of mixtures of air and water vapour.

radiotelemetry A system by which radiowaves of an appropriate frequency are used to transmit information between sites in different locations.

relative humidity (RH) The relationship between the quantity of moisture present in a volume of air (**absolute humidity**, q.v.) and the maximum quantity of moisture that could exist in the same volume of air (i.e. at **saturation**, q.v.), expressed as a percentage.

$$\text{relative humidity (\%)} = \frac{\text{absolute humidity}}{\text{saturation}} \times 100$$

saturation The point at which liquid water stops evaporating into the air as water vapour and the volume of air in question has absorbed the maximum amount of moisture it can hold. Saturation occurs at different temperatures for a

given volume of air – the higher the temperature, the more moisture can be absorbed.

silica gel A granular material that is produced in various particle sizes. It is known mainly for its drying properties, but it behaves like organic materials in so far as it can take up water from moist air and release it when the air is dry. It can do this quickly and has a large moisture reservoir.

specific moisture reservoir The moisture (in grams) absorbed by 1 kilogram of buffer material with an increase of 1 per cent RH.

spectral power distribution The relative power of light from a light source in different parts of the spectrum. Different light sources have different spectral power distribution curves.

spot reading The use of meters in environmental monitoring to carry out random checks of various parameters such as light, relative humidity, temperature, and pollution.

tagging See **environmental tagging**.

thermal load The aggregate of the incidental heat gains within a space, including solar gains and the heat generated by appliances and occupants.

thermal lag The ability of the structure to delay the effect of internal and external heat gains on the internal climate. These gains include changes in the external climate, such as solar gains through windows and internal heat gains from people and lighting.

thermohygrograph An instrument which records on a graph ambient temperature and relative humidity. The former is done by use of a bimetallic strip and the latter by use of a hair element. Information is mechanically transmitted to independent pointers which register the readings as a graph on a rotating drum.

tungsten filament lamp The ordinary, domestic (General Service Lamp) is the most common lamp of this type. It operates by heating a tungsten filament to incandescence in a glass envelope filled with inert gas. It produces more heat than visible light.

tungsten halogen This is similar to a tungsten filament lamp except that halogens are used as the gases within a small glass envelope. It produces more ultraviolet radiation than heat, so a glass shield is needed to suppress it.

U-value The rate of heat transfer (in watts) through 1 square metre of a structure when the temperature on each side of the structure differs by 1°C.

ultraviolet (UV) radiation The band of the electromagnetic spectrum most damaging to museum materials, lying between visible light and X-rays. It can be measured using a UV monitor and can be controlled using filters.

visible storage Provision of public access to that part of museum collection held in storage.

Select bibliography

American Society of Heating, Refrigerating and Air-conditioning Engineers, Inc., *ASHRAE Handbooks: Fundamentals, Systems, Equipment, Applications*. ASHRAE, Atlanta, GA, 1989.

Anon., 'Space for Services': Pt 1, 'The architectural dimension' (12 February); Pt 2, 'Environmental quality', and Pt 3 'High technology controls' (18 February); Pt 4, 'Strategic planning' (26 February); Pt 5, 'Distribution and sizing' (5 March); Pt 6, 'Structure and services' (12 March); Pt 7, 'Distribution within spaces' (19 March), *Architects Journal*, London, 1986.

Antomarchi, C. and de Guichen, G., 'Pour une nouvelle approche des normes climatiques dans les musées', *Preprints of ICOM Committee for Conservation*, 8th Triennial Meeting, Sydney, 1987.

Association for Preservation Technology and the American Institute of Conservation, *The New Orleans Charter for the Joint Preservation of Historic Structures and Artifacts*, APT/AIC, Fredericksburg/Washington, DC, October 1991.

Ayres, J. M., Druzick, J., Haiad, J. C., Lau, H., and Weintraub, S., 'Energy conservation and climate control in museums', *International Journal of Museum Management and Curatorship*, 8, London, 1989.

Bakken, A., Velure, M., and Fjerdumsmoen, G., 'Underground storage – two attempts, one in Norway and one in Zambia, a situation report', *Preprints of ICOM Committee for Conservation*, 8th Triennial Meeting, Sydney, 1987.

BRESCU (Building Research Energy Conservation Support Unit), *Selecting Air Conditioning Systems, A Guide for Building Clients and Their Advisers*, Best Practice Programme, Good Practice Guide 71, Garston, January 1993.

Brimblecombe, P., 'The composition of museum air', *Atmospheric Environment*, 24A, 1989, pp. 1–9.

British Standards Institution, BS 1006, *Methods of Test for Colour Fastness of Textiles and Leather*, BSI, London, 1978.

——BS 5250, *Code of Practice for Control of Condensation in Buildings*, BSI, London, 1989.

——BS 5368, *Methods of Testing Windows*: Pt 1, Air permeability test; Pt 2, Water tightness test under pressure; Pt 3, Wind resistance test, BSI, London, 1985 and 1986.

——BS 5412, *Specification for Type H Industrial Vacuum Cleaners for Dust, Hazards to Health*, Section 2.2, Supplement 1, BSI, London, 1986.

——BS 5454, *Recommendations for Storage and Exhibition of Archival Documents*, BSI, London, 1989.

——BS 5720, *Code of Practice for Mechanical Ventilation*, BSI, London, 1979.

——BS 5803, *Thermal Insulation for Use in Pitched Roof Spaces in Dwellings*, BSI, London, 1985.

——BS 5925, *Ventilation Principles and Designing for Natural Ventilation*, BSI, London, 1991.

——BS 6229, *Code of Practice for Flat Roofs with Continuously Supported Covering*, BSI, London, 1982.

——BS 6375, *Performance of Windows*: Pt 1, Classification of weather tightness, BSI, London, 1989.

——BS 6540, *Air Filters used in Air-Conditioning and General Ventilation*, BSI, London, 1985.

——BS 8210, *Building Maintenance Management*, BSI, London, 1986.

Building Research Establishment, *Thermal Insulation: Avoiding Risks*, Report, HMSO, London, 1989.

——*External Walls: Joints with Windows and Doors – Detailing for Sealants*, Defect Action Sheet 68, BRE Defects Prevention Unit, London, 1985.

Button, D. and Pye, B., *Glass in Buildings: A Guide to Modern Architectural Glass Performance*, Pilkington with Butterworth Architecture, Oxford, 1993.

Canadian Ministry of Culture and Communications, *Guidelines for Museums*, Heritage Branch, Ontario, 1991.

——*Standards for Community Museums in Ontario*, Heritage Branch, Ontario, 1991.

——(ed.) *Museums Environment Energy*, Museums & Galleries Commission and HMSO, London, 1994.

Cassar, M., 'A flexible climate-controlled storage system for a collection of ivory veneers from Nimrud', *International Journal of Museum Management and Curatorship*, 5 (2), Oxford, 1986, pp. 171–81.

——'The effect of building design on the health of museum collections', *Building Pathology*, 89, Hutton & Rostron Environmental Investigations Ltd, Oxford, September 1990, pp. 171–84.

——'Environmental strategies for museum collection storage', *SSCR Journal*, 3 (4), Edinburgh, November 1992.

——(ed.) *Museums Environment Energy*, Museums & Galleries Commission and HMSO, London, 1994.

Cassar, M. and Oreszczyn, T., 'Environmental surveys in museums and galleries in the United Kingdom', *Museum Management and Curatorship*, 10 (4), Oxford, 1991, pp. 385–402.

Child, R. E., 'Pest management strategies for collections', *SSCR Journal*, 3 (4), Edinburgh, November 1992.

Church of England, *The Inspection of Churches*, Measure, 1955; confirmed by Pastoral Measure, London, 1986.

CIBSE (Chartered Institution of Building Services Engineers), *Applications Manual: Window Design*, The Chartered Institute of Building Services Engineers, London, 1987.

——*Lighting Guide: Lighting for Museums and Art Galleries*, The Chartered Institution of Building Services Engineers, London, 1994.

——*CIBSE Code for Interior Lighting*, The Chartered Institution of Building Services Engineers, London, 1984.

——*CIBSE Guide*. Volume A, *Design Data*; Volume B, *Installation and Equipment Data*; Volume C, *Reference Data*, CIBSE, London, 1988 (reprint).

——*Minimising the Risk of Legionnaires' Disease*, CIBSE Technical Memorandum TM13, CIBSE, London, 1991.

——*Energy Audits and Surveys Applications Manual* (AM5: 1991), CIBSE, London, 1991.

Cuttle, C., 'Lighting works of art for exhibition and conservation', *Lighting Research and Technology*, 20, 1988.

Daniels, V. and Wilthew, S., 'An investigation into the use of cobalt salt impregnated papers for the measurement of relative humidity', in Gerhard, C., *Preventive Conservation in the Tropics: A Bibliography*, Institute of Fine Arts Conservation Center, New York University, August 1990.

de Guichen, G., *Climate in Museums*, ICCROM, Rome, 2nd edn, 1988.

Department of the Environment and The Welsh Office, *The Building Regulations 1985*: C, *Site Preparation and Resistance to Moisture*, and C4, *Resistance to Weather and Ground Moisture* (Approved Document, HMSO, 1992); F, *Ventilation*, F1, *Means of Ventilation*, and F2, *Condensation* (Approved Document, HMSO, 1992 – under revision); J, *Heat Producing Appliances*, L, *Conservation of Fuel and Power*, and L1, *Conservation of Fuel and Power* (Approved Document, HMSO, 1992 – under revision).

Energy Efficiency Office, *Energy Audits*, Fuel Efficiency Booklet No. 1, London, 1984.

——*Introduction to Energy Efficiency in Museums, Galleries, Libraries and Churches*, Department of the Environment, London, 1994.

Feilden, B. M. 'Architectural factors affecting the internal environment of historic buildings', *Preprints of the IIC Vienna Conference*, 1980.

Feller, R. L., 'Further studies on the international [*sic*] blue-wool standards for exposure to light', *Preprints of the ICOM Committee for Conservation*, 5th Triennial Meeting, Zagreb, 1978.

Feller, R. L. and Johnstone-Feller, R. M., 'Continued investigations involving the ISO blue-wool standards of exposure', *Preprints of the ICOM Committee for Conservation*, 6th Triennial Meeting, Ottawa, 1981.

Ford, B., 'Monitoring colour change in textiles on display', *Studies in Conservation*, 37 (1), London, 1992.

Health and Safety Commission, *Approved Code of Practice for the Control of Substances Hazardous to Health in Fumigation Operations*, HSC, London, 1988.

—*Approved Code of Practice for the Prevention and Control of Legionellosis (including Legionnaires' Disease)*, HMSO, London, 1991.

—*Approved Code of Practice for the Safe Use of Non-Agricultural Pesticides*, HSC, London, 1991.

Health and Safety Executive, *Health and Safety at Work etc. Act*, HMSO, London, 1974.

—*Factory Act and Offices, Shops and Railway Premises Act*, HMSO, London, 1963.

—*Control of Substances Hazardous to Health Regulations (COSHH)*, HMSO, London, 1989.

—*The Control of Legionellosis including Legionnaires' Disease*, HMSO, London, 1991.

—*Humidifier Fever* (J. M. Sykes), Specialist Inspector Report No. 11, HMSO, London, 1989.

—*The Selection and Use of Disinfectants* (A. N. Cottam), Specialist Inspector Report No. 17, HMSO, London, 1989.

—*Ventilation in the Workplace*, Guidance Note EH22, HMSO, London, 1988.

Hitchcock, A. and Jacoby, G. C., 'Measurement of relative humidity in museums at high altitude', *Studies in Conservation*, 25, London, 1980.

HMSO, *Pesticides* (A list of approved pesticides published annually on behalf of the Health and Safety Executive, and the Ministry of Agriculture, Fisheries and Food), HMSO, London.

—*Tables of Temperature, Relative Humidity and Precipitation for the World*, Parts 1–6, 1958–78, HMSO, London.

Jackman, P. J., *Specification of Indoor Environmental Performance of Buildings*, BSRIA Technical Note 3/87, Bracknell, Berks, 1987.

Kamba, N. and Miura, S. (eds), *Control of Museum Climate in Asia and the Pacific Area*, Organising Committee of the IIC Kyoto Conference, Japan, September 1988.

Kay, G. N., *Mechanical and Electrical Systems for Historic Buildings*, McGraw-Hill, New York, 1991.

Keene, S. (ed.), *Managing Conservation*, Papers from a UKIC / Museum of London Conference, UKIC, London, 1990.

Kelly, A., *Maintenance Planning and Control*, Butterworth, Oxford, 1985.

Kenjo, T., 'Certain deterioration factors for works of art and simple devices to monitor them', *International Journal of Museum Management and Curatorship*, 5, Oxford, 1986.

King, S. and Pearson, C., 'Environmental control for cultural institutions', *Preprints of ARAAFU Colloquium on Preventive Conservation*, Paris, 1992.

Lafontaine, R. H., 'Recommended environmental monitors for museums, archives and art galleries', *Canadian Conservation Institute Technical Bulletin*, 3, Ottawa, 1975.

—'Environmental norms for Canadian museums, art galleries and archives', *Canadian Conservation Institute Technical Bulletin*, 5, Ottawa, 1981.

Lee, R., *Building Maintenance Management*, 4th edn, Blackwell Scientific Publications, Oxford, 1987.

Lighting Industry Federation, *Lamp Guide*, 1990 edn, Lighting Industry Federation.

Lighting in Museums, Galleries and Historic Houses, Preprints of conference organised by the United Kingdom Institute for Conservation, Museums Association, and Group of Designers and Interpreters in Museums, Bristol, 1987.

Lord, B. and Dexter Lord, G., 'The museum planning process', *Museums Journal*, 87 (4), London, 1988.

—*The Manual of Museum Planning*, HMSO, London, 1991.

Lord, B., Dexter Lord, G., and Nicks, J., *The Cost of Collecting*, HMSO, London, 1989.

Macleod, K., 'Relative humidity: its importance, measurement and control in museums', *Canadian Conservation Institute Technical Bulletin*, 1 (reprint), Ottawa, 1978.

McMullen, R., *Environmental Science in Building*, 2nd edn, Macmillan Education, London, 1989.

Mecklenburg, M. F. (ed.), *Art in Transit: Studies in the Transport of Paintings*, Division of Conservation, National Gallery of Art, Washington, DC, 1991.

Meteorological Office, *Hygrometric Tables for Aspirated Hygrometer Readings in Degrees Celsius*, MET.O. 265C, Pt III, 2nd edn, HMSO, London, 1964.

——*Averages and Frequency Distributions of Humidity for Great Britain and Northern Ireland, 1961–70*, Climatological Memorandum 103, HMSO, London, August 1976.

——*Handbook of Meteorological Instruments*, HMSO, London, 1981.

Michalski, S., 'Towards specific lighting guidelines', *Preprints of the ICOM Committee for Conservation*, 9th Triennial Meeting, Dresden, 1990.

——'Relative humidity: a discussion of correct/incorrect values', *Preprints of ICOM Committee for Conservation*, 10th Triennial Meeting, Washington, DC, 1993.

Museums & Galleries Commission, *Standards in the Museum Care of (Archaeological, Biological, Geological and Larger and Working Objects) Collections*, Museums & Galleries Commission, London, 1992 onwards.

NASA, *Comparative Climatic Data for the United States through 1989*, National Climatic Data Center, Federal Building, Ashville, NC 28801, USA.

National Audit Office, *Management of Collections of the English National Museums and Galleries*, HMSO, London, 1988.

National Bureau of Standards, *Air Quality Criteria for Storage of Paper-Based Archival Records*, NB SIR 83-2795, National Bureau of Standards, Washington, DC, 1983.

Olgyay, V., *Design with Climate: A Bioclimatic Approach to Architectural Regionalism*, Van Nostrand Reinhold, New York, 1992.

Oreszczyn, T., Mullany, T. and Riain, C. N., 'A survey of energy use in museums and galleries', *Museums Environment Energy* (M. Cassar, ed.), Museums & Galleries Commission and HMSO, 1994.

Padfield, T., 'Low energy climate control in museum stores', *Preprints of the ICOM Committee for Conservation*, 9th Triennial Meeting, Dresden, 1990.

Pearce, E. A. and Smith, C. G., *The World Weather Guide*, 2nd edn, Hutchinson, London, 1990.

Pinniger, D., *Insect Pests in Museums*, Archetype Books, 1991.

Pragnell, R. F., 'Recording humidity: no need to lose your hair', *Environmental Engineering*, September 1990, pp. 13–18.

Ramer, B., *A Conservation Survey of Museum Collections in Scotland*, HMSO, Edinburgh, 1989.

Royal Institute of Chartered Surveyors, *Planned Building Maintenance*, RICS Building Surveying Practice Note 4, London, 1980.

——*Memorandum of Agreement between Client and Project Manager*, RICS, London, 1989.

Runyard, S. and Ambrose, T., *Forward Planning*, Routledge in association with the Museums & Galleries Commission, London, November 1991.

Sandwith, H. and Stainton, S., *The National Trust Manual of Housekeeping*, Viking in association with The National Trust, London, revised edn, 1991.

Saunders, D., 'Fluorescent lamps: a practical assessment', *National Gallery Technical Bulletin*, No. 11, London, 1987.

——'Ultraviolet filters for artificial light sources', *National Gallery Technical Bulletin*, No. 13, London, 1989.

——'Ultraviolet absorbing films for museum glazing', *Conservation News*, 47, London, 1992.

Scottish Society for Conservation and Restoration, *Environmental Monitoring and Control*, Preprints from the SSCR and Museums Association Conference, Dundee, 1989.

Sease, C., 'A new means of controlling relative humidity in exhibit cases', *Collections Forum*, 1 (1), 1990.

Smith, M., *Maintenance and Utility Costs – Results of a Survey*, BSRIA Technical Memorandum 3/91, Bracknell, Berks, March 1991.

Staniforth, S., 'The logging of light levels in National Trust houses', *Preprints of ICOM Committee for Conservation*, 9th Triennial Meeting, Dresden, 1990.

Staniforth, S. and Hayes, B., 'Temperature and relative humidity measurement and control in National Trust Houses', *Preprints of ICOM*

Committee for Conservation, 8th Triennial Meeting, Sydney, 1987.

Staveley, H. S. and Glover, P., *Building Surveys*, Butterworth-Heinemann, Oxford, 2nd edn, 1990.

Storer, J. D., *Conservation of Industrial Collections: A Survey*, Science Museum, and The Conservation Unit, Museums & Galleries Commission, London, 1989.

Thomson, G., 'Annual exposure to light within museums', *Studies in Conservation*, 12, London, 1967.

——'Stabilisation of RH in exhibition cases: hygrometric half-time', *Studies in Conservation*, 22 (2), London, 1977.

——*The Museum Environment*, Butterworth, 2nd edn, Oxford, 1986.

Tinsdeall, N. J., *The Sound Insulation provided by Windows*, BRE Information paper IP6/94, Watford, May 1994.

Toishi, K. and Koyano, M., 'Conservation and exhibition of cultural property in the natural environment in the Far East', *Preprints of the IIC Kyoto Congress*, 1988.

United Kingdom Institute for Conservation, *Storage*, Preprints from the UKIC Conference, London, October 1991.

——*Life after Death: The Practical Conservation of Natural History Collections*, UKIC / Ipswich Borough Council Conference, February 1992, pp. 9–12.

United States Department of Commerce, *Preservation of the Declaration of Independence and Constitution of the United States*, National Bureau of Standards Circular 505, Washington, DC, 1951.

United States Department of the Interior, *The Secretary of the Interior's Standards for Rehabilitation and Guidelines for Rehabilitating Historic Buildings*, Washington, DC, revised, 1983.

——*The Secretary of the Interior's Standards for Historic Preservation: Projects with Guidelines for Applying Standards* (prepared in 1979 by W. Brown Morton III and Gary L. Hume), Washington, DC, 1985.

Watts Pocket Handbook 1993, Watts & Partners, 11–12 Haymarket, London SW1Y 4BP (071 973 6652).

Weintraub, S. and Anson, G. O., 'Technics: natural light in museums: an asset or a threat?', *Progressive Architecture*, May 1990, pp. 49–54.

Wide, D., 'Specification for minimal maintenance', *International Journal of Museum Management and Curatorship*, 3 (4), Oxford, 1984.

Wild, L. J., *Commissioning of HVAC Systems: Division of Responsibilities*, BSRIA Technical Memorandum 1/88, Bracknell, Berks, 1988.

Zycherman, L. A. and Schrock, J. R., *A Guide to Museum Pest Control*, Foundation of the American Institute for Conservation of Historic and Artistic Works and Association of Systematics Collections, Washington, DC, 1988.

Other general bibliographic sources

BSRIA, *Museums and Art Galleries Bibliography*, LB10/90, 4th edn, June 1990, Bracknell, Berks, UK.

Building Research Energy Conservation Support Unit (BRESCU), Information Leaflets, Garston, Hertfordshire, UK.

Canadian Conservation Institute, CCI Notes and Technical Bulletins, Ottawa, Canada.

Heath, M., *The Directory: Products and Services for Museums, Galleries, Historic Houses, Heritage and Related Arts Organisations*, The Museum Development Company, London, 1991.

Scottish Museums Council, *Caring for Museums Collections*, A Video and Information Pack, Edinburgh, Scotland.

Society for the Protection of Ancient Buildings (SPAB), Information Sheets and Technical Pamphlets, London, UK.

Sources of other information

Ancient Monuments Society

The Ancient Monuments Society was set up to save historic buildings. It advises English Heritage and Welsh Planning Authorities on any applications which involve demolition work on a listed building. The Society has a partnership with the Friends of Friendless Churches and maintains buildings through this partnership. They can also advise on ways to save threatened buildings.

St Ann's Vestry Hall
Church Entry
Blackfriars
London EC4V 5HB
England

British Museum Materials Testing Service

The Service is available to anyone who wishes to submit samples. For a fee, any material which is to be used in the storage and display of antiquities can be evaluated for its effect on the type of object with which it is intended to be used. However, files on over two thousand previously evaluated materials can be consulted free of charge by prior arrangement. It is advisable to rely on results of tests carried out in the last three years, because manufacturers can and do alter the composition of materials without notification.

Conservation Research Section
The British Museum
London WC1B 3DG
England

BRE (Building Research Establishment)

This technical consultancy offers a service in the analysis of thermohygrograph charts. A quarterly or annual agreement is preferred. BRE can provide a weekly 'instant' response or quarterly 'batch' response. Charges depend on whether analysis is in the form of printed summary or on computer disc. The consultancy can also provide a quarterly or annual report on the internal climate, related to external weather conditions.

Scottish Laboratory
Kelvin Road
East Kilbride
Glasgow G75 0RZ
Scotland

BSRIA (Building Services Research and Information Association)

Membership is open to all organisations concerned with the manufacture, design, installation, and operation of building services. Benefits to members include access to BSRIA research programmes, the services of specialist technical staff to respond to

technical and commercial inquiries, and access to the IBSEDEX database. Client services (also available to non-members) include equipment and systems testing, practical and theoretical design evaluation, the application of computers, and market research and instrument hire.

Old Bracknell Lane West
Bracknell
Berkshire RG12 4AH
England

The Building Centre Ltd

The Building Centre Ltd is an exhibition and information centre for building products and services. Companies either display their products directly by taking a stand at the Centre, or they may supply literature to the Centre for free distribution to visitors. The aim of the Building Centre is to supply company literature to anyone needing information on products, which can range from bricks to sanitary ware. Visits to the Centre, which also has a specialist bookshop, are encouraged; consequently, information will not be sent by post. However, there is a telephone helpline to trace companies that offer specific products.

26 Store Street
London WC1E 7BT
England

CADW (Welsh Historic Monuments)

CADW is the division of the Welsh Office which advises the Secretary of State on matters related to heritage, primarily buildings. It is made up of staff who include professionals from the fields of archaeology and conservation architecture able to advise on ancient monuments and historic buildings. Grants are available from CADW for the repair and restoration of historic buildings, maintenance of ancient monuments and work in conservation areas, and

small grants to civic societies and similar bodies.

Brunel House
2 Fitzalan Road
Cardiff CF2 1UY
Wales

CIBSE (Chartered Institution of Building Services Engineers)

CIBSE is the professional association for building services engineers. It also has a specialist lighting division. As a qualifying body, CIBSE ensures that members are properly trained and experienced and that they follow a code of professional conduct, and advises universities and colleges on building services courses. The Institution produces a wide range of technical guidance and organises conferences and seminars to update building services engineers.

Delta House
222 Balham High Road
London SW12 9BS
England

CIRIA (Construction Industry Research and Information Association)

CIRIA exists to facilitate the exchange of ideas and experience between organisations interested in building or civil engineering. Current work covers building and structural design, construction operations, ground engineering, water engineering, construction management, environmental management, and quality assurance.

6 Storey's Gate
Westminster
London SW1P 3AU
England

DoE Fuel Branch

The Fuel Branch is responsible for negotiating and managing contacts for the supply of

coal, automotive fuels, heating oils, natural gas, liquefied petroleum gas, and lubricants. It arranges electricity contracts for sites consuming more than 1 megawatt of power per annum, and has a scheme for the purchase of motor fuels via agency cards. The branch is dedicated to efficient and cost-effective energy purchasing, supply, and use. It conducts energy advisory services including energy usage assessments and tariff analysis. All services are available to fully or partially public funded bodies.

Department of the Environment
Fuel Branch
Room 2/26
St Christopher House
South Walk Street
London SE1 0TE
England

EDAS (Energy Design Advice Scheme)

EDAS is a Department of Trade and Industry discretionary initiative. It is aimed at improving the energy and environmental performance of the building stock by making low energy building design expertise more accessible for the energy efficient design and refurbishment of buildings. Advice is offered to design teams or their clients via regional centres:

The Bartlett Graduate School
Philips House
University College London
Gower Street
London WC1E 6BT
England

University of Ulster
at Jordanstown
Newtownabbey BT37 0QB
Northern Ireland

Royal Incorporation of Architects
in Scotland

15 Rutland Square
Edinburgh EH1 2BE
Scotland

The University of Sheffield
PO Box 595
Floor 13, The Arts Tower
Sheffield S10 2UJ
England

EEO (Energy Efficiency Office)

The EEO is a division of the Department of the Environment, based in London, with offices in each region of the UK. It works directly with energy consumers, the energy efficiency industry and buildings professionals, as well as with other government departments and a wide range of non-governmental bodies, on initiatives to promote energy efficiency. It employs the Energy Technology Support Unit (ETSU) and the Building Research Energy Conservation Support Unit (BRESCU) as lead contractors on its technical information programmes, and provides financial support for the work of Neighbourhood Energy Action and Energy Action Scotland.

The Office provides guidance and information in the form of publications, seminars and energy management groups.

2 Marsham Street
London SW1P 3EB
England

English Heritage

English Heritage is the organisation in England primarily responsible for the statutory requirements of the conservation of the historic environment. Its main aims are to secure the preservation of the country's architectural and archaeological heritage. Through the management of the four hundred historic properties in its care, it also helps to promote the public's enjoyment

and knowledge of historic sites. English Heritage has another important role in advising the government in an official capacity on matters of conservation, listing and scheduling. It is the major public funding source for historic buildings, historic towns, ancient monuments, and rescue archaeology. The largest portion of its funding comes from the government in the form of grant-aid.

25 Savile Row
London W1X 2BT
England

Georgian Group

The Georgian Group was founded in 1937. Its primary role is to try to save Georgian buildings, monuments, parks, and gardens which are under threat and to encourage the appropriate repair or restoration. It is also there to provide the public with a knowledge of Georgian architecture and town planning, and of the taste in decorative arts, design, and craftsmanship of the time. The Group is consulted for works relating to alterations to listed Georgian buildings. It is funded by membership subscriptions and grants from the Monument Trust and Department of the Environment.

37 Spital Square
London E1 6DY
England

TBV Science Ltd

The TBV Science laboratories provide analytical services and consultancy to local authorities, industry and private individuals. Their areas of work include water monitoring of heating and ventilation systems, analysis of air quality, microbiology including Legionella surveys, and materials analysis.

Great Guildford House
30 Great Guildford Street
London SE1 0ES
England

MAFF (Ministry of Agriculture, Fisheries and Food)

The Central Science Laboratory of the Ministry of Agriculture Fisheries and Food at Slough offers specialist advice and consultancy on pest problems in museums, including the identification of insect specimens and causes of damage, advice on pest detection methods and selection of the most effective and appropriate control options including the use of insecticides, freezing and carbon dioxide.

Central Science Laboratory
Ministry of Agriculture, Fisheries and Food
London Road
Slough SL3 7HJ
England

The Meteorological Office Commercial Service

The service that the Meteorological Office provides is based on its forecasting and climatological expertise. For weather forecasting it uses a sophisticated forecast model based on hourly weather observations worldwide. The emphasis is on 'site-specific' forecasts for up to a week ahead for a particular town or individual building. Observations are stored as a computerised climatological data archive, spanning many decades. Flexible data sorting programs mean the data can be analysed in a number of ways such as weather extremes for design purposes; frequencies of relative humidity and temperature; and simple averages of temperature, radiation, sunshine, rainfall. Driving rain and wind-chill indices, and degree-day values can also be calculated, and the office provides a data interpretation service.

Meteorological Office Commercial Services
Johnson House
London Road
Bracknell
Berkshire RG12 2SY
England

Museum Councils in the United Kingdom

The Museum Councils are partnerships set up by their members who include almost every public and charitable museum in the UK. Most are constituted as charitable companies limited by guarantee; they are answerable to their members for the services they provide, which include technical and financial help and advice, conservation, design and display, management and development planning, and staff training.

The ten Councils are:

Area Museum Council for the South West
(Avon, Cornwall, Devon, Dorset, Glos, Somerset, Wilts, Isles of Scilly)
Hestercombe House
Cheddon Fitzpaine
Taunton TA2 8LQ
England

South Eastern Museums Service
(incorporates the London Museums Service; Beds, Berks, Bucks, Cambs, Essex, Greater London, Hants, Herts, Isle of Wight, Kent, Norfolk, Oxon, Suffolk, Surrey, East & West Sussex, Channel Islands)
Ferroners House
Barbican
London EC2Y 8AA
England

Council of Museums in Wales
The Courtyard
Letty Street
Cathays
Cardiff CF2 4EL

West Midlands Area Museum Service
(Hereford & Worcs, Shropshire, Staffs, Warwicks)
Hanbury Road
Stoke Prior
Bromsgrove B60 4AD
England

East Midlands Museums Service
(Derbys, Leics, Lincs, Northants, Notts)
Courtyard Buildings
Wollaton Park
Nottingham NG8 2AE
England

Northern Ireland Museums Council
185 Stranmillis Road
Belfast BT9 5DU
Northern Ireland

North West Museums Service
(Cheshire, Cumbria, Gr. Manchester, Lancs, Merseyside, Isle of Man)
Griffin Lodge
Cavendish Place
Blackburn BB2 2PN
England

Yorkshire and Humberside Museums Council
(North, West & South Yorks, Humbs)
Farnley Hall
Hall Lane
Leeds LS12 5HA
England

North of England Museums Service
(Cleveland, Durham, Northumberland, Tyne & Wear)
House of Recovery
Bath Lane
Newcastle upon Tyne NE4 5SQ
England

Scottish Museums Council
County House
20–22 Torphichen Street
Edinburgh EH3 8JB
Scotland

National Measurement Accreditation Service (NAMAS)

NAMAS, a service of the National Physical Laboratory, assesses, accredits, and monitors calibration and testing laboratories. Subject to its stringent requirements, these laboratories are then authorised to issue formal certificates and reports for specific types of measurements and tests. Calibrations of all kinds come within the scope of NAMAS accreditation including optical, humidity, and temperature measurements. NAMAS provides publicity for accredited laboratories and a service to their users through the publication of a NAMAS Directory of Accredited Laboratories.

NAMAS Executive
National Physical Laboratory
Teddington
Middlesex TW11 0LW
England

National Trust

The National Trust was founded in 1895 and incorporated by Act of Parliament in 1907. Its primary aim is to preserve land with outstanding natural features or animal or plant life and buildings of beauty or historic interest for the nation. It owns over two hundred historic houses whose contents comprise a huge collection of historic objects and works of art. It is an independent organisation with charitable status, funded chiefly by members' subscriptions and donations.

36 Queen Anne's Gate
London SW1H 9AS
England

RIBA (Royal Institute of British Architects): The Clients' Advisory Service (CAS)

The purpose of the CAS is to assist clients in their selection of architects, initially by providing free lists of suitable practices according to the information provided by the client on their potential project. The service has a comprehensive computerised databank backed up by files on the work of individual practices working in the UK and abroad; this covers services offered, past experience and special skills.

The CAS operates from the RIBA Headquarters and from regional offices throughout the UK.

66 Portland Place
London W1N 4AD
England

The Royal Institution of Chartered Surveyors

The Royal Institution of Chartered Surveyors covers all aspects of land, building and construction. For the repair and maintenance of buildings and all aspects of the built environment in general, advice should be obtained from a chartered building surveyor. Generally, the information required by a contractor is best presented as accurate plans, elevations and sections. To obtain detailed advice, contact either the Building or Land Surveyors Divisions at:

12 Great George Street
London SW1P 3AD
England

Scottish Conservation Bureau

The Scottish Conservation Bureau exists to provide information, advice and support to all those concerned with the conservation of historic artefacts and cultural property in Scotland. It maintains a register of firms and individuals involved in conservation work throughout Scotland. Information is also available on conservation training, equipment and materials, other organisations involved in the field, and general

conservation activities in Scotland. A library of conservation literature is kept at the Bureau's offices.

Historic Scotland
Stenhouse Conservation Centre
3 Stenhouse Mill Lane
Edinburgh EH11 3LR
Scotland

SPAB (Society for the Protection of Ancient Buildings)

SPAB concerns itself with the repair and preservation of old buildings, and provides a technical advisory service in connection with problems in buildings. This work is carried out under the general guidance of the Society's Technical Panel, or through the agency of expert members in the field.

37 Spital Square
London E1 6DY
England

Victorian Society

The Victorian Society was founded in 1958 as a national society which was responsible for the study and protection of Victorian and Edwardian architecture and decorative arts. Since 1971, the Society has provided advice for local authorities on planning applications which may involve demolition or alteration of a listed building. It can also advise with regard to alterations to listed churches of the period if these are not covered by planning legislation. The Society is a registered charity and its sources of funding are membership subscriptions, legacies, bequests, income from investments and a grant from the Department of the Environment.

1 Priory Gardens
London W4 1YT
England

Index

161